ARCHITECTURAL
PHOTOGRAPHY

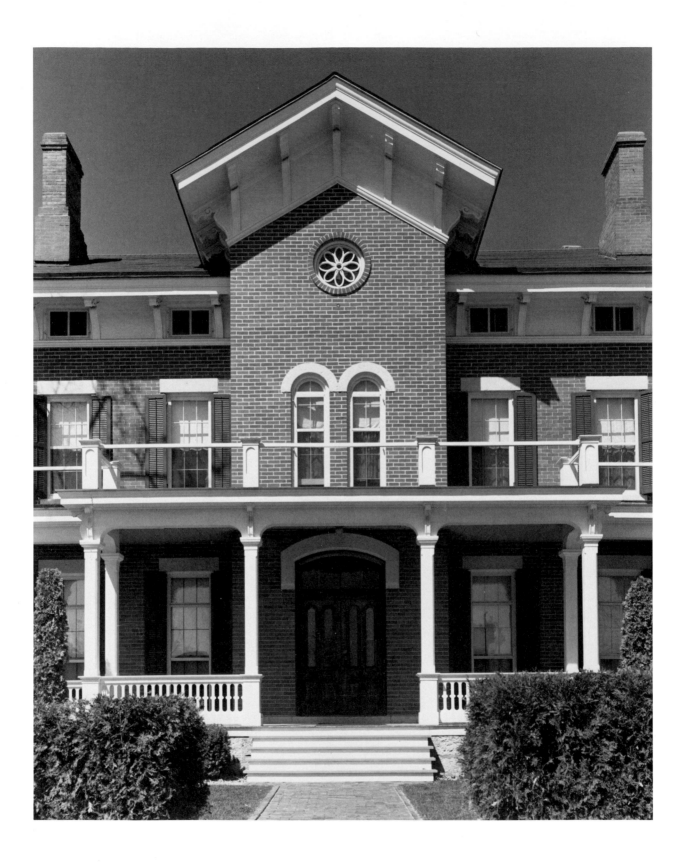

Architectural Photography

Techniques for Architects, Preservationists, Historians, Photographers, and Urban Planners

Text and Photographs by
Jeff Dean

The American Association for State and Local History
Nashville, Tennessee

Frontispiece: An elaborate Victorian mansion in Galena, Illinois, photographed by Jeff Dean with a Pentax 6 x 7 camera and 75mm Pentax-Shift lens. JA 12 '12

Designed by Gary Gore

Publication of this book was made possible in part by funds from the sale of the Bicentennial State Histories, which were supported by the National Endowment for the Humanities.

Library of Congress Cataloguing-in-Publication Data

Dean, Jeff, 1940–
 Architectural photography.

 Bibliography: p.
 Includes index.
 1. Photography, Architectural. I. Title.
TR659.D47 778.9′4 81-12830
ISBN 0-910050-54-6 AACR2

For
the late Charles Mattoon Brooks, Jr.,
Professor Emeritus of Architecture,
Lawrence University,
a great teacher

For
Gordon D. Orr, Jr., FAIA,
a friend to historic buildings

For
Jill Weber Dean,
encourager and helper

Contents

Here is one of my earliest attempts to photograph architecture at the Art and Architecture Building, Yale University, New Haven, Connecticut, in 1963. It demonstrates nicely one axiom of architectural photography: if you are going to have convergence, then go all the way with it and do not be timid. (See chapter 3.)

Preface

*Why is this thus? What is the reason of
this thusness?*
—Artemus Ward (1834–1867)

THIS IS a book about the photography of architecture. I am not an architectural photographer, however—at least not in the sense that Jack Boucher, Julius Schulman, and Ezra Stoller are architectural photographers. I photograph architecture, but do not earn my primary living so doing. This probably places me in the same category as most of the people who will read this book. That is why I am writing it. For some time I have felt that there needs to be a book on the market that deals with the photography of structures and buildings—historic and modern—for readers who are not professional commercial photographers with a current or prospective specialty in client-contracted architectural photography. The glossy books on this subject that have been published are addressed primarily to the professionals in photography. This book is not.

Many readers looking at the photos included in this book will say, "Hey, I could have taken those pictures!" Absolutely true! Nearly anyone could take photographs of the quality I have used as illustrations. There is no big secret to taking good architectural photos—anyone with some visual sensitivity and a sense of care about photographic details can take them. Some of the illustrations I have used were taken easily and came out reasonably well: I just happened to come across the building when the lighting was good and the foliage was right. Some of my more mediocre photos, on the other hand, I worked the hardest to get. It seems that when you plan a photo, it is very hard to get it all just right. But planning is the most important ingredient in getting a needed photograph, and this book should help you do that.

I presume to write this book because of the need for it. Necessity, as they almost say, is the mother of creation. My credentials for writing about photography are probably similar to those of many readers: about two decades of effort in capturing interesting, high-quality images of historic and modern buildings. My "teachers" over these years have been Trial, Error, and Personal Experience, and I have come to know them well—especially Error. My "textbooks" have been some camera manuals, a few magazine articles, and the photographs I've observed in architectural history books and professional architectural magazines. Accordingly, this book is, in places, a highly personal account. I have also endeavored to provide objective facts in appropriate places.

I first confronted a personal desire to photograph a building *well* in the early 1960s, while I was a student at Yale University's School of Architecture. There, I and my fellow classmates were the first students to occupy Paul Rudolph's well-known Art and Architecture Building, now a monument in the architecture of Brutalism, which virtually demanded attempts to photograph it. It is such a strong, sculptural statement, composed of soaring verticals and macho, shadow-generating horizontals, that it quickly revealed amateurish attempts to photograph it for what they were. Due to my limited knowledge (I once thought a dry-mount press was a print dryer) and more limited equipment in those days, I never did photograph it very well. But I clearly remember

the great Ezra Stoller and his assistant set up a huge 8 x 10 view camera on Chapel Street to take the images that later became famous. They waited literally for hours until the light was just right, the traffic and pedestrians were acceptable, and the clouds were in the best position.

Stoller is one of a few great architectural photographers who are in a league by themselves. This book is not intended to produce craftsmen of their caliber. To become like them, one needs to serve as apprentice to one of them for years to learn the art and craft of creating great photographs. This book is of more humble stuff, aimed at elevating interested readers to a basic level of competency.

This book is for those of you working in professional architecture, historic preservation, urban and regional planning, architectural history, and magazine and newspaper photography, as well as serious amateurs, who have occasional-to-frequent need to take good architectural photographs. It is in-between in the sense that it assumes you have a basic, working knowledge of the fundamentals of photography, but that you are not a professional architectural photographer, nor are you planning to become one any time soon. If you fit into this group, then you are probably working with, have worked with, or plan to use a 35mm single-lens-reflex camera system; so this book assumes that to be true. It also assumes that you are curious about or interested in trying a photographic system of larger format, most likely a 4 x 5 view camera or a medium-format single-lens reflex, or that at least you might best be exposed to information about these larger formats. It is a book that has been needed for some time, and some of you may wish you had been able to read it before you invested hundreds or thousands of dollars in your present 35mm system.

As I wrote this book, I had to deal with the rapidly evolving photo equipment industry, which destined the book to be somewhat out of date as soon as it is printed. For example, I had not planned originally a chapter on medium-format architectural photography, because the equipment for that simply had not been suitable. But then, very late in the process, I discovered that both Pentax and Bronica sabotaged my best-laid plans by introducing special architectural lenses for their medium-format cameras. At the last minute, therefore, I prepared a short chapter to cover that format, to provide the latest-possible information and alert readers to

expect more developments in the future. I became an equipment sleuth, in trying to discover the latest word about the relatively obscure lenses for architectural photography in all formats.

Gary Gore, then Director of Publications at the American Association for State and Local History, deserves the credit for causing a book such as this to become a reality. He suggested it to me, after I had suggested to him a brief Technical Leaflet on the subject.

Skot Weidemann, a professional commercial and architectural photographer in Madison, Wisconsin, deserves my thanks—and gets it—for initiating me into some secrets of the pros and for helping me keep track of new equipment developments.

While I worked on this manuscript, Jill Weber Dean, for fourteen years the managing editor of *Wisconsin Trails* magazine, kindly helped by shouldering the family burdens I normally carry and by giving the text a light editing, even as she attended law school classes.

Special thanks are due to the importers of the following photographic equipment for their co-operation in lending me their fine equipment: Canon, Minolta, Olympus, Schneider, and Pentax. Barry Goldberg, of Pentax, especially seemed to move mountains to get me the information and equipment I needed. The importers of Nikon and Carl Zeiss equipment also provided me with helpful information.

I enjoyed writing this book and collecting the photographs needed to illustrate it, though I would have preferred that the project last for years, not just a few months. I will certainly welcome notifications from readers about errors and omissions, if any. These will be incorporated in any future editions that might appear.

If this book helps readers to avoid the mistakes—some stupid, some judgmental—that I have made so liberally in the past, it will have served its purpose.

JEFF DEAN
Madison, Wisconsin
January 1981

1 Introduction

The peculiar value of photography as a means of obtaining representations of architectural subjects has for some time attracted much attention, and now that this marvelous art has both attained to so high a degree of perfection and its treatment is also so generally understood, the present period appears to be most favorable for the foundation of this Association.
—Architectural Photographic Association,
 London, England: 1856

ARCHITECTURAL photography is a specialized branch of photographic endeavor that seeks to illustrate buildings, structures, and their environment for one or more of several purposes. Because architecture itself is, in part, a visual art form, architectural photographs have come to have considerable importance. The impressions and understandings that most students, professionals, and lay people have of most architectural landmarks are obtained through the intervening, two-dimensional medium of architectural photography. Indeed, some critics have suggested that architectural photography is so important that it has become itself a primary influence on the development of modern architecture, and that many architects—intentionally or unconsciously— design buildings so that they are photogenic.

This importance has given rise to what one might call the "antiseptic" school of architectural photography. That is, newly constructed buildings are photographed for journals, displays, potential clients, and posterity with fresh paint, new rugs, untouched furniture, perfect lighting, always sunny skies, and no people. The influence of this school is so strong, and its images so enchanting, that historic buildings are occasionally "sanitized" to evoke an almost sterile newness before their portraits are taken. As ours is an age of protest, among other things, this traditional form of professional architectural photography has become the subject of currently popular criticism. Exceptionally pristine photographs of flawless buildings are held to be misleading distortions of reality, masking truth by

artificial purity. This influence is causing architectural photography to evolve in new directions, as is the arrival on the photographic scene of the perfected 35mm SLR camera with PC (or shift) lens, permitting, for the first time, hand-held, perspective-controlled photographs.

The remarkable talents of traditional, professional architectural photographers should not be dismissed, however, for they have produced and continue to produce unforgettable images of superb clarity and quality. Very often, they are employed by architects to illustrate recently designed buildings in the structures' Sunday best; and they have brought such assignments to a pinnacle of artistry and technical quality. That they can take as a subject a mundane building and make it seem exceptional demonstrates the power and editorial selectivity of architectural photography.

The ability of the architectural photographer to select his views and manipulate his medium can be used to enhance or denigrate any building. It can be used to place a building on a figurative pedestal, for isolated contemplation, as though it were a work of sculpture, or it can place a building or a series of buildings in an environment. Some buildings are best considered by themselves, for the architect chose to design them in isolation, without reference to the immediate environment. Others, intended to fit into their surroundings, both enhance those surroundings and are enhanced by them. A photographer, then, can show the failure of the first sort of building, or hide it; and he can show the success of the latter. Viewpoint, then, is

all-important to an architectural photographer, as is lens selection. Moving a camera a few feet—sometimes only a few inches—can completely change a later viewer's impression of a building.

The fact that so many people gain so much of their information about buildings from photographs is both a blessing and a frustration. Never before have so many people been able to see and appreciate so many historic and modern buildings of architectural significance. Could there be so many universities with architectural history curricula covering so many buildings without the development of the 35mm slide? Photography disseminates architectural information rapidly and widely and helps society to appreciate fine architecture, whether historic or modern. Yet simultaneously, architectural photographs are by nature static and two-dimensional. They can never give viewers a true understanding of the totality and spatial flow of a given building, especially one that is complex. One nationally prominent educator in historic preservation estimated that it would take about 65,000 photographs to depict an ordinary building

adequately. While one might quibble with that number—or that concept—the statement does serve to demonstrate that no building can be completely appreciated by two-dimensional photographs. Accordingly, any photograph of any building is an editorial statement about it. Though one can go to great lengths to assure objective documentation of a building in a recording project, the views selected are selected views.

Architectural photographers, then, frequently step in to take the birth portraits of new buildings in their most publishable finery. Photographers also are there, wittingly or not, to capture funereal views before buildings are demolished. In some ways, this can be considered architectural photography's most important contribution to posterity. Photographers for the National Park Service's Historic American Buildings Survey (HABS) have documented tens of thousands of historic buildings throughout the United States, a large percentage of which are no longer standing. In England, the National Buildings Record has done the same. Of such buildings, photographers must take not only dramatic and

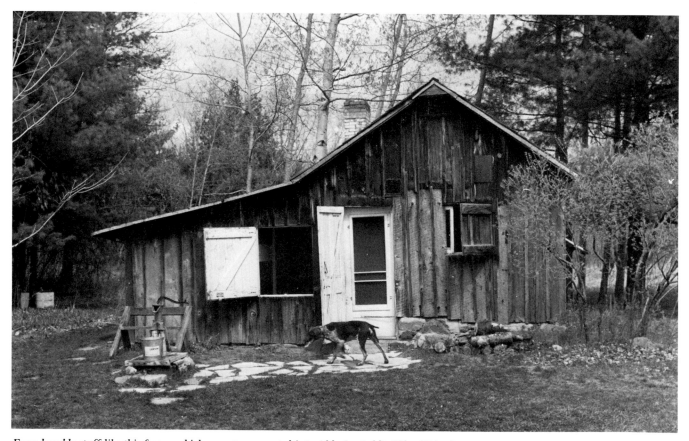

Even humble stuff like this former chicken-coop, converted into Aldo Leopold's "Shack" in the 1930s, may be worthy topics for an architectural photographer. Leopold became one of America's foremost nature writers in the mid-twentieth century.

evocative views, but they must produce documentary views and detail shots, preferably scalable, for their records may well be all that will remain on the public record of lost architecture.

Many of us have an occasional and pressing need to produce correct, clear, and interesting photographs of historic and modern buildings. Most of us in this situation need to do so with small-format, or 35mm, equipment. Some of us would like to move up to larger formats.

Architects put together portfolios of their work to show to prospective clients. They may create 35mm slide shows as educational tools to present to schools, clubs, and the general public. Historic preservationists need good architectural photographs for publications, National Register of Historic Places nominations, speeches, and public information. Planners use them to explain proposals and illustrate conditions to commissions, neighborhood groups, and each other. Newspaper and magazine photographers photograph buildings occasionally, and with the necessary skills and equipment can look forward to such assignments as

being challenging. Historians and architectural historians with a proclivity for photography can document buildings for articles, books, and lectures, and should be able to use the medium especially well when documenting buildings prior to their demolition. Free-lance photographers, who must handle a myriad of situations well, need to take good architectural photographs for speculation and assignments. Calendars and post cards, for example, make frequent use of such illustrations.

The American historic preservation and urban conservation movements of the 1960s and 1970s put legions of professional surveyors in the field, documenting architectural subjects with photography. Never before have so many buildings and structures been photographed so frequently by such multitudes. There is hardly a city in the United States that hasn't witnessed an architectural surveyor stalking its streets, draped with cameras and clipboards, peering at and photographing buildings and structures. Yet I would estimate, also, that never before has such a small percentage of architectural photographs been executed really well. That is

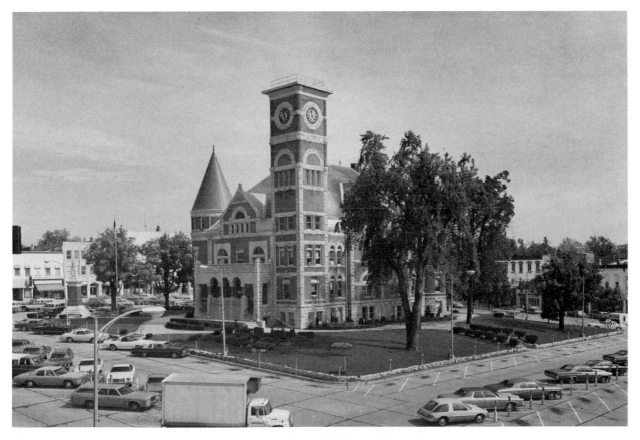

The viewpoint a photographer selects can speak volumes about a building and its environment. Here, it is all too apparent that a fine nineteenth-century county courthouse is surrounded by a sea of parked cars.

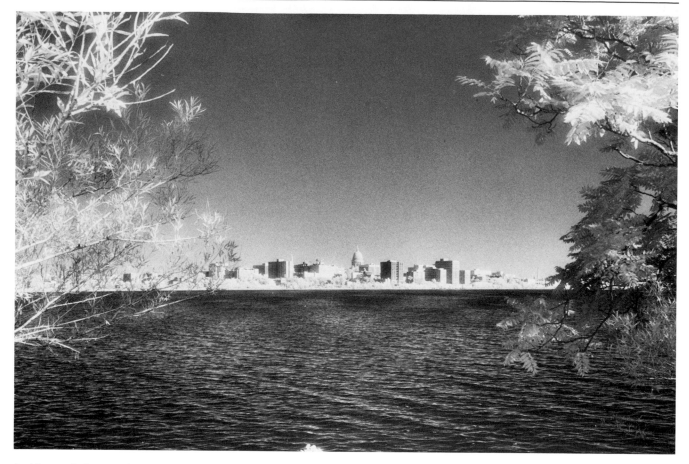

Architectural photography and landscape photography can overlap. To me, this is a view of the Wisconsin State Capitol in its setting, showing the way it dominates the skyline of an isthmus. The dark water and sky and the light foliage are a result of using infrared film.

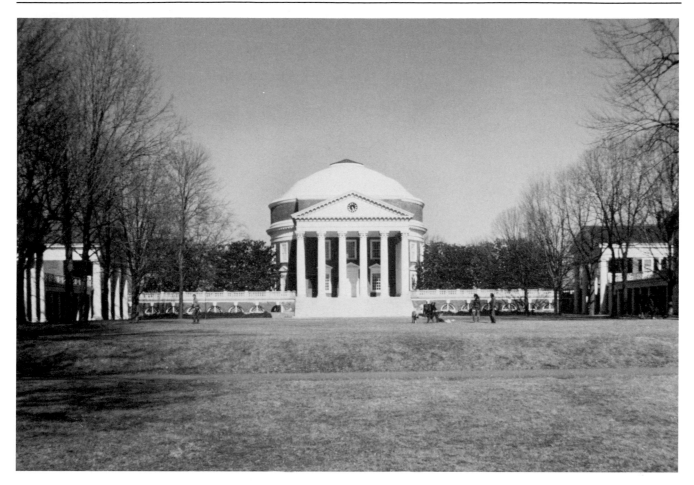

*The Rotunda, a library at the center of the famous University of Virginia campus at
Charlottesville, was designed by architect Thomas Jefferson. Built in the early 1820s, the structure
was a major monument in the American Classical Revival. This photograph was originally a
35mm slide and was converted into a black-and-white print through a color internegative.*

*Architectural photographers sometimes unwittingly document
doomed structures. Here is A. H. Dahl's photograph, made about
1880, of the United States Post Office in Madison, Wisconsin.
The building was one of the first Second Empire structures this
side of the Atlantic Ocean. It was designed by federal architect
Alfred B. Mullet and built between 1867 and 1871. It was
demolished in the late 1920s.*—Photograph courtesy of the
State Historical Society of Wisconsin.

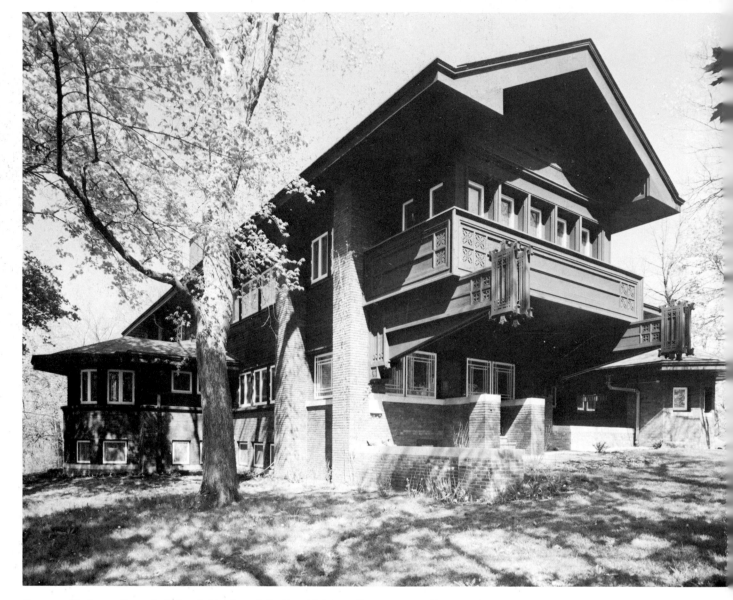

Images with the quality and clarity of this view of the Harold C. Bradley House, Madison,
Wisconsin, designed by Louis Henri Sullivan and built in 1909, are taken by a 4 x 5 large-format
view camera. This photograph would not have been possible with a 35mm camera, because of the
closeness of surrounding foliage to the house. This view was taken with a Calumet CC-402 camera
and Schneider 75mm Super Angulon lens.

because surveyors have not been carefully trained in and equipped for architectural photography. This is due, in part, to the absence of any handbook to deal with the subject. Architectural photography with 35mm equipment—the mainstay of most photographers today—has been held by the professional architectural photography community, until very recently, to be amateurish and inadequate, as is illustrated by the quotations preceding chapter 3. Fortunately, since 1961, modern perspective-control (PC), or shift, lenses for 35mm cameras are changing that attitude, and even some top-flight pros like Julius Schulman and John Veltri now confess publicly to using such gear, along with their large-format equipment.

Understandably, however, professional architectural photographers recommend that they be hired when truly fine architectural photographs are required. There is much to support that suggestion, when the budget permits. Top-rate pros, by virtue of their reputations, experiences, and contacts, can open doors for architects. One cannot deny that photographs by Ezra Stoller are much more likely to be purchased by the editors of *Architectural Record* or *Progressive Architecture* than are those of Clarence Cameranut. Moreover, such pros know the market for photos of building components and can get an architect's newest creation splashed in advertisements for window units or structural elements throughout the nation. Then, too, a true pro can obtain images that simply are beyond the capability and understanding of most of the rest of us. His years of experience provide an incomparable base of information and methodologies. I firmly believe that when a budget permits it and conditions seem to warrant it, a professional architectural photographer should be hired. That holds true especially for professional architects in private practice, but is also generally proper for projects of the Historic American Buildings Survey. And it can also pay benefits for organizers of local preservation projects when lush, high-quality images can become important public relations tools.

It is also understandable, however, that many—if not most—project budgets cannot support a professional architectural photographer. Therefore, there has been a need for practical information for photographers of buildings, especially those using 35mm equipment.

Architectural photography has some important differences from ordinary photography. The geometric nature of the vast majority of buildings requires accommodation by the camera and/or lenses used in order to avoid the bizarre effects, in more extreme cases, of perspective distortion. When the eye sees perspective distortion in the daily world, the human mind makes mental adjustments to correct it. An ordinary camera cannot do that. There are special considerations needed for lighting, types of film used, filters, and virtually every other aspect of photography. The architectural photographer truly needs to understand rudimentary things about the sun and its arc across the sky during any given day and throughout the year. He should keep an ear and eye tuned to the weather. He needs to be selective about the times of day, of the week, and of the year in venturing out to capture images.

In short, architectural photography requires planning—that is probably its single most important ingredient. While some architectural photographs are virtually spontaneous and accidental, views of buildings required by some advance purpose are not. Though it is possible for a photographer casually to grab a good picture of a building, the odds are stacked heavily against him. Only thoughtful planning can prevent a photographer from arriving at the site in overcast, or with the facade in deep shadow—or, worse, back-lit—or at a time when the building is cluttered with cars, trucks, or motorized houses, or when the fountains in front are turned off. Only continuous attention to picky details can prevent a whole roll of film from being ruined after a three-hundred-mile drive because the photographer forgot to check the meter's ASA setting, or failed to compensate for a filter when using a hand-held meter, or forgot to load film into the sheet-film holder. Only if such crucial details are well in hand can the photographer even begin to consider such elements in good photographs as composition, expression, and tones. With the number of things that seem arrayed against architectural photographers to cause them to fail, it is perhaps amazing that one ever succeeds.

2

Thirty-five-millimeter Equipment

Here is a vast world of beautiful, almost idealistic equipment which can produce miracles, it seems. Whatever is required of a photographer can be achieved with 35mm cameras. Even in architecture and interiors, the 35mm can produce image after image of superb, quality scenes.
—Julius Schulman, 1977

PROFESSIONAL architectural photographers rely primarily on large-format camera equipment: four-inch-by-five-inch (4 x 5) and larger view cameras, discussed in chapter 5. The mainstay of architects, preservationists, planners, architectural historians, and many other professional photographers, however, is the thirty-five-millimeter (35mm), small-format camera, and most especially the single-lens-reflex camera (SLR) system.

Until the 1960s, the viewfinder camera—such as the Leica "M" series or fabled Argus C-3—was the predominant 35mm camera widely used by amateurs and those professionals trying something other than the 4 x 5 Speed Graphlex. The development of the SLR, however, revolutionized 35mm cameras, because of the major advantages it offers compared to the viewfinder type. In using the viewfinder camera, the photographer frames the scene to be photographed through an optical viewfinder separated a small distance from the lens through which the scene will be photographed. This has two inherent disadvantages for the architectural photographer: first, he cannot see precisely what the lens sees, due to parallax error; second, when he changes lenses, the viewfinder does not automatically compensate for the angles of view of all the lenses he uses. The SLR cured these ills and proved to be a far superior camera for architectural, and much general, photography.

The line drawing of the basic elements of an SLR camera, on page 9, illustrates the way an SLR works. The photographer looks through an eyepiece behind a pentaprism mounted on top of the camera. The line of vision then changes direction 90 degrees

downward to a mirror mounted behind the lens; and then 90 degrees forward again through the lens. Thus, the photographer actually looks through the lens itself. When the shutter button is depressed, the mirror flips upward and out of the way as, simultaneously, a focal-plane shutter behind it opens, permitting the image to reach the film. Whenever a different lens is mounted on the

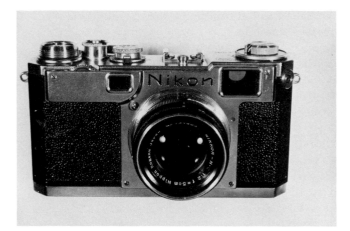

The Nikon S2, made from 1954 to 1957, is a high-quality rangefinder camera with a separate optical viewfinder that gave rise to parallax error because the viewfinder looks at a scene at an angle different from that seen through the lens. Nikon rangefinder cameras such as this were "discovered" by U.S. war correspondents in Korea and Japan. When they brought them home, the cameras were found to possess optics equal to or superior to the fabled German lenses of the time, even though the Japanese lenses and cameras were less expensive. Nikon cameras quickly became a staple of professional photographers, and remain so today.

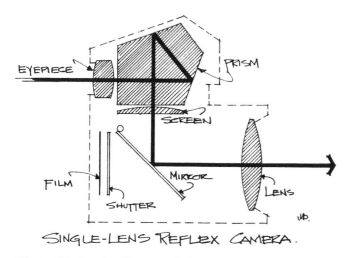

EYEPIECE
PRISM
SCREEN
FILM
MIRROR
SHUTTER
LENS
∞

SINGLE-LENS REFLEX CAMERA.

Fig. 1. This drawing illustrates the basic parts of a single-lens-reflex camera, or SLR. The photographer's line of sight passes through the eyepiece into a prism, then is deflected downward to a viewfinder screen, which receives the image from the mirror below it that, in turn, is reflected from the lens. Thus the photographer looks directly through the lens of the camera when framing the view. When the shutter button is depressed, the mirror flips upward beneath the screen, the shutter opens, and the image is projected by the lens onto the film. In such a camera, whenever the lens is changed, the photographer's view is automatically changed, as well. The perfection of this camera type has brought 35mm architectural photography to a new level of sophistication and potential.

camera, the scene viewed by the photographer automatically changes, because he views through the lens. Obviously, the parallax errors of the older viewfinder camera type also vanish.

The SLR camera does have some disadvantages, but they do not hinder an architectural photographer. The disadvantages include a shutter that is relatively noisy, a bulky camera body, and the possibility of camera motion due to the flipping mirror. These problems have been so minimized in recent years, however, that newspaper and magazine photographers now generally rely on SLRs for most of their work. Nevertheless, cameras that must be pocketable, unobtrusive, or completely silent—as for courtroom photography during trials—generally remain viewfinder types.

The modern SLR arose out of the fortuitous combination of the 35mm format camera with

reflex viewing and the pentaprism, which permitted eye-level viewing. A camera design that permitted reflex viewing through the lens had been patented as early as 1861, but the first SLR camera in the 35mm format was not produced until 1935, when the *Cnopm* ("Sport"), made by GOMZ, appeared in the Soviet Union. This camera did not have a prism and required waist-level viewing. The next year a more modern-looking 35mm SLR, the Ihagee Kine Exakta, with a similar viewing system, came out in Germany. The first Japanese camera to incorporate reflex viewing in the format was the 1951 Asahiflex 1, ancestor of the famous Pentax cameras. A pentaprism design was patented in the 1890s, but it was not until about 1948 or 1949 that the first 35mm camera combining single-lens-reflex viewing with eye-level sighting through a pentaprism mounted above the viewfinder screen went into production. This historic camera was the Contax S, built in East Germany by VEB Pentacon, Dresden. Though the Japanese had been following German leads for many years, in 1959 Nippon Kogaku, Tokyo, introduced the Nikon F, the heart of the world's largest system of 35mm SLR photographic equipment, which quickly became the professional photographer's standard camera and the standard by which the rest of the industry was judged. In the Nikon system, prisms, viewfinder screens, lenses, and backs all were interchangeable, and in 1962 a special Photomic pentaprism with a built-in meter was introduced for the Nikon F. Nikon reigned as the unequalled king of systems SLRs for many years, and even today it is widely used by professionals and serious amateurs in spite of greater competition from Canon, Asahi Pentax, Olympus, Carl Zeiss, Leica, and other fine equipment.

The best 35mm cameras for architectural photography, then, are SLRs. Though almost any SLR camera can be used to produce good architectural photographs, the best SLR should have certain specific characteristics. One should be certain that the camera selected has a tripod socket and can accept cable releases. For reasons explained in chapter 3, the camera should have not only interchangeable lenses, but interchangeable viewfinder screens and at least one shift lens available. Some manufacturers have bubble levels that can be attached to their SLRs, and these are also useful.

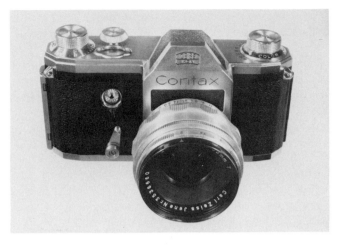

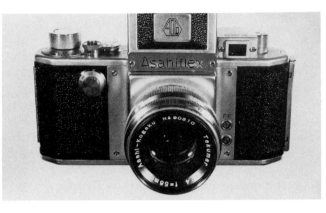

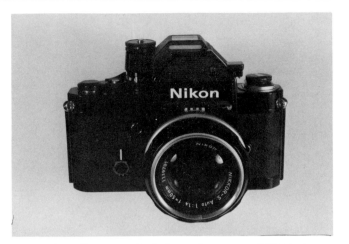

A typical, quality 35mm single-lens reflex camera (SLR) is the Nikon F2S with a 50mm f/1.4 Nikkor lens. This type of camera is the mainstay of small-format architectural photography.

Two historic cameras that pioneered in the development of the modern 35mm SLR were East Germany's Contax S and Japan's Asahiflex II. The Contax S, introduced in the late 1940s, was the first camera ever produced that combined the earlier 35mm SLR design with an eye-level pentaprism for viewing and focusing. It, therefore, was the direct forerunner of the modern eye-level SLR so popular today and so important for architectural photography in the 35mm format. The Asahiflex was Japan's first SLR, introduced in 1952, though it had no pentaprism and was held at chest level and viewed from above. The Asahiflex II illustrated here had the world's first instant-return mirror in an SLR with a finder capable of both viewing and focusing. Japanese and German camera manufacturers battled each other for dominance in the emerging world market for 35mm SLR cameras, and Japan eventually won. Curiously, the U.S. has never produced a 35mm SLR.

The variety and number of SLR cameras on the market can be bewildering to the new photographer. Ours is now an age of electronics and automation, both helpful for general photography; but for architectural photography, "state-of-the-art" SLR cameras are not really required. Mechanical shutter systems and manual exposure-setting work just fine, and automatic cameras *can* be a disadvantage. For example, the older Nikon FTN camera was a superb instrument for photographing buildings. Since it was phased out, two newer generations of large, professional Nikons have replaced it: the F2 and F3. However, neither of these newer cameras offers architectural photographers any significant advantages, especially considering the FTN's record as a rugged workhorse. Therefore, the photographer considering the Nikon system and limited on cash would be well advised to locate a good, used FTN and use the money saved to help buy the correct lenses. The FTN does not have the auto-exposure capability of the F3, but the architectural photographer does not need it. Moreover, the FTN can accept interchangeable viewfinder screens and lenses completely compatible with the newer Nikons.

Similar arguments can be made with respect to other systems. The photographer can, for example, choose the Olympus OM-1 manual SLR rather than the OM-2 automatic at a considerable savings with no appreciable disadvantage suffered in photographing buildings, as both cameras accept the same interchangeable screens and lenses. The

architectural photographer shopping for cameras, in other words, can save money by paying for only the camera body he really needs in order to help purchase the number and variety of lenses he will require.

The nearsighted photographer will find especially useful the eyepiece correction lenses available for some cameras. By obtaining one of these that matches his viewing eye's prescription, he can use the camera without wearing eyeglasses. Numerous manufacturers advertise that a photographer wearing eyeglasses can see the whole viewfinder screen in their SLRs. I have yet to try a camera on which this is genuinely true. The only way for a person needing vision correction to see the whole image is either to use contact lenses or to obtain an eyepiece-correction lens for the camera itself.

Lenses available for 35mm SLR cameras range from extremely wide-angle and fisheye lenses of 10mm, or less, to telephoto lenses of 1,000mm or more. For architectural photographers, the most useful range of lenses is from about 20mm to 135mm or perhaps 200mm. Except for special effects, the lenses on the extreme ends of the available range have little utility in photographing buildings.

Wide-angle lenses. Wide-angle lenses are the most useful to an architectural photographer. Frequently a building is surrounded by trees, foliage, or other buildings, and the photographer needs to position himself inside them to obtain an unobstructed point of view. In this situation, the so-called normal lens of 50mm to 55mm cannot cover the whole building and usually can include only a portion of its exterior facade. A wide-angle lens, however, with its greater angle of coverage, can include the entire building. In urban areas especially, the 35mm lens is actually the "normal" lens for an architectural photographer.

Interior photography frequently demands extremely wide-angle lenses of 20mm to 24mm focal length in order to cover a reasonable amount of a given room or space. Frequently, when working with interiors, an architectural photographer will reach into his equipment bag for the widest-angle lens he owns. Depending on the building involved and the photographer's objectives, a 20mm lens could become the "normal" lens during an assignment.

Wide-angle lenses are so important to architectural photography that I frequently advise beginners who can afford only one camera body and one lens to start out with a 35mm lens and put off buying a 50mm "normal" lens. Even after a photographer has acquired a battery of lenses, he will probably find himself reaching for his 35mm lens very often—perhaps even most of the time. The photographer lucky enough to be able to afford several lenses should arm himself with several wide-angles, including a 20mm, 24mm, 28mm, and 35mm, as well as a 50mm lens.

Telephoto lenses. Telephoto lenses are used less frequently than wide-angle lenses in architectural photography. Primarily, telephotos are for capturing details of decoration or construction. If anything, however, the telephoto lens is used too little by the average photographer of buildings. How many times have you seen a slide show where nearly all the views were three-quarters shots of building after building, always taken from a distance of about fifty to a hundred feet with a 50mm or 35mm lens? Do you find yourself nodding when the speaker talks about this or that type of construction detail while, on the screen, the views are of distant buildings? Variety is desperately needed in such shows. When discussing a detail of design or a type of brick or stonework, the speaker should be showing the detail—up close! There is no better way to illustrate cobblestone work, for example, than by showing a view taken when the camera was a foot or so from the stones, focused as closely as it could go, and preferably with side light. Telephoto lenses add important variety to slide shows and other presentations by focusing the attention of the viewer on those elements you wish him to see. Buildings frequently are intended to be viewed from a range of distances, and reveal different things at different distances.

For most purposes, a 105mm or 135mm lens will enable a photographer to provide that kind of variety and detailed illustration. And, incidentally, these lenses can double nicely as portrait lenses, for you can photograph your subject without sitting on top of him or her.

Zoom lenses. Zoom lenses are those that offer, within limits, variable focal lengths, such as 43mm to 86mm or 50mm to 300mm. In some lenses, one can obtain a moderate wide-angle, a normal, and a moderate telephoto lens, all in one unit. Zoom lenses offer the considerable convenience that you would imagine: one lens can be carried, instead of three or more.

*This is the Isaac Porter House, Cooksville, Wisconsin,
photographed repeatedly from the same position with 20mm,
28mm, 35mm, 50mm, 135mm, and 200mm lenses on a 35mm
SLR camera.*

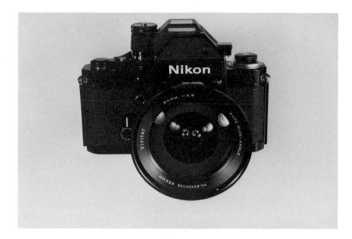

The very wide-angle Vivitar f/3.8 20mm lens is especially suitable for photographing interiors. Lenses much wider than this tend to become quite expensive and are often "fisheye" lenses that produce circular images.

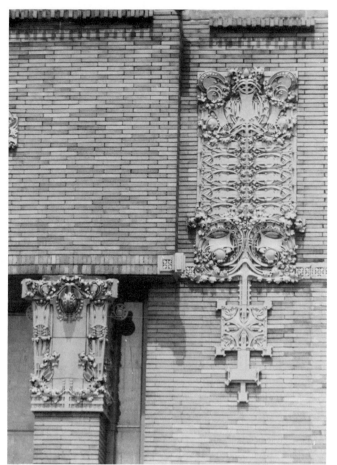

A 135mm telephoto lens can bring high-up detail close in, as in this detail shot of George Grant Elmslie's wonderful geometric ornament on the Merchants Bank, Winona, Minnesota. This picture was originally a color slide and was converted into a black and white print by use of a 35mm color internegative.

However, they are still generally conceded to be less sharp than fixed-focal-length lenses; and, second, they are generally slower than fixed lenses. Crispness and sharpness are crucial to architectural photographers, so zoom lenses should be approached with caution. If you are considering one, try to borrow the lens first and then compare its sharpness at various focal-length settings in direct comparison with fixed-focal-length lenses of similar lengths. Mount the camera on a tripod to take the test photographs with very-fine-grain film. Compare the negatives with a magnifying glass to see whether the zoom lens you are considering is as sharp as a fixed lens. It is safe to say that zoom lenses are improving in sharpness every year and that in time they may equal fixed lenses.

Macro lenses. Most SLR manufacturers make special "macro" lenses that can be very useful in architectural photography and, for that matter, in general photography. These lenses, which come in various focal lengths, are capable of focusing to extremely close distances. The 55mm f/2.8 Micro-Nikkor, for example, focuses so closely that the image on the resulting negative is half the actual life size of the subject photographed. This is called a 1:2 reproduction ratio. Moreover, with an adapter ring, this lens can be focused down to a 1:1 ratio; that is, the film image and the subject photographed are the same size. This allows a photographer to get extremely close to small subjects or structural details for illustrative purposes.

The disadvantages of macrophotography, as it is called, are that the depth of field at such close distances is very shallow and that camera motion is very apparent. To use a Micro-Nikkor or similar lens at its closest distances, you really have to mount the camera on a tripod or photocopying stand. Also, macro lenses tend to be slower than ordinary lenses.

Applications for macro lenses include the photography of architectural models, reproducing black-and-white prints for slides, and illustrating building details or deterioration. The photographer considering a macro lens could either obtain one instead of a normal 50mm lens, or trade in the latter for a macro lens. A macro lens can do almost

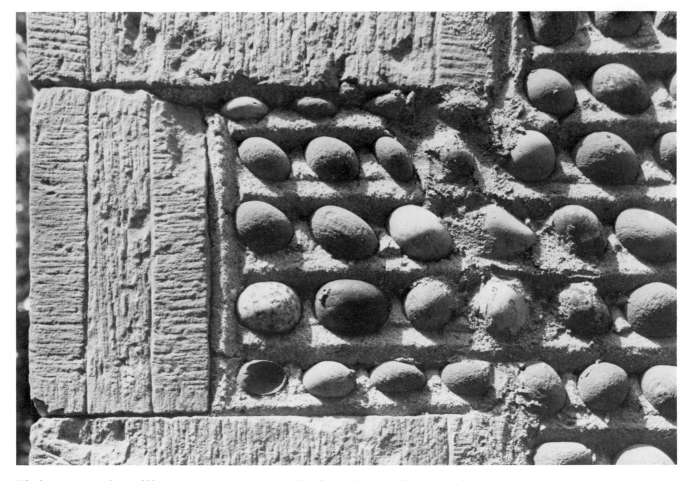

The best way to explain cobblestone masonry to someone unfamiliar with it is to show it—up close!
Here, even the tool markings on the quoins are visible on the John Preston House, built circa 1840
in Sodus Township, Wayne County, New York.

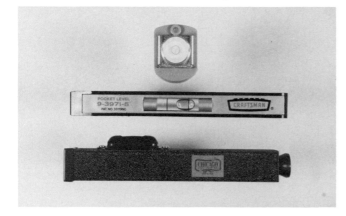

Keeping a camera level when photographing a building is a vital consideration for high-quality architectural photography. The devices shown here help in leveling a camera. On top is a slide-in bubble level for a camera's accessory shoe; below it is a five-inch Sears pocket level; at the bottom is a sighting hand level.

anything a normal lens can do, so owning both types would not be necessary.

Macro photography can also be accomplished by attaching screw-in, single-element, close-up lenses to the front of a camera's normal lens. These attach just like photographic filters. Close-up lenses come in various powers that enable focusing with the regular camera lens within narrow limits. Each power of close-up lens only works within a certain range of distance from the subject, so there is an unavoidable amount of fiddling around trying various close-up lenses when a picture is being set up. This inconvenience is eliminated if a macro lens is at hand. A further disadvantage of using close-up lenses is that normal lenses can cause distortion at extremely close distances with close-up lenses attached. Macro lenses have been designed specifically to avoid such distortion.

Tripods. A serious architectural photographer will need to have a good, solid, high-quality tripod. This is not an area in which to skimp and save, as a fine tripod is relatively inexpensive. It is mandatory for interiors, twilight and night views, and double-exposures. Beyond these, it is advisable at any time.

I have gone through several tripods in my time. I started out with a cheap, lightweight, portable model. I moved to a middleweight, middle-priced, somewhat cumbersome type. Finally, I bit the bullet and purchased a heavyweight, braced, cumbersome model with built-in bubble-levels. In spite of its heft and bulk, this is the one I normally take with me now.

Whenever a camera is out of plumb, that fact shows up on the photograph, assuming the building itself was plumb. An architectural photographer needs to be properly armed to determine whether his camera is level. Better tripods have built-in levels, and these are helpful. Some cameras can be fitted with bubble levels that attach to accessory shoes. A sighting hand-level can be obtained from drafting-supply stores and can be used to locate lens-level points on buildings. An inexpensive pocket level, such as Sears' Craftsman 9-3971-5", should be carried like a pocket pen and used to check a

release will fit it *and* will trip the shutter when depressed. (If you ever set up your tripod and find you have forgotten your cable release, you can use the camera's self-timer to trip the shutter without camera motion.)

Viewfinder screens. Most major SLR camera manufacturers produce cameras with interchangeable viewfinder screens. If they do this, they nearly always also produce at least one screen having etched or inked horizontal and vertical lines forming a grid—a bit like a tic-tac-toe board—with five vertical and three horizontal lines. The designations of some of these screens, and the cameras that accept them, are listed below.

The cameras listed are invaluable to the architectural photographer because of this capability, so it makes sense to go to extra lengths to acquire these models. (Obviously, newer models that come out after this book is published should also be investigated for screen interchangeability.) With grid screens installed, these cameras enable you to line buildings up with precision according to grid lines, facilitating accurate and hand-held architectural photography. Without one of these screens, a photographer must attempt endlessly to line

Manufacturer	Screen Designation	Cameras Screen Fits*
Canon	Type D	Canon F-1, AE-1 Program
Carl Zeiss	Sectioned Matte	Contax RTS
Leitz	(Unnamed)	Leica R4
Minolta	Type L	Minolta XK Motor
Nikon	Type E	Nikon FTN, F2, F3, FE
Olympus	Type 1-10	Olympus OM-1, OM-2
Pentax	Type SG	Pentax LX, MX

*NOTE: These are cameras with user-installed interchangeable viewfinder screens. Some other models accept factory-installed grid screens; check with manufacturers about these.

tripod-mounted camera's levelness from side-to-side and front-to-back. An etched-grid viewfinder screen should be installed in a 35mm SLR as a final check.

When one acquires a tripod, one should also obtain a cable release to use with it: they go hand in hand. A cable release attaches to the shutter-release mechanism of a camera and allows the photographer to trip the shutter without touching the camera itself, thus eliminating the major source of camera motion. When purchasing a cable release, take your camera with you to the store to make certain the

buildings up with the edges of viewfinder images. While some become adept at this exercise, they nevertheless are working under an unnecessary handicap.

In preparing this book, I tested the Canon, Nikon, Olympus, and Pentax grid screens listed above. Of these, I found Canon's to be the clearest and most easily seen under adverse or confusing circumstances. The others I tried were all comparable in being precise and adequate to the task.

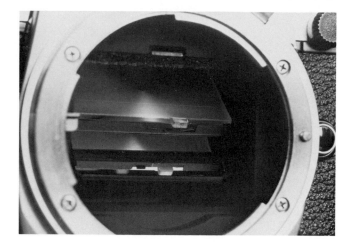

A tiny "trapdoor" inside the Nikon FE—and similar cameras, like the Olympus and the Pentax MX—drops down to provide access to an interchangeable viewfinder screen. You grab the screen by the tab on the right with a small, special tweezer, reaching through the bayonet lens mount in the foreground. This picture was taken with a 55mm Nikon Micro-Nikkor macro lens.

The grid screen is also helpful in leveling the camera so that it is pointing neither up nor down and, in this, complements the various levels available. This avoids the perspective problem of vertical convergence, discussed in detail in the next chapter. The screen's parallel vertical lines can be aligned with verticals on most buildings to preclude this phenomenon.

Buying a camera. Selecting and purchasing a camera can be an agonizing and confusing experience to a person uncertain of his needs and available equipment. Talking to friends who are photo enthusiasts, I have found, can be helpful. It can also be misleading, because many well-meaning hobbyists have irrational attachments to particular brands and seek reinforcement in their own selections by encouraging their friends to buy identical equipment. Moreover, the normal photo-bug is not terribly concerned with architectural photography and, therefore, is not aware of its special problems and equipment. It is best not to set out seriously to buy equipment until you have firm ideas about what your needs are—and then do not let friends or salesmen sway you from your objectively identified criteria. Here are some basic guidelines for selecting either a new or used SLR for architectural photography purposes:

1. The camera should accept interchangeable lenses. When automatic lenses are attached to it, the camera should take meter readings at full aperture and should stop down to taking aperture when the shutter is tripped. Watch out for "bargain" older-model cameras that do not operate this way.

2. The camera's associated lens system should have a wide range of lenses from at least about 20mm to 200mm and should include at least one type of PC, or shift, lens (see next chapter).

3. The camera should accept user-installed interchangeable viewfinder screens, and the camera's system should offer a grid-screen. At a minimum, the camera should accept a factory-installed grid-screen.

4. The manufacturer's lenses should fit most or all SLR cameras it has produced in the past decade or so, as this demonstrates a commitment to avoiding obsolescence whenever possible.

5. The camera should have a record of durability and a reputation for quality. Have you seen professional photographers using the camera?

6. The more fussy and complicated are the gadgets on the camera, the more there is to maintain and break down. Simplicity is a virtue.

7. The camera's manufacturer should have been around for a long while and still be in business (not funny!).

Finding a *new* camera of the type you select is probably easy; finding a *used* camera is not. All major manufacturers have nationwide warranties, so you can buy your camera by mail order from a major city offering the lowest prices without worry. Monthly photography magazines have copious advertisements in their rear sections that give you current discount prices for any popular equipment, and some even have toll-free "800" long-distance telephone numbers and accept common charge cards so you can phone your order in. Recently, smaller cities have had photo stores open up, offering discount prices competitive with those in New York or Los Angeles, so do not overlook them. There are advantages to buying locally, like instant replacement and convenient service. There are also advantages to ordering out-of-state from major stores, such as in-stock equipment, lowest prices, and the avoidance of state sales taxes (taxes are very high on expensive cameras, but shipping costs are low by UPS because the equipment is so small).

Locating good used equipment is a lot harder. The best national source I know is a monthly classified publication, *Shutterbug Ads* (P.O. Box F, Titusville, Florida 32780). It has about a hundred pages, crammed full of ads for used cameras, lenses, and related equipment either wanted or for sale. It is

fascinating reading, even if you are not in the market. Other than that, you can try local sources, such as camera stores, newspaper ads, and buy-sell shops. Do talk to local professional photographers, because they occasionally sell equipment, and also check into local camera clubs. The best deals I ever found were for two 35mm PC-Nikkor lenses: one through *Shutterbug Ads*, by placing a "lens wanted" ad, and the other when it came up quite accidentally in a conversation with a photographer.

Caring for equipment. Photographic equipment will need to be cleaned occasionally. Bodies of SLR cameras will need cleaning at regular intervals; how frequently depends on how well they are cared for. Whether it is your own equipment or your employer's, it pays dividends to care for it well. Cleaning an SLR camera thoroughly can cost a hundred dollars or more, but replacing one is more expensive.

It seems to be fashionable among hip photographers these days not to bother with the hassle of using an ever-ready case for their SLRs. This may enhance their laid-back images, but it does little for their cameras, which get dusty, gritty, and dented with relative speed. It is wiser to guard such an investment with a protective, individual case and to keep the case closed when the camera is not being used. An architectural photographer rarely has to be ready to shoot a picture without warning, so it makes no sense to leave a valuable SLR sitting on a car seat, windows open, with sand and dirt lodging in its crevices. Cameras of some photographers—generally those not using their own equipment—seem to require cleaning every few months. Others can go for years without needing to be cleaned professionally. The difference? It is one of attitude and concern for cleanliness.

There are many sizes and styles of individual cases for lenses to protect them when they are not mounted on cameras. However, once a photographer begins to accumulate a variety of equipment, he confronts a problem of bulk, weight, and access to all of it. To meet this problem, and simultaneously to eliminate a host of small, individual cases, manufacturers have developed hundreds of styles of equipment cases. There are leather and leatherlike gadget bags, soft shoulder bags, compartment cases, and foam-lined hard cases in a bewildering array of prices and styles. Before buying one, you should carefully consider how you will use your equipment and how you will need to

A typical luggage-style, foam-filled 35mm equipment case. The foam pad is carved out by the photographer to accommodate his particular cameras and lenses. This medium-sized case easily carries two large 35mm SLR bodies, seven lenses, several filters, and other miscellaneous small items.

have access to it. If you will usually be working out of a car, you really do not need to have a lightweight, contoured case such as is used by hikers. If you will carry your equipment on airplanes, trains, and buses, you will need a hard shell and foam padding for maximum protection. If you are fairly set on your choice of equipment, you can carve up a thick, foam pad in a luggage-style case with impunity. But if your equipment changes regularly, you need the flexibility of adjustable compartments. Soft equipment offers lightness; hard-shelled equipment offers protection. Selecting a case is an individual choice based on personal and professional requirements.

Because an author should be accountable to his readers, I confess I have gone through numerous types of cases and now use an aluminum luggage-style case in which is a thick, foam pad that I carved up to approximate the shapes of my basic 35mm equipment. Opening and extracting equipment from this case requires me to set the case down on a horizontal surface and is, therefore, somewhat slow and cumbersome. However, I place first priority on protecting my gear and appreciate the generous foam padding this case offers each piece of equipment. My 4 x 5 equipment is carried in a conventional Calumet case for this purpose: forget about easy portability for 4 x 5 cameras and lenses.

Protecting film from the summer's excessive heat is a problem of special concern to architectural photographers, who tend to work in warm and

sunny weather a good deal. Some photographers have experimented successfully with ice chests, using a *small* amount of ice to keep the interior temperature down in the sixty degrees Fahrenheit range. They then carry sensitive film and equipment inside the chest in hot weather. At a minimum, a camera and film should never be left in a closed car in hot weather and should be protected from heat in other places, as well. I always try to park my car in the shade in the summer. When I leave it, I take my cameras with me.

Lenses and filters need to be cleaned regularly, as they are easily fouled by dust, dirt, and fingers. A special lens cleaner is readily available in any photography store, as is soft, lintless, lens-cleaning tissue. A squeeze-bulb blower or can of compressed gas is much more effective at removing dust and lint from lenses and filters than is blowing on them, as the latter technique is low on power and high on saliva. Brushes are useful for cleaning lenses too, but should be of the antistatic type. Ordinary brushes generate static electricity when they are used to wipe a lens. That helps dust adhere to the surface of a lens, when the opposite result is desired.

Do not use facial or bathroom tissues on lenses, nor tissues for cleaning eyeglasses. These substances leave either lint or chemical residues on a photographic lens. Lens-cleaning tissues are the only type that should touch your lenses and filters. Use liquid very sparingly on a lens, except for underwater types, so that it does not seep in behind the front lens element.

Reflex mirrors on SLR cameras and reflex housings for 4 x 5 cameras employ front-surface mirrors. This means that the reflective surface is actually the exposed surface of the mirror and is not protected, like a bathroom mirror, by a layer of glass. These mirror surfaces are very sensitive to abrasion. For cleaning them, all that is recommended—and recommendations do vary—is either compressed gas or gentle brushing or both.

A camera's battery compartment should also be regularly cleaned. If this is not done, a camera may develop apparent battery failure that, in fact, is simply corrosion. Clean the ends of batteries with a pencil eraser or by rubbing them on any convenient cloth, and use the eraser on the camera's battery contacts. Blow out the battery housing, preferably with compressed gas, before reinstalling the batteries. If you have an apparent battery failure, try cleaning and replacing the batteries before putting in new ones. In my experience, cleaning will restore

full power, most of the time. But if that does not work, take out your spare, fresh batteries—which you always carry, right?— and install them.

Typical 35mm equipment. A typical set-up for a small-format architectural photographer on an assignment or photography trip would include the following:

1. 35mm SLR body, with case and neckstrap, for black-and-white film
2. 35mm SLR body, with case and neckstrap, for color film
3. Two 35mm PC lenses mounted on the above bodies
4. One 105mm or 135mm telephoto lens
5. One 28mm wide-angle lens, preferably a PC lens
6. One 20mm-to-24mm very-wide-angle lens
7. One 50mm-to-55mm normal lens, preferably a macro lens
8. Lens hoods for the lenses carried
9. A selection of filters (see chapter 7)
10. One sturdy tripod with bubble levels
11. One cable release
12. One equipment-carrying case
13. Extra supplies of black-and-white and color film
14. One 5-inch pocket level (such as Sears 9-3971-5″)
15. Spare camera batteries

Depending on the resources of the photographer and the nature of the anticipated photographs, the following equipment might also be taken:

1. 35mm SLR body, with case, for infrared or color-negative film
2. One electronic flash unit
3. Photoflood lamps and stands and extension cords
4. Kit to produce scalable photographic prints (see chapter 12)
5. Zoom lens(es)

In short, a great deal of money can be spent on obtaining adequate photographic equipment. Indeed, the sky's the limit. For most work, however, the first list of equipment above would prepare the small-format architectural photographer for nearly all situations and would probably take beginning photographers several years to accumulate. The beginner should not be discouraged by the length of the list. If he agrees with it and uses it, he can set goals for equipment acquisition that will guide him usefully for some time and will help him avoid unnecessary or completely erroneous purchases.

Perspective Control in the 35mm Format

. . . miniature cameras are totally unsuitable for architectural and sculptural photography. Architectural photographs taken with such cameras are usually easily detectable by their inclination of vertical lines, and though this fault can be corrected in the enlarger, rectification of converging lines by tilting the easel of the enlarger is an irksome and time-wasting procedure.
—Helmut Gernsheim, 1949

With the invention of the perspective control lens (PC-Nikkor) for the Nikon, the 35mm single-lens reflex camera became a highly usable tool for the architectural photographer . . . [It] makes it possible to photograph a tall building without the effect of vertical lines converging.
—John Veltri, 1974

AUTHOR Gernsheim in 1949 identified the most significant drawback of the miniature, or 35mm, camera in architectural photography. Writing twenty-five years later, Veltri noted the solution of this problem, originally by Nikon.

The need to prevent parallel lines from converging toward a vanishing point is a problem unique to architectural photography. Anyone who has looked at photographs or motion pictures has seen this convergence at one time or another. Typically, it occurs when the sides of a building seem tilted backward because the camera had been pointed upward to include the top of the building in the view. Horizontal convergence is less annoying to a viewer because it seems more natural; but that also can be reduced or eliminated when necessary. Moreover, both vertical and horizontal convergence can be corrected simultaneously.

The convergence of parallel lines toward each other—perspective distortion—can be used for dramatic effects. We have all seen photographs of tall buildings taken from a position close to the base of a building with the camera pointed almost straight up. This emphasizes the height of the building and makes it relate visually more to the sky than to the ground. Such views seem natural and acceptable. But lesser convergence, when the camera is tilted upward only moderately, is more visually disturbing.

This is because the lines of the building seem to be almost parallel, but not quite. There is then a psychological desire to correct this and straighten them out. Writing in 1949, Leslie Shaw said, "As a general guidance, it can be said that slight tilting of the camera should be avoided at all costs, since it will produce in the finished picture a degree of distortion which will merely create in the mind of the beholder a feeling of discomfort. If it is necessary to tilt the camera at all, let there be no qualms about it, and tilt it violently."

In Shaw's time, of course, there was only one option for eliminating "discomfort" in architectural photographs: the large and bulky view camera. Today the serious architectural photographer has at his disposal an array of small-format camera lenses designed to correct the convergence of parallel lines. The photographer who works only with prints and does his own darkroom work *can* make corrections on the enlarger, but that method is much less satisfactory, because it can only work with prints, and it requires corrections whenever prints are enlarged.

The drawings on page 20 illustrate the most common type of perspective distortion and the corrective procedure. The solution is always to keep the film plane vertical. If the lens can be moved upward without tilting the camera body upward, no

19

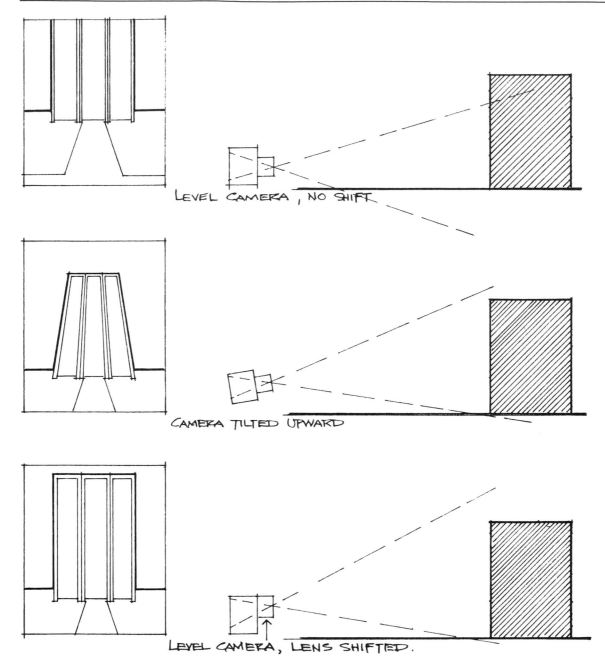

LEVEL CAMERA, NO SHIFT

CAMERA TILTED UPWARD

LEVEL CAMERA, LENS SHIFTED.

Fig. 2. These drawings illustrate the basic principles of perspective distortion and its correction with a shifting lens or rising lens standard. In the top drawings, the top of the building is cut off, as shown in the simulated view on the left. In the middle drawings, as the camera is tipped upward to cover the top of the building, it begins to recede backward, vanishing toward a point above the building. In the bottom drawing, the camera is returned to a level position, and the lens is then shifted upward without tilting the camera. This brings in the top of the building without causing convergence. While these drawings illustrate the most common perspective-convergence problem, such lenses can also correct distortions looking downward, sideways, or in diagonal directions.

perspective distortion will be induced in the resulting image. An extension of this logic to the horizontal plane reveals that if the lens can be shifted sideways, horizontal convergence would be eliminated and the photographer could, for example, take a seeming straight-on picture of a building's facade even if he was standing off center. Combining both horizontal and vertical shifts permits a photographer to straighten out convergence in both directions simultaneously.

In 1961, Nikon, a Japanese camera manufacturer renowned for quality and the production of many types of lenses, introduced a truly revolutionary lens that provided a solution to the architectural convergence dilemma: the 35mm f/3.5 PC-Nikkor. This lens included an internal track and screw-gear mechanism that permitted the lens elements to be shifted as much as 11mm off center. Moreover, the lens rotated 360 degrees in its mounting base, so that shifts could be made in any desired direction. In 1968, Nikon redesigned the lens to increase its maximum aperture to f/2.8 and to move the shift-control knob further out from the camera body, so that it would clear the meter housing on a Nikon FTN camera. This faster 35mm shift lens is still available from Nikon. Curiously, however, the older f/3.5 model, which weighs two ounces less than its replacement, is more compact and works extremely well with the latest generation of compact Nikon cameras. Indeed, I find that its compactness and light weight makes it more suitable for use with the newest, small Nikons—a paradox in one sense, perhaps, but a credit to Nikon's policy of nonobsolescence. In any case, this older PC lens is both an important plateau in the history of architectural photography and a fine lens for the latest electronic, diminutive cameras.

In 1967, a German lens maker, Schneider, also known for quality optics, produced a second shifting lens, the 35mm f/4.0 PA-Curtagon, which remains in production today. Instead of employing a screw-gear mechanism like Nikkor's, the Schneider was operated by a rotating shift-control collar. Its lens elements also revolved in the mount to permit shifts in any direction. In the 1970s, other manufacturers followed these pioneering efforts with their own versions of shifting lenses, and Canon introduced a 35mm shift lens that also could tilt up to 8 degrees to control the plane of focus.

There are, of course, inherent limitations in the amount of shift any given lens can make. This is

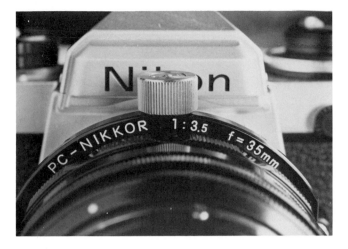

In 1961, Nikon introduced the world's first perspective-control lens for controlling convergence in buildings, the f/3.5 35mm PC-Nikkor.

determined primarily by the circle of coverage of the lens at the film plane. A lens cannot be shifted so far that the image area projected by the lens terminates inside the boundaries of a frame of film. That would result in image cutoff by a semicircular area of darkness. A few shifting lenses allow the careless photographer to shift beyond the limits of their film-covering power, so photographers should experiment to find and understand the limits of their lenses. However, the more a given lens can shift without image cut-off, the more flexibility it gives a photographer. My testing of the various lenses on the market indicates that, in general, 35mm PC lenses can shift to their limits without cut-off. (Incidentally, no shifting lens for an SLR can shift proportionally as far as some lenses mounted on large-format view cameras.)

To understand the importance of the development of the PC, or shift, lens to architectural photography, read Gernsheim's quotation at the start of this chapter and project yourself backward in time to the years prior to 1961, when Nikon's PC lens was introduced. To obtain corrected photographs in those halcyon days, you would have to use a view camera, carry around a tall stepladder (which Gernsheim recommended), or make corrections on a darkroom enlarging easel. Obtaining corrected 35mm slides was, for all intents and purposes, impossible. Nikon changed all that and permitted the properly equipped photographer to stand before a building, raise a camera to his eye, shift the lens, and obtain perfectly corrected

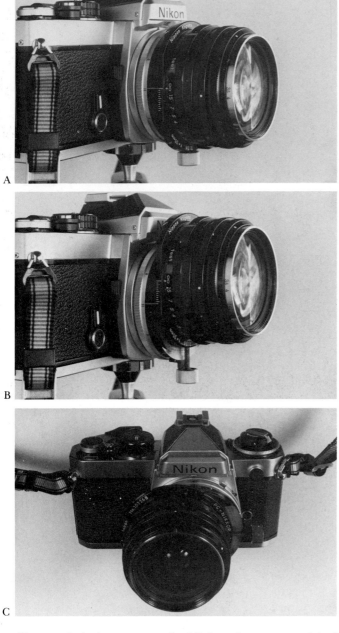

Here are the basic movements of a shift lens, shown on an original 35mm PC-Nikkor. In photo A, the lens is set on center, with no shift. In photo B, the lens is shifted upward to the maximum 11mm, as though photographing a tall building. In photo C, the lens has been rotated 90 degrees and shifted 11mm sideways, as though to correct horizontal convergence.

photographs—even including 35mm slides! What was even more remarkable about this milestone invention was that so few photographers of buildings picked up on it. Even two decades later, the existence of these lenses is relatively little known. In time, however, the history of architectural photography will have to recognize 1961 as one of its most revolutionary years.

Lens manufacturers mostly call these lenses either PC, for *perspective control*, or shift lenses. The former designation refers to the purpose, or goal, of such lenses: the control of perspective convergence. The latter term refers to the means such lenses employ to achieve their purposes: shifting. The terms can be used interchangeably. I prefer to use the designation "PC" most of the time because I think it is more important to keep the objective in mind than the means.

Because of the singular importance of the PC lens for 35mm architectural photography, and because these lenses remain relatively little known among general photography audiences, I will examine them individually and in detail in this chapter (see Table 1). Any person seriously interested in architectural photography would be well advised to select his camera equipment from the outset depending on which of these lenses he would like to acquire, whether immediately or in time. Each lens has its distinct features, advantages, and disadvantages, as does each camera system.

PC Lenses of 35mm Focal Length

As of this writing, PC lenses are available only in two focal lengths for 35mm SLR cameras: 35mm and 28mm wide-angles. The former lenses are less expensive and tend to be more compact than the latter, but have a lesser angle of view. Currently, 35mm PC lenses are made by Nikon, Olympus, Schneider, Leica (also a Schneider), Minolta, Canon, and Carl Zeiss (for Contax and Yashica SLRs). Only two 28mm PC lenses are on the market now: Nikon's and Pentax's. In preparing this book, I tested and evaluated lenses made by Pentax, Olympus, Schneider, and Minolta, thanks to the courtesy of their respective importers, as well as the Nikkors that I personally own.

Nikon 35mm f/2.8 PC-Nikkor. According to my observations, the Nikon 35mm f/2.8 PC-Nikkor is the most popular PC lens on the market today,

Table 1
PC Lenses And Etched-Grid Viewfinder Screens For 35mm SLR Cameras

Lens Mfr.	Lens Name	Focal Length in Millimeters	Maximum Aperture of Lens (f/–)	Minimum Aperture of Lens (f/–)	Closest Focusing Distance in Inches	Maximum Possible Shift in Millimeters	Weight of Lens in Ounces	Retail Price Factor as a Multiple of the Olympus Zuiko-Shift Lens Retail Price	Shifting Mechanism: S=Screw Gear, R=Ring Controlled Gear, T=Two Tracks	Diaphragm Control Mechanism During Exposure P=Preset, A=Automatic, M=Manual	Grid Viewfinder Screen Designation	Camera Bodies the Grid Viewfinder Screen Will Fit[1]	Camera Bodies the Perspective Controlling Lens Will Fit
Canon	Canon TS	35	2.8	22	12	11	19	1.6	S	P	D	Canon F-1, AE-1 Program	Canon SLRs
Minolta	Rokkor-X	35	2.8	22	12	11/8	20	2.1	T	A	L	Minolta XK	Minolta XD-11, XD-5, XK, all Minolta SRT bodies
Nikon[2]	PC-Nikkor	35	3.5	32	12	11	10	[2]	S	P	E	Nikon F, F2, F3, & FE	All Nikons & Nikkormats[2]
Nikon	PC-Nikkor	35	2.8	32	12	11	12	1.2	S	P	E	Nikon F, F2, F3, & FE	All Nikons & Nikkormats
Nikon	PC-Nikkor	28	3.5	22	12	11	15	2.1	S	P	E	Nikon F, F2, F3, & FE	All Nikons & Nikkormats
Olympus	Zuiko-Shift	35	2.8	22	10	12	11	1.0	T	P	1 10	Olympus OM-1, OM-2	Olympus OM-1, OM-2
Pentax	Pentax-Shift	28	3.5	32	12	11	21	1.8	R	P	SG	Pentax LX, MX	All Pentax K-mount SLRs
Schneider	PA-Curtagon	35	4.0	22	18	7	9	2.0	R	M	——————		Schneider proprietary universal mounting system
Schneider	PA-Curtagon-R	35	4.0	22	18	7	10	2.2	R	M	—— Leica R4		Leicaflex, Leica R3, R4
Carl Zeiss	PC-Distagon	35	2.8	22	12	10	26	2.2	R	M	Sec. Matte	Contax RTS	Yashica FR, FX, and Contax RTS, 137, 139

[1]Cameras listed have interchangeable screens. Some other cameras can have grid screens installed by camera service centers.
[2]This lens, introduced in 1961 as the first PC lens on the market, was replaced in 1968 by a revised, f/2.8 PC-Nikkor lens. The original f/3.5 PC-Nikkor cannot be used on Nikon FTN or F2 models with meter-prisms installed because the shifting element will not clear the front of these prism housings. It will fit all other Nikon SLRs and will work on those F and F2 models with nonmetered viewfinders. The newer f/2.8 PC-Nikkors have a longer mount and work on all Nikon SLRs.

Here I moved in close to the Walter Rudin house, designed by Frank Lloyd Wright, to try to use the small flowerbed as a foreground element. A lower camera angle might have helped, but would then have caused the roof to be at a more severe angle. Like many photos, this is a compromise and is only partially successful, but it would have been impossible to get all lines square without an etched-grid viewfinder screen.

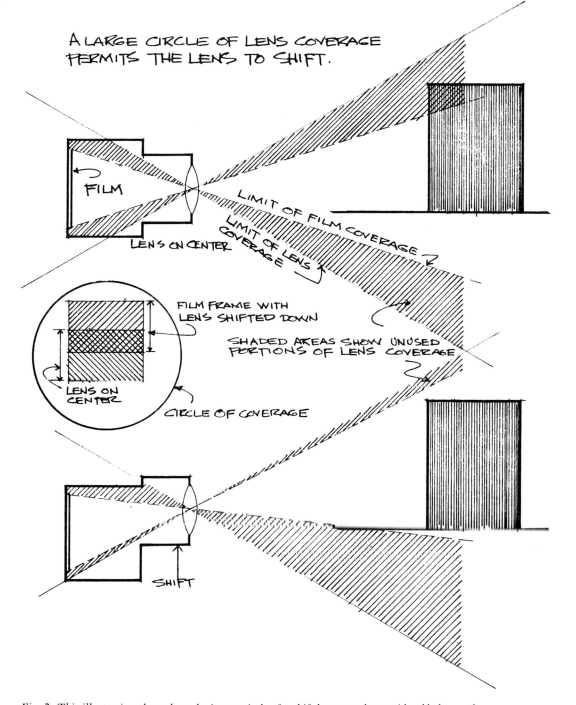

A LARGE CIRCLE OF LENS COVERAGE PERMITS THE LENS TO SHIFT.

FILM

LENS ON CENTER

LIMIT OF FILM COVERAGE

LIMIT OF LENS COVERAGE

FILM FRAME WITH LENS SHIFTED DOWN

SHADED AREAS SHOW UNUSED PORTIONS OF LENS COVERAGE

LENS ON CENTER

CIRCLE OF COVERAGE

SHIFT

Fig. 3. *This illustration shows how the image circle of a shift lens must be considerably larger than the frame of film being exposed in order to permit shifting. Only a portion of the lens's coverage is used to expose any given frame. As the lens is shifted upward, for example, to compensate for vertical perspective distortion, the film is, in effect, moved downward within the circle of coverage of the lens. The circle of coverage of a lens determines the limit to which it can be shifted for perspective correction. The shaded areas show portions of the lens's coverage not being used to expose the frame.*

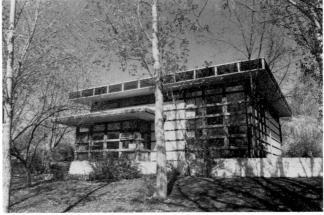

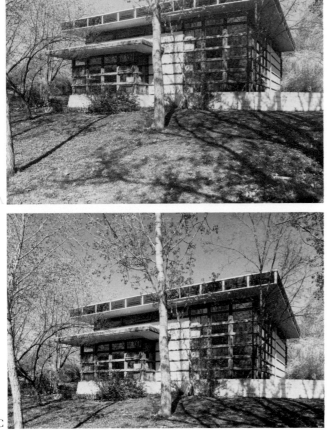

These three photographs demonstrate the perspective-correcting ability of a PC, or shift, lens. In photo A, the camera is held level, showing how the top of the building would be cut off with a normal lens. In photo B, the camera is tipped upward to bring the top of the building into the view. Note the way the vertical lines converge toward each other. In view C, a 35mm PC-Nikkor lens is shifted upward on a level camera, to bring in the top of the house without causing convergence.

probably because it is relatively inexpensive, fits a popular system, and has been on the market since 1968, following its f/3.5 predecessor, introduced in 1961. It fits all models of Nikon SLRs, including the Nikons F, F2, F3, FM, and FE, and also fits all Nikkormat SLRs. Most likely, it will continue to fit future Nikon SLRs because of this particular manufacturer's emphasis on minimizing obsolescence of older equipment when new models are brought out.

The Nikon Type E interchangeable viewfinder grid-screen is made to be used with this lens and its 28mm sister lens, and fits all Nikon SLRs except the FM and EM. The standard Type E screen fits all of these models except the F3 and FE, which have their own, special, front-loaded Type E screens.

The 35mm f/2.8 PC-Nikkor lens is a compact lens that can shift off center 11mm in any direction, because the lens is so mounted that it can rotate 360 degrees in its base. It has an aperture range from f/2.8 to f/32, and its closest focusing capability without accessory screw-in lenses is twelve inches. The lens is a preset design, which means that it must

be stopped down to the taking aperture in order to obtain an accurate through-the-lens meter reading. The brightness of the view is thus reduced while the lens is stopped down, because it does not have an automatic linkage to the shutter release button. All PC lenses on the market except one are preset or manual lenses that do this. (This means, incidentally, that Nikon's much-publicized conversion to "auto-indexing" lenses and bodies means little to the architectural photographer, who would be well satisfied with an older, manually indexed Nikon camera body.)

Because the Nikon 35mm f/2.8 PC-Nikkor lens is relatively ubiquitous, it will be examined closely, so that lenses described later can be related to it.

The lens is a bayonet-mount using Nikon's proprietary mounting system. Before mounting a preset lens such as this, you should set the camera's meter to work with a manual lens. On older Nikons, that means pushing the coupling prong into the meter housing until it clicks; on new "AI" camera bodies, the tiny coupling lever must be pivoted out of the way.

Once the lens is locked into place, it should be set so that the lens elements are on center. Shifting with this lens is done by turning a knurled knob. The lens is placed on center by turning this knob fully clockwise to its stop. Meter readings with Nikon through-the-lens meters and a PC lens should only

A shift lens moves the lens elements in their mounts, as demonstrated here by two f/2.8, 35mm PC-Nikkors. The lens on the right is shifted fully. A shift lens needs to have a large circle of coverage to expose a frame of film fully in its shifted position.

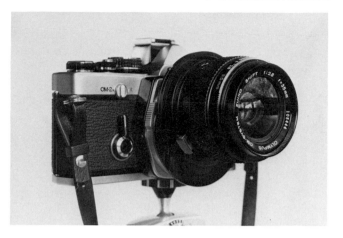

The Olympus 35mm f/2.8 Zuiko-Shift lens here is mounted on an Olympus OM-2N camera in its maximum 11mm upward shift position. This is a fine, compact lens with the best preset feature on the market, the operation of which is controlled by the silver button on the bottom of the lens.

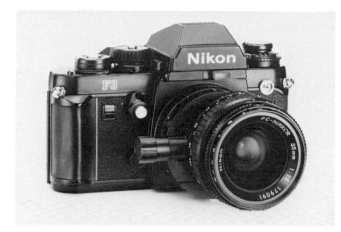

Nikon's latest 35mm f/2.8 PC-Nikkor here is mounted on a Nikon F3 camera in its maximum 11mm shift position to the side. This revision of the f/2.8 PC-Nikkor was introduced in 1980, replacing the first f/2.8 version introduced in 1968 that, in turn, replaced the original 1961 f/3.5 PC-Nikkor of 35mm focal length.—Photograph courtesy of Nikon, Inc.

be made with the lens on center—that is, not shifted. Readings taken through shifted lenses will be erroneous. (This is generally true with any of the lenses from other manufacturers as well.)

The Nikkor PC lens has two aperture rings: one is a locking ring that serves as a stop for the other ring, which actually sets the aperture of the diaphragm. Thus, if you set the locking ring at f/11, for example, the aperture ring will not turn to any setting with an opening smaller than f/11. You can then readily set the lens at f/11—or whatever setting the locking ring is set to—by feel and without looking at the aperture ring. In practice, when using a through-the-lens meter, however, it is easier simply to set the locking ring at f/32—the smallest setting—and forget it, thus using the lens as though it were a manual lens. One other manufacturer, Olympus, has a better presetting system than Nikon's, making it more useful even when using a through-the-lens meter.

The lens may be rotated 360 degrees to shift in any direction. The knurled knob is placed opposite the direction in which the lens is to be shifted. If the lens is to be shifted upward, for example, the knob is set at the bottom of the lens, its most convenient position to the photographer.

Because of the relative popularity of the 35mm PC-Nikkor lenses, the chances are that if used PC lenses are to be found locally, they will be these lenses. The national classified publication *Shutterbug Ads* will occasionally carry ads for several PC, or shift, lenses being sold privately.

Olympus 35mm f/2.8 Zuiko-Shift. The Olympus system, at this writing, offers the new architectural photographer the most economical combination of camera, shift lens, and interchangeable grid-screen in the OM–1 body, Zuiko-Shift lens, and type 1–10 screen. In addition, there is no more compact and lightweight combination of these three elements from a single manufacturer, though Schneider's PA-Curtagon is a lighter and smaller lens.

Though the Zuiko-Shift lens is the most affordable new shift lens on the market, it is first-rate, quality equipment. Because of its shifting-tracks system, it is slightly smaller than the 35mm PC-Nikkor and has no projecting knurled-screw head to interrupt its shape. This lens slides vertically and horizontally in two overlapping tracks; it does *not* rotate in its mount as do Nikkors, Canons, Pentaxes, and Schneiders. To shift the lens, the operator simply pushes it in the desired direction. Such simplicity is striking, but does not offer the precise, smooth control possible with a screw-gear mechanism. In practice, when the photographer overcomes the initial friction and click-stop at zero shift, the lens has a tendency to jolt all the way to its shift-stops. However, I believe a photographer practiced in using this PC lens would learn to control this motion precisely by gripping the lens firmly during a shift. The lens can shift simultaneously in the vertical and horizontal directions in its overlapping tracks, and the amount of diagonal shift is controlled by the design of the lens to prevent image cut-off.

Of the preset PC lenses, the Olympus has the best mechanism for presetting apertures. A push-button on the lens barrel, when left out, leaves the lens diaphragm at full aperture regardless of the setting of the aperture ring. To set the diaphragm to taking aperture, the photographer merely pushes in this button, which remains in until pushed a second time, and the lens is set to whatever setting is indicated on the aperture ring. Thus, it is easy to go back and forth between full f/2.8 and taking apertures, which aids in composition and focusing. Except for Minolta, all other PC-type lenses either employ the double-aperture-ring presetting system or have a simple manual system with no preset capability. There is no preset system as successful as Olympus's for alternating between full and taking apertures.

The Zuiko-Shift lens fits either the OM-1 or the OM-2 SLR camera, both of which also accept the Olympus 1-10 grid viewfinder screen. The OM-1 is a compact, match-needle, manual SLR; the OM-2, almost identical on the outside, offers either automatic or manual exposure. The viewfinder screen is changed identically in both of these cameras—through the lens mount, after the lens has been removed. A small tweezer is provided with the screen and is used to extract the existing screen and install the desired one. A tiny trapdoorlike frame pops down to disgorge the screen, and the grid screen is gently—very gently—placed into this frame, which is then closed upward until it clicks

into place. Though not a difficult operation, it is not for the ham-fisted. Nothing should be forced. This screen-changing system was also adopted by Nikon for its FE camera, and by Pentax for its LX and MX models.

Because of its compactness and economy, the Olympus system is an excellent one for the beginning photographer to acquire. The major disadvantage of the system is that it does not offer a 28mm PC lens as of this writing; only Nikon currently offers both 35mm and 28mm shift lenses.

Schneider 35mm f/4.0 PA-Curtagon. The Schneider 35mm f/4.0 PA-Curtagon, a West German lens weighing only nine ounces, is the smallest and lightest PC lens on the market and was, in 1967, only the second shift lens introduced to the public. It attaches to many different Schneider proprietary mounts to fit a host of SLR cameras, including some motion-picture cameras(!), and boasts Schneider's world-renowned optics. It does not seem to be generally carried by photo stores, but can readily be ordered by them from the importer. Moreover, it is quite expensive in comparison to Japanese lenses, in spite of having a relatively limited shifting ability—a maximum shift of seven millimeters.

Using this fine little lens, even with its limited shift, is easy and natural. The shifting mechanism is controlled by a ring that turns smoothly and easily and has a nice, positive click-stop at zero shift. The photographer cannot shift the lens beyond its covering power. The lens revolves in its mount, like the Nikkor PCs, so that it can be shifted in any direction. On the loaner lens I tried, the rotation was accomplished a little too easily; I could inadvertently commence rotation of the lens barrel when all I desired to do was shift the lens. The shifting ring does offer positive control of the amount of shift, making the lens easier to use than an Olympus shift lens and on a par with Nikon's.

The PA-Curtagon is a manual lens without a preset feature. To set the aperture, you simply rotate the diaphragm ring to the desired setting, and the diaphragm blades are then set at that aperture. You must set the aperture either with a through-the-lens meter or by referring visually to the aperture settings on the lens barrel. Of course, this means that you will then view the scene with the lens stopped down. A preset lens offers a more convenient alternative, as does, of course, Minolta's automatic diaphragm.

A photographer who is a die-hard loyalist to a

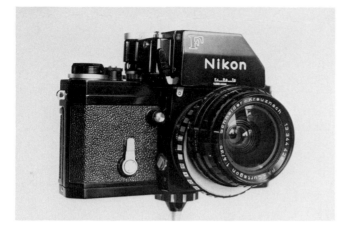

Schneider's 35mm f/4.0 PA-Curtagon lens is here mounted on a Nikon FTN camera and shifted to its maximum 7mm upward position. This pricey lens is the most compact shift lens on the market, and it fits nearly any 35mm SLR and many movie cameras, through Schneider's proprietary lens-mounting universal system. The owners of some systems wishing to have a shift lens have only the Schneider to fit their cameras.

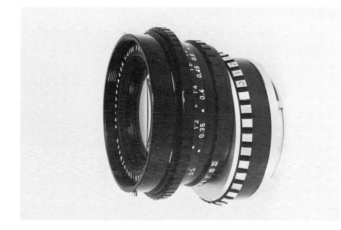

Leica's version of the Schneider 35mm f/4.0 PA-Curtagon designed for use exclusively on Leica SLR cameras. The filter size is considerably larger on this lens than on Schneider's own version.—Photograph courtesy of E. Leitz, Inc.

certain brand of camera that does not have its own proprietary shift lens has only the Schneider PA-Curtagon to fill this need. As this lens has been on the market for many years, it might be possible to find a used one and avoid some of the strength of the German mark against the dollar.

A Pentax photographer who has a 28mm Pentax-Shift lens and wishes to obtain a 35mm PC lens could also turn to the Schneider in a Pentax mount to round out his system. This is really the

only way, other than buying Nikon equipment in the first place, for an architectural photographer to acquire both 28mm and 35mm PC lenses and work exclusively with a single system—in this instance, the Pentax system.

Leitz 35mm f/4.0 PA-Curtagon. In all important respects, the Leitz 35mm f/4.0 PA-Curtagon lens is identical to the Schneider 35mm f/4.0 PA-Curtagon. The only apparent difference is that the front of the Leitz lens is designed to accept a series 8 filter, instead of the small-diameter Schneider filter. Schneider manufactures the Leitz PA-Curtagon lens as well as its own, the former under contract to Leitz. The Leitz version fits only the Leicaflex and Leica SLR cameras. The Leica R4 accepts user-interchangeable viewfinder screens, and a grid screen is available to fit it.

Canon 35mm f/2.8 TS lens. The Canon 35mm f/2.8 TS lens is unique among PC lenses in that it not only shifts 11mm in all directions, but it has the capability of tilting as well—the TS designation stands for "tilt and shift."

The shifting mechanism of the Canon TS is similar to that of the Nikkor PC lenses. It is operated by a screw-gear, has a maximum shift of eleven millimeters and rotates in its mount so as to permit shifting in any desired direction. Other than these similarities, the Canon TS is completely different from the Nikkors. It weighs nineteen ounces—a substantial lens, due, in large measure, to the mechanism required to tilt as well as shift the lens—whereas the Nikkor 35mm weighs twelve ounces. The Canon is a manual lens without a preset feature, a *modus operandi* it shares with the Schneider. To help its manual operation, however, it has click-stops at every aperture setting. Like the Schneider, though, it does require the use of a through-the-lens meter to enable the lens to be used hand-held without frequent reference to the aperture ring's settings. The screw-gear shifts the lens eleven millimeters in two directions without rotating the lens, unlike the Nikkors, so the shifting knob cannot be swung underneath the lens to operate an upward shift of the lens. While this requires the lens to revolve only 180 degrees to shift in any direction, it also means that vertical shifts in the horizontal format must be obtained when the knob is upward, an awkward position for a photographer wishing to operate this knob and the shutter release simultaneously. The same hand must

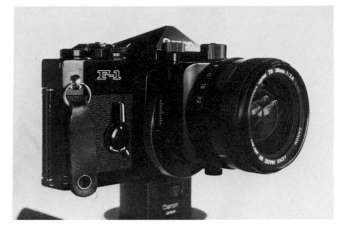

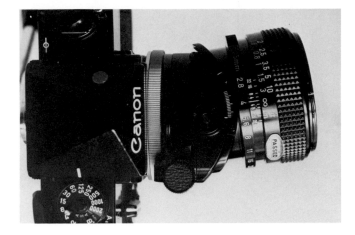

Canon's 35mm f/2.8 Tilt-and-Shift (TS) lens is mounted here on a Canon F-1 camera in its maximum 11mm upward-shift position. The top left knob controls the amount of shift; the right knob operates the tilt mechanism. Below the camera is a small tripod-elevator block provided with the lens so that the lens can clear tripod pan-heads in all shift positions.

Canon's 35mm f/2.8 TS lens, viewed from above, reveals the way it tilts up to 8 degrees, which can be done in any direction by revolving the lens in its mount. This lens's tilt feature is unique among such lenses for 35mm SLRs.

be used to operate both the knob and the shutter button, requiring a back-and-forth motion that is not necessary for any other shift lens.

Canon's grid viewfinder screen, designated the "D" screen, is the best such screen on the market. The lines on other screens are etched; those on the Canon appear to have been inscribed with black ink. They are much bolder to the viewer than other manufacturers' grid lines, making them easy to see and use, even when the lens is stopped down to f/22 and a dark filter is mounted on it. Other screens are sometimes hard to "read" with stopped-down lenses, especially when shooting buildings that have numerous vertical lines.

The tilt feature of the Canon TS is, I believe, most useful in photographing architectural models, a conclusion verified by an acquaintance who is a long-time user of the Canon TS lens. The tilt can be used to bring into focus with the lens at full aperture all parts of a wall or surface receding at an angle to the photographer. This is not really a problem when shooting full-size buildings with a 35mm lens because of the latter's extreme depth of field. Tilting is much more important to large-format view cameras, which must use considerably longer lenses and thus have a greater problem with correct focus. In experimenting with the TS lens, I could not set up a condition with a full-size building where the tilt was useful under normal conditions. However, to the photographer regularly shooting model

buildings, the tilt feature would be an invaluable asset.

The aperture and focus rings on the Canon TS are large and easy to find and use, unlike some of the other lenses with fussier proportions. It is the easiest aperture ring to find of any shift lens. In that respect, it was the opposite of the Pentax-Shift, which has six control rings that can be very confusing to use, and the Schneider, which has small rings that can be problematical for large-fingered photographers.

Only the Canon F-1 and Canon AE-1 Program cameras, as of this writing, can accept the Canon D grid screen, and they are the logical camera bodies in this system for architectural photographers. The F-1 is a complete systems camera, like the Nikon F, F2, F3, and Pentax LX; the AE-1 Program simply has changeable screens. The F-1 is a particularly good choice for photographers of architectural models, because there is a special rotary viewfinder for it that enables waist-level viewing through the pentaprism—a more convenient position for viewing models.

Carl Zeiss 35mm f/2.8 PC-Distagon. The Carl Zeiss 35mm f/2.8 PC-Distagon, recently introduced, fits certain Yashica and Contax cameras, including the Yashica FR and FX series and the Contax 137, 139, and RTS. Only the Contax RTS accepts user-installed interchangeable viewfinder screens,

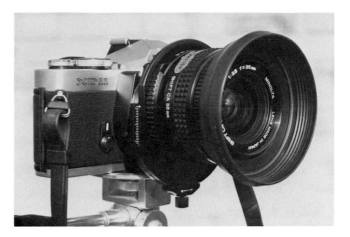

Carl Zeiss's 35mm f/2.8 PC-Distagon lens at its maximum shift of 10 millimeters.—Photograph courtesy of Carl Zeiss Corp.

Minolta's 35mm f/2.8 Shift-Rokkor-X lens is here mounted on a Minolta XD-11 camera in its maximum 11mm upward-shift position. The rubber lens hood is integral with the lens. One of the "brake" levers is seen pointing downward at the bottom of the lens. The XD-11 does not accept a grid viewfinder screen.

for which is available the "Sectioned Matte" grid screen.

The PC-Distagon shifts ten millimeters in all directions by virtue of a rotating mount similar especially to the Pentax and Schneider mounts. The amount of shift is controlled by a shifting ring with click stops every 15 degrees, similar to the Pentax ring. Aperture control is manual, without a preset option.

The PC-Distagon, weighing a hefty twenty-eight ounces, is about a quarter-pound heavier than the next-heaviest PC lens, the Pentax-Shift, which, at twenty-eight millimeters, is a wider-angle lens and has three built-in filters, to boot. Because I was not provided with a loaner Distagon, I cannot report on the reason for the lens's immensity. This Carl Zeiss lens has the honor, also, of being the most expensive 35mm format shift lens on the market and requiring the largest filter, at 70mm diameter.

Minolta 35mm f/2.8 Shift Rokkor-X. The Minolta 35mm f/2.8 Shift Rokkor-X lens is unique among shifting lenses for 35mm SLRs in that it has an automatic diaphragm. That is, the Rokkor-X permits you to focus and view the scene at full aperture. Then, when you trip the shutter, the lens stops down to the taking aperture automatically. There is one catch to this: in order to use a Minolta camera body's through-the-lens meter, you must manually stop the lens down momentarily to taking aperture to obtain a correct exposure reading. In spite of that inconvenience, resulting from the fact that the meter was not coupled to the lens even though the diaphragm was connected to the shutter release, an

automatic diaphragm like that of the Minolta clearly is superior either to the preset or manual alternatives in other systems.

The mystery of how Minolta managed to couple a shifting lens to the shutter release in order to obtain automatic diaphragm operation was solved when I discovered, inside the rear of this lens, a tiny cable, closely resembling a miniaturized motorcycle clutch cable, linking the diaphragm to the shutter. This flexible cable maintains a linkage even when the lens is shifted.

The shifting mechanism of the Minolta lens is identical to that of the Olympus Shift lens: two overlapping tracks are oriented at 90 degrees to each other and enable the lens to shift along one or both tracks simultaneously. However, the tracks in the Minolta are substantially larger than those of the Olympus, making for a bulkier lens. On the side and bottom of the Minolta lens are two knobs the Olympus does not have. These are brakes, or screw-clamps, that lock the lens in any position of shift. There are no click-stops for zero shift, as on the Olympus lens, a condition that makes the center positions of each track hard to locate—impossible to find by feel alone.

At about twenty ounces, the Minolta shift lens is a weighty instrument. It weighs more, even, than Canon's TS lens, and twice as much as Olympus's shifting lens, which has the same maximum aperture as Minolta's. Indeed, the Minolta lens is so heavy that, if the screw-clamps are loosened, the lens will

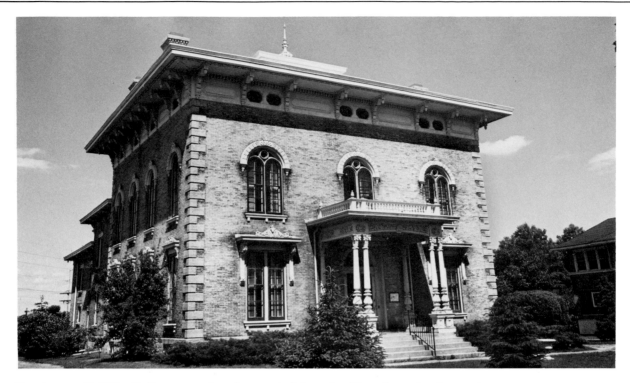

Here is a pre-Civil War Italianate mansion photographed through a 35mm lens pointed upward and not shifted to correct for perspective distortion. (Nikon camera with 35 mm f/2.8 PC-Nikkor lens.)

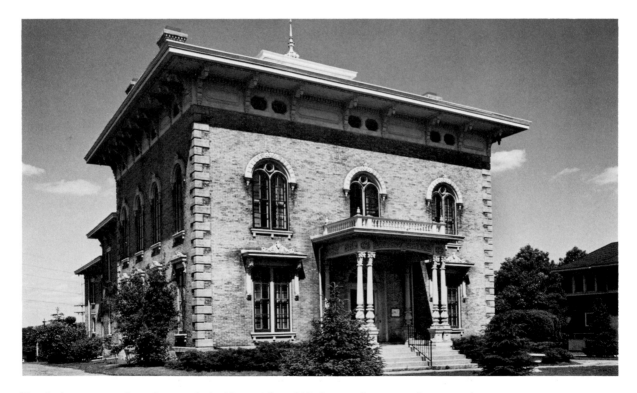

Here is the same mansion, photographed with a PC lens shifted upward to correct for perspective distortion, enabling the vertical lines to remain parallel to each other. (Nikon camera with 35mm f/2.8 PC-Nikkor lens.)

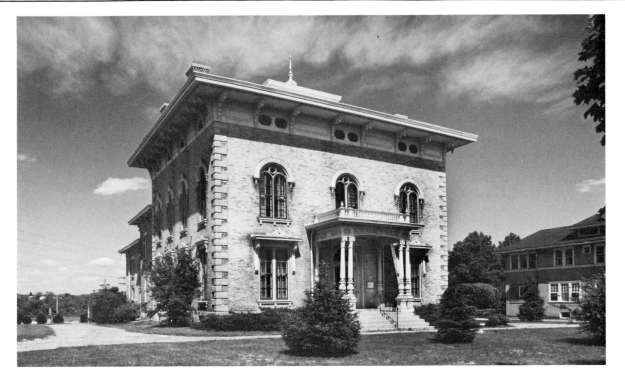

From the same vantage point, here is the Italianate mansion taken with a 28mm perspective-control lens, showing the difference in angle of view compared to the view taken with a 35mm lens. (Nikon camera with 28mm f/4.0 PC-Nikkor lens.)

slide downward to its lower shift stops, due to gravity alone. Thus the clamps must be used to prevent this lens from sliding around on its own.

The best currently produced camera body for this lens is the Minolta XK, which accepts user-installed viewfinder screens, including a type L grid screen. Unfortunately, at this writing the XK is a limited-production body that can be ordered only with a motor drive, and it is extremely expensive. The lens will, of course, fit other Minoltas perfectly well, but none of these can be obtained with a type L grid screen. As new camera models are introduced often, these days, readers interested in the Minolta system should monitor this manufacturer's new cameras. Watch for an economical new model that has user-interchangeable viewfinder screens, including the type L grid screen. Competition will probably drive Minolta into producing one of these camera types in the near future.

PC Lenses of 28mm Focal Length

The 28mm perspective-control lens offers a wider angle of coverage than the 35mm lenses just described. This is a major advantage in urban areas or in photographing buildings in densely foliated surroundings. It is also useful in photographing interiors with perspective correction. These 28mm lenses tend to be more expensive than their 35mm counterparts—although, as noted, the most expensive PC lens on the market is a 35mm model—because more sophisticated and larger lens elements are needed for the 28mm type. It was the introduction of the 28mm PC-Nikkor that led Julius Schulman, in his book, to describe the capability of 35mm SLRs with shift lenses in glowing terms.

Only two 28mm PC lenses are on the market as of this writing: those by Nikon and Pentax. The advantages of the Nikon lens are its compactness and its place in a system with a sister 35mm PC lens, which offers important flexibility. The advantages of the Pentax are its built-in filters and its ability to shift further without image cutoff.

Image cutoff is a more serious problem with a 28mm shift lens than with a 35mm shift lens because the equivalent shift of which the former is capable is greater than that of the latter. Both the Nikon and the Pentax 28mm shift lenses can shift up to 11mm

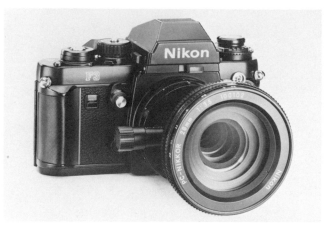

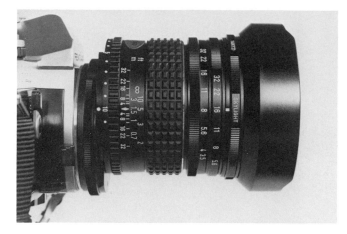

Nikon's latest 28mm f/3.5 PC-Nikkor lens here is mounted on a Nikon F3 camera in its maximum 11mm shift position to the side. The knurled knob on the left of the lens controls the amount of shift. This lens replaced the 28mm f/4.0 PC-Nikkor in 1980.—Photograph courtesy of Nikon, Inc.

Pentax's 28mm shift lens has almost as many control collars as Saturn has rings. Starting from the left are the rotation ring, the shift ring (with the white numeral 10), the wide focusing ring, the diaphragm-control ring, the aperture-presetting ring, and the filter-control ring (with the word SKYLIGHT on it). The lens-mounting ring is positioned inside the segmental rotation ring. It takes getting used to.

off center. That amount of shift is equivalent to a 35mm shift lens moving off center 14mm—which, of course, none of them can do. Thus, the design problems in making a 28mm shift lens are more severe, in part contributing to their generally greater cost.

The effect of a given amount of shift by a 28mm lens is greater than that of a 35mm PC lens, for the same reason. A photographer standing one hundred feet from the facade of a building can, by shifting his 28mm lens the full 11mm, move the image thirty-nine feet in the plane of the facade. A 35mm lens, also shifting 11mm at a one-hundred-foot distance, moves the image only thirty-one feet.

Nikon 28mm f/3.5 PC-Nikkor. The shift mechanism, mount, and shifting limits for the Nikon 28mm f/3.5 PC-Nikkor lens are identical to those of the 35mm PC-Nikkor, already described. One who is used to the 35mm PC-Nikkor, however, will have to make an adjustment in changing to the 28mm version, as the former does not shift beyond its circle of coverage, while the latter does. The 28mm PC-Nikkor will shift to its 11mm limit in the horizontal format without cutoff, but it will only shift 8mm in the vertical format before cutoff begins. Diagonal shifts should be limited to 7mm to avoid cutoff. A series of shifting limits are inscribed on the lens mount for all directions of shift. These limiting marks should be scrupulously observed with the 28mm PC-Nikkor.

Bear in mind that cutoff occurs on the film before it occurs in the viewfinder, so the photographer cannot always trust what he sees. The f/3.5 version of the 28mm PC-Nikkor was introduced in 1980 to replace the f/4.0 model, which had been available for several years.

Weighing less than fourteen ounces, the 28mm PC-Nikkor lens is substantial only with respect to its 35mm sister lens, for it is quite a bit lighter than some of the other 35mm shift lenses on the market. The Pentax 28mm shift lens weighs twenty-two ounces, or 57 percent more. The 28mm PC-Nikkor requires a large filter, 72mm in diameter, compared to Nikon's normal 52mm filter for the majority of its other lenses. A filter that big is a serious investment, in itself.

In use, the 28mm PC-Nikkor offers all the natural convenience of its small sister, provided one keeps its shift limits in mind. In use, a more limited shift is not a serious problem because, due to its shorter focal length, the effective shift of a 28mm lens is greater than the same amount of shift on a 35mm lens.

Pentax 28mm f/3.5 Pentax-Shift. The Pentax 28mm f/3.5 Pentax-Shift lens is Pentax's only PC lens, and it is quite a bit bulkier—being more than an inch longer—than the 28mm Nikkor. There is a gigantic

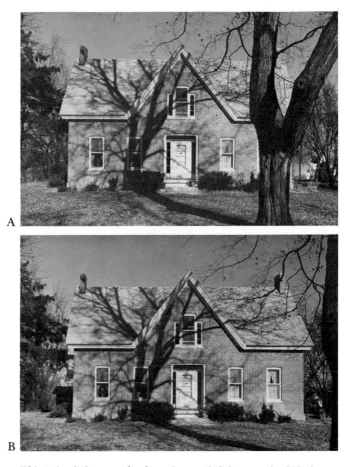

A

B

Pentax's 28mm f/3.5 Pentax-Shift lens is here mounted on a Pentax MX camera in its maximum 11mm upward-shift position. This superb lens weighs more than the MX camera, which accepts interchangeable viewfinder screens through the lens mount.

This pair of photographs shows how a shift lens can be shifted horizontally to permit the photographer to take a straight-on view of a building without interference by an obstruction in front of the building. In view A, the tree obstructs the normal view of the house. In B, the photographer has moved to the left, eliminating the tree from the view, and preserved an approximation of a straight-on view by shifting the PC lens sideways. Notice, however, that the edges of the roof on either side reveal the change in position by the change in their perspective.

chunk of glass on the business end of the Pentax-Shift, though that is not a problem, because the lens has three filters built-in on a rotating wheel: yellow, orange, and skylight. In spite of that, the Pentax lens was less expensive than Nikkor's 28mm lens as of this writing, not even including the cost of three 72mm filters to equip the Nikkor similarly. The Pentax lens is, indeed, a remarkable achievement in design.

The Pentax-Shift lens revolves in its mount, as the Nikkors and the Schneider do, and thus can be shifted in any direction desired. However, the shifting control mechanism is a collar, like that of the Schneider but with eleven positive click-stops for the 11mm of shift possible. The lens is a preset design with a locking aperture ring, like those of the Nikkors. Indeed, there are six control rings surrounding this lens. Starting from the base, these are: rotation ring, shift ring, focus ring, aperture ring, aperture-locking ring, and filter-selection ring. Obviously, it takes some practice with this lens to avoid changing filters, for example, when you wish to set the aperture.

At this writing, Pentax manufactures two camera bodies that accept the Pentax-Shift lens and user-interchangeable viewfinder screens, including the Pentax type-SG grid screen. The Pentax LX is a systems camera, like the Canon F-1 or Nikon F3, in that it has an interchangeable viewfinder as well as changeable screens. The Pentax MX camera is a compact and economical manual camera similar to

the Olympus OM-1, and it weighs less than the Pentax shift lens itself. The grid screen may be mounted into the LX or the MX the same way as on the Olympus OM-1 or Nikon FE: through the front camera mount opening.

In use, the Pentax-Shift lens's weight is a disadvantage, but its three internal filters are a delight and very convenient. They end fumbling around to install separate filters. However, having only three filters built in is limiting. Infrared photography, for example, requires a red or infrared filter, neither of which is built in. The Pentax-Shift lens has a special slot in it that permits

the insertion of gelatin filters to meet that need. The positive click-stops of the shift-control ring are a bit too positive, and the absence of such stops on the Schneider was preferable. The aperture-locking ring operates the same as Nikkor's; it is better than a manual system, but inferior to Olympus's push-button or Minolta's automatic diaphragm.

The serious photographer of architecture will eventually wish to have both 35mm and 28mm PC lenses in his 35mm SLR arsenal. At present, I know of just four options to make that possible. First, one can work with the Nikon system, which includes both lenses. Second, one can work with the Pentax system and obtain a Schneider 35mm PA-Curtagon in a Pentax mount as well as a 28mm Pentax-Shift. Third, one can work with the Canon system to obtain the 35mm Canon TS lens, along with a 28mm PC-Nikkor, for which one can acquire a Canon-made adapter that fits Nikon-made lenses to Canon bodies. Fourth, one can obtain a 35mm body and shift lens from Minolta, Olympus, Canon, or Zeiss, and a separate 28mm shift lens and body from Pentax. The first three options are preferable, of course, because the lenses and camera bodies under each option would be thoroughly interchangeable.

Regardless of the system a photographer chooses, however, the use of shift lenses will enable him to take correct architectural photographs that otherwise would be unattainable.

Using a PC lens. I cannot remember how I adjusted to using a PC lens years ago, but I have since witnessed many other photographers try them for the first time and make their own adjustments. A little experimentation is in order before setting out to use one.

Pick up the lens the first time you confront it and examine its various motions. See how the shifting controls operate and what the lens does in its mount when they are operated. Then practice using the lens to view tall buildings without distortion through an SLR's viewfinder. The most common reaction I see to first attempts to shift a lens is for the photographer to point the camera progressively downward as he shifts the lens upward. I cannot explain why that happens, but it does. Therefore, the best thing to do, right at the start, is to mount the camera on a tripod, so it cannot move in that errant way. Aim the camera at the building so that the center of the viewfinder is on a point at about

lens level on the building. A handy aid in this operation is an inexpensive sighting hand-level sold by drafting supply stores and some building supply houses. If you sight through such a device with your eye at lens level, you can identify points on the facade of the building at the same height as the lens by aligning the bubble with the horizontal cross-hair. Once the camera is set on the level, lock the tripod so the camera cannot be pointed up or down. Then look through the viewfinder and shift the lens upward. You will then be able to witness the effect of such lenses. Once this operation is thoroughly understood, you can accomplish the same feat without a tripod. Even then, however, a tripod is mandatory for accurate corrections.

The majority of times perspective correction is needed will involve this motion, shifting the lens upward to correct vertical distortion. However, all such lenses provide for shifts in any direction: sideways, downward, and diagonally, as well as upward. These motions also have their uses.

The most common situation for horizontal shift? You are photographing a relatively flat facade and desire a straight-on view, but there is some obstacle, such as a light or flag pole, a piece of sculpture, or a tree, in the way. If you can eliminate the obstruction by stepping to one side or the other, you can still take a seeming straight-on view by shifting the lens sideways or, if vertical distortion would also be present, diagonally upward. Horizontal shift is also helpful in reducing the amount of convergence in a dramatically receding wall plane, if you desire a reduction.

Downward shift, in my experience, is rarely used. It is for views taken from high positions looking down—perhaps in photographing an urban scene from a high vantage point, or the interior of a multistory space from a balcony. It could also be useful in taking oblique aerial photographs, though PC photography from airplanes is rendered difficult by the constant motion of the aircraft with respect to the buildings being photographed.

Panoramas and strip photos. Several camera manufacturers who make PC lenses make a point of the fact that these lenses can be used to produce panoramic views without horizontal perspective distortion. This technique involves shifting the lens horizontally all the way to one side and taking a picture, then shifting to the opposite direction fully and taking another shot. The resulting overlapping

frames can be used to make prints that are joined in the middle to produce panoramas. Anyone attempting this procedure should mount the camera rigidly to a heavy tripod prior to taking the requisite exposures. Personally, I think one could accomplish the same results by simply using a wider-angle lens than the PC lens to obtain the same amount of horizontal coverage. That would also avoid the inevitable vertical seam in the middle of the picture. Nevertheless, the technique does exist, and some readers may find it helpful.

More useful to me are strip photographs. Taking strip photographs involves taking a series of photographs along a street facade. The resulting prints can be attached together in a string to produce an unbroken illustration of an entire block face. I first used this technique when I was working in a city planning department as part of a commercial rehabilitation project. The resulting string of prints can be used to produce drawings of proposals and clearly to illustrate exisiting conditions to citizens and plan commissioners. Preservationists can use the same technique to demonstrate the historical qualities of a commercial district.

There are a couple of things to keep in mind when producing strip photographs of commercial areas. First, the technique really only works when photographing buildings that are joined to each other, as are row buildings. Gaps between buildings produce disturbing results. Second, it is important to stand exactly the same distance away from the facades for each photograph, so that the resulting pictures join together perfectly. Third, the camera must be perfectly level for each exposure, meaning a PC lens must be used. Otherwise, the buildings will fit together to form a shallow U, which is completely useless. Fourth, parked cars in front of the buildings create a mosaic of disjointed car parts in the foreground of a strip photo. It is obviously best to take the photos without cars in the viewfinder, if that can be managed. Sunday mornings are good times to take east-facing street faces. Fifth, each photograph must be taken from directly in front of the desired point that is to be in the middle of the frame. Then all horizontal lines will be parallel to each other, as in a one-point perspective drawing. One can achieve this by standing in the correct position or, if there is an obstruction, by shifting a PC lens horizontally or diagonally to produce the appearance of the correct perspective. Sixth, I generally plan strip photos so that the edges of frames approximate the edges of buildings. That masks the joints between photographs.

Panoramas and strip photos are just two unique applications of PC lenses. Others may be discovered by readers who experiment with the potential uses of these lenses.

Medium-Format Architectural Photography

Apart from the fact that this equipment provides a larger image . . . this size camera does not really offer the advantages of the 35mm, especially since there is no lens equivalent to the PC-Nikkors.
—Julius Schulman, 1977

The Pentax 6 x 7 System . . . now offers you another first: the SMC Pentax 6 x 7 75mm shift lens . . . which gives the system the element of perspective correction such as found on view cameras.
—Pentax sales brochure, 1980

A REVOLUTION is brewing in medium-format architectural photography, even as this book is being written. Just as Nikon precipitated the serious use of 35mm SLRs in architectural photography with its 1961 introduction of a PC lens, so has Pentax started a revolution in the medium-format field by its introduction early in 1980 of a shift lens for its 6 x 7 Pentax SLR.

It is too early to predict just how sweeping will be the results of this revolution, but there are some signs indicating it could be important. The medium-format SLR has become a mainstay of serious professional photographers, but was rarely useful to architectural photographers because of the absence of a shifting capability. Pentax has changed the ground rules. The medium format provides a photographer with a significant increase in negative and transparency sizes, but results in an increase in equipment bulk and inconvenience. In this format, the architectural photographer can now find a relatively large image size coupled with easy-to-use equipment capable of perspective correction.

Medium-format cameras and systems are based on 120 and 220 films, sizes that produce negatives and transparencies with one dimension of about 6 centimeters, or 2¼ inches, and a variety of frame dimensions running parallel to the roll of film, depending on the camera. The most common formats are 6 x 6 cm, or 2¼ inches square, and

6 x 7 cm, or 2¼ inches by 2¾ inches, resulting in numerous cameras designated as "66" or "67." A less popular frame size is 6 x 4.5 cm, or 2¼ inches by 1⅝ inches, resulting in cameras designated "645."

A wider variety of camera body styles may well be available in medium formats than in any other. There are SLRs, twin-lens reflexes (TLRs), range-finder cameras, press cameras, and view cameras, of which only the view cameras have a full range of swings, tilts, and shifts (see chapter 5 for a complete discussion of view cameras). The medium-format view camera, however, is difficult to justify, because it is just as cumbersome and inconvenient as large-format view cameras, without having the generous frame size of the latter. The press-type camera, typified by the Horseman, imported by Calumet, combines some of the flexibility of the view camera with some of the convenience of a range-finder camera, but in this compromise does not offer the complete advantages of either.

The medium-format SLR is very popular with professional photographers, because it combines the familiarity in use of the 35mm SLR with a substantially larger frame size, which provides enhanced sharpness. What is lost in the transition from 35mm to 6 x 6 or 6 x 7 is light weight, compactness, and relatively low camera body and lens costs. However, until 1980, architectural

A Pentax 6 x 7 SLR with 75mm shift lens, left, dwarfs a Nikon FE with a 35mm PC-Nikkor, right, and weighs three times as much. This big Pentax is really a scaled-up version of the familiar 35mm SLR. In spite of its size, the Pentax handles well and operates with familiar ease.

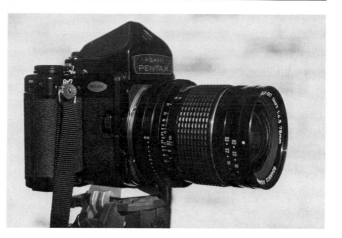

An Asahi Pentax 6 x 7 medium-format camera with a 75mm f/4.5 Pentax-Shift lens set on center, with zero shift.

Here, the big Pentax 6 x 7 SLR has the 75mm Pentax-Shift lens set at its maximum 20mm upward-shift position. The amount of shift is controlled by the rotating collar on the rear of the lens, on which the marking of "20" can be seen set to the right of the white dot.

photographers could have little interest in medium-format SLRs because there was no PC lens on the market to correct architectural perspective distortion. That problem has been cured by at least Pentax and Bronica. Their introduction of shift lenses is so recent that it would be reasonable to expect more shift lenses for medium-format cameras to appear in the coming years.

SMC 75mm f/4.5 Pentax-Shift lens. Pentax's well-known and popular 6 x 7 format SLR camera has been on the market for years and is a proven workhorse. In appearance and handling, it resembles a heavy, oversized 35mm SLR, which makes it feel comfortable to photographers experienced in using the 35mm camera. The new 75mm shift lens for this camera, introduced in February 1980, costs about twice as much as its little brother, the 28mm f/3.5 Pentax-Shift that fits 35mm Pentax SLRs, and approximates in focal length the equivalent of a 35mm lens fitted on a 35mm camera. The 6 x 7 Pentax camera-and-lens combination gives the architectural photographer a system that is almost as convenient to use as a 35mm SLR with a shift lens, but produces an image area more than four times greater. The combination weighs about six pounds, two ounces, a little more than the combined weight of two big Nikon FTN or F2 cameras fitted with PC-Nikkor lenses. In short, after you have been carrying around a Pentax 6 x 7 camera with a 75mm shift lens for a while, you know

you have been handling a *big* camera.

The 75mm Pentax-Shift lens operates like the 28mm Pentax-Shift. That is, it is a preset, manual design, and the amount of shift is controlled by a rotating collar. The lens can accept either a front-mounted 87mm screw-in filter; or small gelatin filters can be fitted to rear clips inside the lens mount. It rotates 360 degrees in its mount to permit shifts in any desired direction. Unlike its smaller brother lens, the 75mm shift lens can be moved as much as 20mm off center and does not have built-in filters. In comparison to a 35mm PC lens in the 35mm format, the 75mm Pentax-Shift lens has

slightly less equivalent shift capacity. Its 20mm of shift would be equivalent to about 9mm of shift on a 35mm PC lens.

The Pentax 6 x 7 camera has interchangeable prisms: one contains a built-in meter, and one does not. It can also be fitted with one of three grid viewfinder screens by a Pentax repair station; they are not interchangeable by the user. These grid screens have seven vertical and five horizontal lines, whereas a 35mm grid screen has five vertical and three horizontal. Having such a grid screen installed would be mandatory for an architectural photographer using the Pentax 6 x 7 and shift lens as a combination.

The 6 x 7-cm or 2¼ x 2¾-inch format employed in the Pentax is called by some an ideal format. The reason is that these proportions are identical to those of the standard 8 x 10 or 16 x 20 photographic print and the format produces sharp images with relatively convenient-to-use equipment. Other medium formats result in equipment that is smaller in bulk and weight than the Pentax 6 x 7. The fabled Hasselblad 6 x 6 SLR system is probably the best-known among these, but as of yet includes no shift lens for architectural photography, severely limiting this system's utility. Moreover, some photographers simply do not care for square frame sizes, though others, admittedly, swear by them. The 6 x 4.5-cm format is used by Bronica for its ETR series of cameras and lenses. The following information clarifies the relative differences in format sizes in the major formats:

Format	Frame Size	Image Area
35mm	About 1 in. x 1½ in.	1.4 sq. in.
6 x 4.5 cm	2¼ in. x 1⅝ in.	3.6 sq. in.
6 x 6 cm	2¼ in. x 2¼ in.	5.1 sq. in.
6 x 7 cm	2¼ in. x 2¾ in.	6.2 sq. in.
4 x 5 in.	4.8 in. x 3.8 in.	18.2 sq. in.

One can see here that the 6 x 7 format offers an image size 450 percent greater than 35mm, but the 6 x 4.5 format is only 250 percent greater, and is just 58 percent as large as a 6 x 7 frame. The 6 x 4.5 provides a lesser advantage to the photographer in comparison to the 35mm format, but the 6 x 7 format is a significant step upward. For the photographer needing a medium format between 35mm and 4 x 5, the 6 x 7 format is the logical choice. Inexplicably, the 6 x 7 format is less expensive than the 6 x 4.5, including the cost of shift lenses.

Bronica 55mm f/4.5 Zenzanon-E Super-Angulon PCS lens. The Bronica 55mm f/4.5 Zenzanon-E Super-Angulon PCS lens, for the Bronica ETRS and ETRC cameras, is fully automatic and has tilt adjustments of up to 10 degrees, as well as providing perspective control through shifting. It weighs in at a beefy three pounds and twelve ounces, making it the heaviest shift lens on the market. Unfortunately, however, it shifts upward (rise) only 12mm, downward (fall) 10mm, and laterally 12mm, which is about the same amount of shift as 35mm and 28mm lenses have in the 35mm format. Twelve millimeters of shift in a 55mm lens is the equivalent of only about 7.5mm shift in a 35mm lens or 6mm of shift in a 28mm lens. The Schneider 35mm f/4.0 PA-Curtagon lens can shift only 7mm, which is not surprising, because the Bronica Zenzanon-E PCS lens was designed, and is made, by Joseph Schneider GmbH and Co., of West Germany. The lens's fully automatic diaphragm is unique among shift lenses, as the Minolta 35mm f/2.8 Shift Rokkor-X lens for 35mm Minolta SLRs is only partially automatic. The 55mm PCS lens has a uniquely monumental filter size, too, at 104mm, which is 26 percent larger in diameter than the filter for the 75mm Pentax-Shift lens in the 6 x 7 format.

The unusual PCS lens fits either of the Bronica 6 x 4.5 SLR cameras, which are true systems cameras with interchangeable viewfinder screens and film holders. A focusing screen with horizontal and vertical grid lines is available for architectural photography and can be installed by the user. The finder prisms also are interchangeable, as they are on Nikon F, Canon F-1, and Pentax LX and 6 x 7 cameras, and one can obtain a plain pentaprism, metered pentaprism, waist-level finder, or rotary finder. A Bronica ETRS camera with prism finder and PCS lens mounted on it weighs in at seven pounds or more, making the combination heavier than the larger-format Pentax 6 x 7 SLR with 75mm shift lens installed on it. The ETRS camera has the capability of interchanging film backs in daylight, which means the photographer needs to have only one camera to accommodate several different types of film. That is a tremendous advantage in architectural photography.

The major disadvantage of the Bronica Zenzanon PCS lens is that it costs more than twice as much as Pentax's 75mm shift lens, and eight times as much as the 35mm PC-Nikkor. Indeed, it is so pricey that it places this system out of the reach of all but the most affluent architectural photographers. In fact,

The Saint Augustine Church, built in 1844 in New Diggings, Wisconsin, was photographed with a medium-format Pentax 6 x 7 camera with a 75mm Pentax-Shift lens and yellow filter. Images produced in this format are extremely crisp, in comparison to 35mm images, permitting substantial enlargements with extremely fine detail.

for the cost of a 55mm f/4.5 Zenzanon-E Super Angulon PCS lens *alone*, one could buy a Pentax 6 x 7 camera, a TTL-meter prism for it, a 75mm Pentax-Shift lens, an Olympus OM-1 35mm SLR camera, and a 35mm f/2.8 Olympus Zuiko-Shift lens, *and* you would still have change left over for film and filters! Of course, if you still choose to pop for the Bronica PCS lens, you can be pretty certain you'll be the only kid on the block to have one.

Plaubel Proshift 69 Superwide Camera. In 1981, a new camera of particular interest to specialized

architectural photographers was introduced. As far as I know, this is the first time any manufacturer has produced a viewfinder-type camera capable of shifting to correct architectural distortion. The Plaubel Proshift 69 Superwide Camera is for the photographer who needs a very-wide-angle, medium-format, PC lens, as its angle of view is similar to that of a 21mm lens on a 35mm SLR camera.

The Plaubel Proshift 69 has a Schneider Super-Angulon 47mm f/5.6 noninterchangeable lens and produces images of 6 x 9 cm on 120 or 220

A row of log-and-ashlar nineteenth-century vernacular houses in Mineral Point, Wisconsin, was taken with the Pentax 6 x 7 camera and 75mm Pentax-Shift lens. No perspective-correcting equipment can straighten out walls such as these, which are tilted at different angles due to settling foundations. The entire city of Mineral Point is listed on the National Register of Historic Places as a historic district.

roll-film. It has an optical viewfinder—but no rangefinder—and the lens shifts up to 15mm vertically or 13mm horizontally, which is equivalent to 11mm and 9½mm respectively in a 35mm PC lens. The optical viewfinder does *not* shift, but pivots in both axes to approximate the view seen by the shifted lens. The camera/lens combination weighs about 3½ pounds and contains a built-in bubble level to aid in leveling the camera on the tripod.

Plaubel Feinmechanik und Optik, GmbH, is a West German photographic products manufacturer. The Proshift 69 is imported by the Copal Corp. of America, Woodside, New York.

Architectural photographers who need a medium-format, easy-to-use SLR with a shift lens can now look to the Pentax 6 x 7 with 75mm shift lens to fill that requirement. Because this system is relatively more expensive than the 35mm systems on the market, I do not expect it to revolutionize architectural photography; the 35mm system simply has too many advantages that offset the medium-format's improved image size. But Pentax's introduction of the 75mm shift lens was just as revolutionary to the medium format as was Nikon's introduction of the PC-Nikkor, two decades earlier, to the 35mm format. New developments are all but

The Bronica ETRS camera here has mounted on it the 55mm f/4.5 Zenzanon-E PCS Super-Angulon lens, which is shown shifted upward 5 millimeters and tilted upward as well. The three projecting knobs control, from left to right, the amount of tilt up or down (the lens cannot be tilted to the sides), the amount of shift up or down, and the amount of shift to either side.—Photograph courtesy of Bronica Co., Ltd., Tokyo, Japan

The Plaubel Proshift 69 Superwide camera has a fixed 47mm lens capable of shifting up to 15mm. The lens angle is similar to a 21mm lens in the 35mm format and provides the professional architectural photographer with a wide-angle shifting lens otherwise unavailable in small- and medium-format photography.—Photograph courtesy of Copal Corp.

certain to appear from other manufacturers of medium-format lenses, and that could affect the future of medium-format architectural photography dramatically.

To some, the medium format will be a godsend, eliminating the need for either smaller or larger systems. Others will find it to be like a fifth wheel: unnecessary if you have both 35mm and 4 x 5 systems. Still others will find it to be a crucial link in an equipment chain in which each link serves a valuable function. Perhaps these different opinions make inevitable the possibility that medium-format equipment will be around always, but not in great quantities.

There is little argument with the position that for the ultimate efforts in architectural photography involving maximum flexibility in manipulating and correcting images, the serious architectural photographer must eventually turn to large-format view cameras, covered in the next chapter.

5 Large-Format Architectural Photography

The view camera . . . is required equipment for architectural photography, for only with camera corrections of the perspective involved is the photographer able to give a true recording of the subject. Distortions can be corrected, or they can be used for dramatic effects if desired. With the various movements of the view camera it is even possible to obtain a scene from an otherwise impossible or tight vantage point.
—Robert C. Cleveland, 1953

Only one camera type, the view camera, has the ability to handle nearly all the situations an architectural photographer is likely to encounter . . . the view camera will help to extend your vision, and will expand your ability to control the final picture in a way that is unsurpassed by any other camera type.
—John Veltri, 1974

NEARLY everyone has seen those large picture books with lush photographs having incredible detail. A superb recent example of that in architectural photography is the National Trust for Historic Preservation's book *Court House*, for which skilled photographers were hired to document county courthouses across the United States. Photographs of such quality, crispness, and evocative detail were taken with large-format view cameras having negatives 4 inches by 5 inches (4 x 5) or larger.

A view camera is a large camera that must be mounted on a sturdy tripod for use. It has two standards: the front standard holds the lens and shutter, and the rear standard includes a ground-glass focusing screen mounted in a spring-loaded frame under which is slid a sheet-film holder for exposures. The standards in most cameras are attached to a monorail beneath them, on which they can slide forward and backward. The monorail, in turn, is held up by a base that is attached to a tripod. The standards are connected to each other by a light-tight, flexible bellows. To use the camera, the photographer attaches a large black cloth to the rear standard and drapes the cloth over his head to permit him to see the image on the ground glass.

As superb as modern 35mm SLR equipment has become, it cannot produce negatives or transparencies that match the sharpness and resolution of those from such a large-format view camera. To those used to the fuzziness found in enlargements made from 35mm negatives, buildings illustrated in prints made from 4 x 5 negatives seem to leap off the paper. Interference from photographic graininess seemingly is absent. You see the building itself, not an image of the building filtered through a fine-mesh sea of grains.

This is not to denigrate the 35mm medium in the least; it does yeoman duty in the face of its inherent limitations. The 35mm frame measures a little less than 1.5 inches by about 1 inch, and has an area of 1.4 square inches. In comparison, the 4 x 5 frame measures about 4.8 by 3.8 inches and has an image area of more than 18 square inches. Thus, the area of the larger frame is 13.5 times greater than that of the smaller. Translated into practical results, a 4 x 5 negative or transparency will have much more detail and will be much clearer.

Because of that, it is all but inevitable that the serious small-format architectural photographer will consider the large-format camera at one point or

44

A photographer burrows under a dark cloth attached to the rear of a Calumet CC-402 Wide-Field view camera in order to see the image on the ground-glass. The medium-weight tripod here is barely adequate to the task of supporting a 4 x 5 camera; a heavier, braced model would be better.

another in his career. A photographer wishing to have his photographs published in quality magazines or books must work in the 4 x 5 medium, as must one taking photos for the Historic American Buildings Survey of the National Architectural and Engineering Record. A photographer preparing negatives for display prints would be well advised to use a 4 x 5 camera, as would one documenting a historic building about to be demolished.

Using a large-format system, however, does not mean that an architectural photographer forever forsakes his tried-and-true 35mm SLR. In fact, the opposite can be true. There is nothing more logical than being able to use both systems together in documenting buildings. The two systems are complementary, both offer advantages

simultaneously, and occasionally they can back each other up.

What—besides clearer images—does the 4 x 5 or larger system offer, and what are its disadvantages? In a view camera, the perspective-correcting mechanisms are incorporated into the camera itself, so *any* lens mounted on it can correct distortion, provided the circle of coverage of a given lens is adequate to the task. That means, for example, that lenses with a wider relative angle than a 28mm PC lens on a 35mm SLR can be called into service with a 4 x 5 view camera. The photograph on page 6—the Harold Bradley house, designed by Louis Henri Sullivan—could not have been taken with a 35mm camera. To get it, a 75mm Schneider Super-Angulon lens was mounted on a 4 x 5 view camera to permit a viewpoint within the perimeter of trees. That lens would be the equivalent of a 22mm PC lens on a 35mm SLR and, of course, no such lens exists.

Other advantages of specific interest to architectural photographers include the view camera's usefulness in producing rectified, scalable prints (see chapter 12) and its flexibility in the use of many different types of film at one time. Because of the latter, a photographer working with a large-format system can get along nicely with one camera body, while a 35mm-using colleague must carry two or more cameras, one for each type of film being exposed. This is because the large-format camera employs separate film holders. The photographer can set up his camera and expose precisely the same view on Plus-X, Ektachrome, and infrared films, without once changing the camera's position. Thus, while it does take more time to set a camera up for large-format photography, once it *is* ready, the photographer can shoot away quickly with many films.

Of course a view camera does have its special disadvantages, too. These include bulkiness, slowness of use, and high cost compared to some 35mm equipment. Regarding use of the view camera, I have clocked myself setting up a camera, taking a photograph, and packing the equipment away again. Risking some error in the interest of speed, that operation takes at least fifteen minutes. Regarding the bulk of a 4 x 5, one generally does not throw a view camera into a camera bag and march off over hill and dale, photographing buildings. Having an automobile, or at least a hand-cart, is a virtual necessity. I use a furniture dolly to cart my large-format equipment around

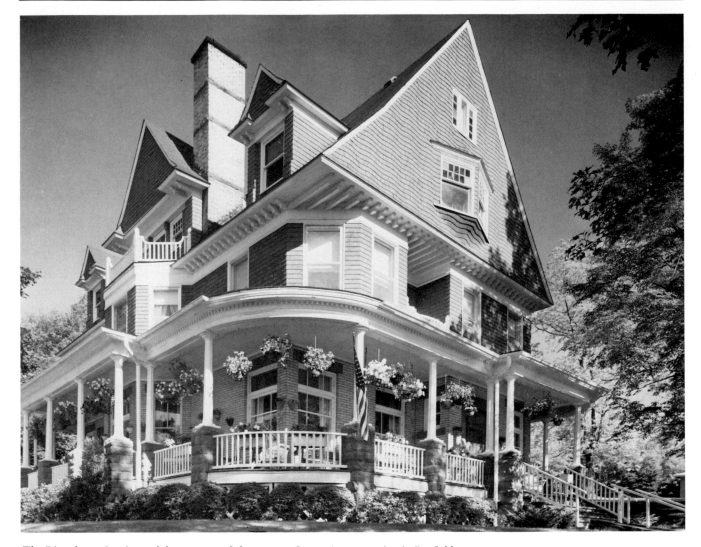

The Rittenhouse Inn is an elaborate turn-of-the-century Queen Anne mansion in Bayfield, Wisconsin, now serving as a restaurant and inn. This view could be made only with a very-wide-angle lens, due to constricted surroundings; in this case, the lens used was a 75mm Schneider Super-Angulon on a 4 x 5 wide-field view camera.

when walking is required. Regarding the cost of equipment and film, an inexpensive wide-field view camera, such as the Calumet CC-402, and a 90mm lens costs about the same as a good 35mm SLR with a less-expensive PC lens. Acquiring additional lenses is more expensive than in a 35mm system, because each lens has its own built-in shutter and has large precision-ground elements; further, such lenses are not made in the volume that small-format lenses are. Finally, 4 x 5 film and processing costs a lot more per frame exposed than does 35mm film. Taking Plus-X film, for example, it will cost you about

fifteen cents today to buy, process, and proof a 35mm frame on a 36-exposure roll. A 4 x 5 frame similarly bought, processed, and proofed would cost about fifty cents, or over three times more. The differences in relative costs for color film are even greater. In short, most photographers cannot afford to squander large amounts of 4 x 5 film in seeking the correct view and exposure. Once negatives for black-and-white films are processed, however, enlargements cost the same amount for each size of film. Depending on the nature of the job, that can go a long way toward equalizing costs.

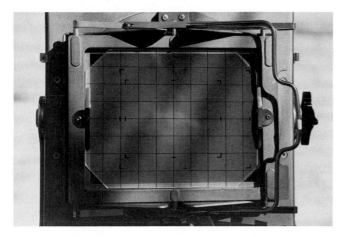

The ground-glass on the rear standard of a 4 x 5 view camera is used for focusing and composition under a dark cloth or within a reflex-viewer accessory attachment. The horizontal and vertical grid lines are required to aid in aligning buildings on the ground-glass, especially because they are viewed upside-down and reversed under the dark cloth.

In use, the view camera does not have a separate viewfinder eyepiece. Focusing and composition is done on a ground glass, which should have vertical and horizontal grid lines inked or etched on it, before film is inserted into the camera. For assistance in focusing accurately, the photographer should carry a pocket magnifier with which to check details of the subject. The image on the ground glass is too dim to be seen in daylight, so a black cloth is attached to the back of the camera and draped over the photographer's head. Reflex viewers also are available and permit the photographer to view the ground glass without a dark cloth. Moreover, a reflex viewer makes the image right-side up, though backwards, instead of upside down, as it is seen under the black cloth. Except in windy weather, these reflex viewers are more convenient than cloths for focusing and composition, but they add another piece of bulky equipment to the photographer's baggage. Viewers belong with equipment that is nice to have, but not essential.

The front standard of the view camera may be shifted upward, downward, to either side, or any combination of these. It may also be swung about, either in the horizontal or vertical axis, or both. Similiar swing motions are possible with the back standard and may be combined with front motions to increase the swing further.

There are other view cameras on the market

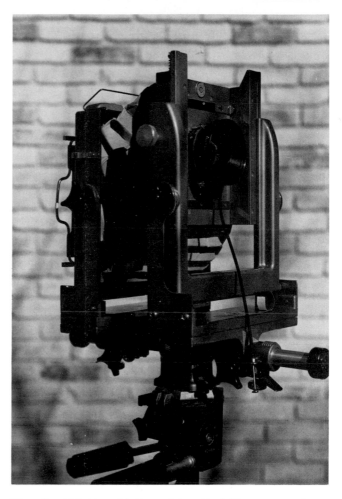

The soft, widely pleated bellows of the wide-field camera permit radical shifts with wide-angle lenses, which are necessary for architectural photography in the 4 x 5 format.

besides the 4 x 5, which is the most common size. Others range from 2¼ x 2¾ up to 5 x 7 and 8 x 10. Rigid-body large-format cameras also are available, but should be avoided because they are not capable of perspective control. View cameras both larger and smaller than 4 x 5 are more expensive than this size and offer less flexibility. One can find a few 2¼-inch-format view cameras on the market capable of extreme shifts, but these are not only very expensive—they also suffer from much of the inconvenience of a view camera without offering its large frame size. Generally, only the true professional architectural photographer ever has a need for a format larger than 4 x 5, though truly spectacular, albeit expensive, results are possible with these extra-large formats.

The photographer starting in large-format architectural photography should select a view camera designed to accommodate wide-angle lenses. Such cameras will have either a very soft bellows with large pleats or a bag-type bellows to permit extreme shifts when the front and back standards of the camera are close to each other. In my experience, the 90mm lens is the one most commonly used, and it would serve as a good "starter" lens. It is roughly equivalent to a 28mm lens on a 35mm SLR. The so-called normal lens on a 4 x 5 camera would be from 150mm to 180mm.

Because most photographers are familiar with lenses in the 35mm format, the information listed below should be helpful in understanding 4 x 5 equivalent lenses. Although different frame proportions in the two formats prevent exact comparisons, you can obtain a rough approximation of equivalencies if you divide the 4 x 5-format lens's focal length by 3.4 to get an equivalent 35mm-format lens length:

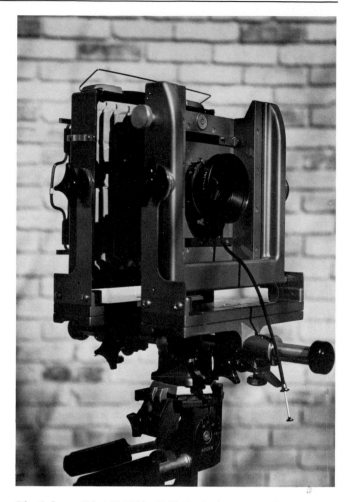

4 x 5 Format Lens	Equivalent 35mm Format Lens
65mm (2½″)	19mm
75mm (3″)	22mm
90mm (3½″)	27mm
100mm (4″)	30mm
128mm (5″)	38mm
150mm (6″)	44mm
165mm (6½″)	49mm
180mm (7″)	53mm
250mm (10″)	74mm
305mm (12″)	90mm

The Calumet CC-402 Wide-Field 4 x 5 view camera is an excellent selection for architectural photography and is relatively inexpensive. Here, it is fitted with a Rodenstock Sironar 150mm f/8 lens and a cable release.

While I do not wish to recommend specific cameras to the reader, the Calumet series of view cameras is widely recognized as being of good quality and relatively inexpensive. The Calumet CC-402 model is that manufacturer's wide-field camera suitable for architectural photography and is illustrated in photographs with this chapter. It has a recessed lens board and soft bellows for use with wide-angle lenses. Other manufacturers offer excellent equipment, as well, some of it both much more expensive and of higher quality than the Calumet series. Both Julius Schulman's and Petersen's books endorse the Calumet cameras as being worthy and good values.

In addition to a camera, lenses, and film holders, the 4 x 5-format view-camera photographer will need other equipment routinely. Foremost is a sturdy tripod, with bubble levels, able to support a large camera without vibration. This means a large, braced tripod. Don't select a tripod on the basis of the least expense or the lightest weight. It would be helpful if the chosen tripod could raise the camera's ground-glass to eye level, as this is the comfortable operating level for many photographs.

A hand-held exposure meter is extremely helpful to the large-format photographer. A neophyte who has a 35mm system and is moving into large-format work could carry along his SLR for this purpose, but after a while that procedure can become annoying. The hand-held spot meter can be useful in taking selective readings in sunlight and shadow-covered areas. In a pinch, one can simply follow the instructions for exposure that accompany film boxes for satisfactory results. However, bracketing

A typical 4 x 5 equipment case carries the view camera in the center, film holders and changing bag on the right, and an exposure meter, dark cloth, filters, and lenses at the left. This is an inexpensive Calumet fiber case.

exposures to cover for possible errors becomes quite expensive in large-format photography because of the film and processing costs for sheet film.

Other accessories for 4 x 5 cameras vary in importance. A large piece of black cloth is mandatory for ground-glass viewing. Some cameras have bubble levels built in, but if a particular camera does not, a 5-inch pocket level should be in the equipment bag. Regarding such bags, a cardboard box may do for a while, but eventually a case designed for 4 x 5 view cameras will be necessary. These cases resemble suitcases, in scale, but can carry nearly everything you need except the tripod.

A typical, beginning, modest 4 x 5 view camera system for an architectural photographer would include the following:

1. Wide-field view camera with soft pleats or bag bellows
2. Starting lens of between 90mm and 150mm focal length
3. Cable release
4. Sturdy, braced tripod
5. Several film holders for sheet film
6. Black cloth for ground-glass viewing
7. Hand magnifying glass
8. Pocket level and/or hand sighting level
9. Filters for black-and-white film
10. Exposure meter
11. Black-and-white and color films
12. Equipment case for above
13. Optional: negative-processing tank and equipment

Whether you should obtain a 4 x 5 developing tank right away and start processing your own negatives depends on whether you have access to a

reliable, quality processor of black-and-white sheet film.

Once this starting set-up is assembled, the first equipment that should be added, as funds and interest allow, are additional lenses such that the range of 75mm to about 150mm is completely covered. Additional film holders can be added occasionally, as it seems one never has enough of these. Thereafter, equipment needs will depend on individual interests and skills.

Setting up and using a 4 x 5 view camera should be practiced initially to avoid wasting time and making mistakes in the field later. It is very different in use from 35mm SLRs. For a better idea of what is involved in using a view camera, let me describe briefly a hypothetical assignment: to photograph the facade of a house. We will assume that the sun, weather, and transportation have all been worked out; with a tap on our typewriter we have conquered our most serious problems!

Upon arriving at the site in our car—and we will need at least a car to carry our gear—we check the building out and tentatively select possible views. At this point, we might use a 35mm SLR camera to evaluate views and take some hand-held photos (remember, 35mm and 4 x 5 systems are complementary). Once we select the desired first view, we move the car as near to that position as is reasonable and open the trunk, tailgate, or whatever.

First out of the car comes the heavy tripod: a large, braced model with built-in bubble levels on the base and pan head. We extend the legs, taking care to get the base as level as possible by referring to the proper bubble level. A level base makes for easier adjustments later. Then out comes the equipment case containing the camera, lenses, exposure meter, black cloth or reflex viewer, and film holders, which we had loaded in a darkroom before we left. Out comes the camera, which we mount atop the tripod. If it is not already in place, we install the chosen lens on the front standard, attach the cable release, and remove the lens covers.

We pull apart the standards—they had been stored compressed together—to approximate a focus on infinity and point the camera at the facade. We install the black cloth under clips on the rear standard provided for that purpose. We open the lens to its maximum aperture, open the shutter, and peer at the ground-glass under the black cloth. At this point, we undoubtedly see an upside-down building that is out of focus and tilting to one side. So we focus roughly as we point the camera in the desired direction, not worrying yet about shifting the lens, but trying to level the camera.

We can now evaluate what we see. We may decide to move the camera to another position, re-evaluate the resulting image, and relevel the tripod. Eventually a preferred position will be found. We then will lock the tripod's pan head so that the camera is perfectly level in both the side-to-side and front-to-back axes. To achieve this three-dimensionally level position, we will refer to the bubble levels and study the image carefully on the ground-glass. We may even use accessory hand levels to double-check things, for the least misorientation will show up clearly on the negative or transparency. When everything is just right, we study the image again to determine what shifts and swings might be necessary. Vertical shifts can be readily made, but horizontal shifts, if desired, will require resetting the pan head. With shifts and swings added in, we can then scrutinize the focus carefully with a hand magnifying glass and gently adjust final focus to perfection. We will also want to consider and check depth of field at this time, as well, because of the relatively long focal length of the lens we are using.

Once the camera is finally set, it must be treated very carefully, so as not to jar it out of alignment. The correct exposure is determined by using the exposure meter, and a filter, if desired, is installed. The lens is closed and set, as is the shutter. Normally, compared to 35mm photography, a small aperture and relatively long exposure will be needed, again a result of the long-focal-length lens in use. If it is windy, the black cloth might be removed to eliminate a possible source of camera motion. If it is quite windy, the photographer will have to time his exposure release to a lull in the wind.

A film holder is inserted into the back of the camera and checked to be certain it has been properly seated without possibility of light leakage. The dark slide may then be removed from the film holder, allowing light from the lens to hit the film when the shutter is tripped. The exposure may then be made, after which the dark slide is reversed—to indicate the film beneath it has been exposed—and reinstalled. If other exposures are desired or if other films are to be used, additional exposures are made. Filtration, of course, must be changed according to film used. I generally expose color films first, to lessen the chance of, for example, taking an Ektachrome photograph through an orange filter, as

the results, while perhaps interesting, are usually not desired.

With the photograph or series of pictures completed, one may again pack away all the equipment. Back at home or office, one should immediately remove from the film holders the film that has been exposed—to avoid later double-exposures—and place the exposed film in a light-tight box for transfer to the photo lab. Simultaneously, fresh film can be inserted into the film holders after the latter have been cleaned as well as possible of dust and dirt. Film holders and boxes must be properly labeled to keep different film types separate.

If the reader is getting the idea that view-camera work is picky, picky, picky, then he is correct. Compared to it, using a 35mm SLR is a breeze. But when view-camera work is done correctly and the desired image actually emerges on the processed film, there is great satisfaction in a job competently done. There are, nevertheless, many ways to ruin 4 x 5 photographs by careless operation of a view camera—I think I may have succeeded in finding them all, personally. Some of the ways I have ruined 4 x 5 films are:

1. Forgetting to remove the dark slide before "taking" a picture;
2. Forgetting to stop the lens down to taking aperture;
3. Not correctly leveling the camera;
4. Shifting the lens so far as to cut off the image without tilting the lens to compensate;
5. Inserting film backwards into the film holder;
6. Becoming confused as to which films were in what holders; and
7. Using out-dated Ektachrome film.

Failure does not always dog my tracks, however, and has taught me a few crucial things that photographers new to view cameras ought to know.

It is much easier to get dirt on 4 x 5 films prior to exposure than on 35mm films, and so cleanliness in working with films and film holders is mandatory. A little explanation of the way these respective film types are handled will make that clear. Thirty-five millimeter films are loaded into cassettes in the factory, unless you are using hand-loaded film. The film is clean, and the cassette is new. Strict standards of cleanliness are maintained at the factory. If the camera is kept reasonably free of dirt and lint, the film will slide out of its cassette and back into it perfectly clean. Even hand-loaded film has little opportunity to get dirty. On the other hand, a 4 x 5 sheet of film is loaded by the photographer into a film holder. The holder has probably been used countless times before: stored in cases, carried around in the dusty, dirty world, and inserted into and removed from cameras in windy conditions. Each time the holder is opened to receive or disgorge film, lint and dust can enter it freely. Whenever a new sheet of film is loaded, there is a good chance it will pick up some dirt or dust on the emulsion surface, preventing light from hitting the film at that point and causing a spot to form on the processed film.

Because of all that, it is much harder to keep sheet film clean and spot-free than 35mm film, even though spots would wreak greater havoc with the latter. Film holders must be protected from dirt as much as possible and cleaned with dirt-free air and/or lint-free cloths prior to loading. They should not be left lying around without the dark slides in place, because this is literally an open-door invitation to dust and lint. The problem is compounded by the fact that whenever you take a 4 x 5 picture, you reverse the dark slide and the outside surface becomes the inside surface, able to foul the film. This constant reversing allows the dark slide to become dirty and deposit material on the next sheet of film. Dirt is not an insurmountable problem, but it is a serious concern. One commercial photographer I know always takes duplicate exposures, simply assuming that dirt will somehow foul at least one of the shots in spite of his precautions.

The photographer using sheet film will also discover that he has a problem getting good, consistent processing of his films, unless he does it himself. Many communities do not have labs that can handle sheet film properly. This is a greater problem with black-and-white negatives than it is with color transparencies, because the latter are much more widely used and processed. I have had 4 x 5 negatives ruined by so-called professional-quality labs, simply because they handle so few of them that they do not have a proper processing system in place. The answer may be to send sheet films to a major processing lab that you know does good work, even though you must work through the mails, with the resulting delays.

My personal answer to black-and-white processing

is to do it myself, when I can. Processing black-and-white negatives is relatively easy and inexpensive in a plastic daylight developing tank. You can then be certain that presoaking and agitation—crucial to sheet film development—have been correctly done. Presoaking, incidentally, involves letting exposed, undeveloped film sit in room-temperature water for a period before commencing development. Through bitter experience, I learned that this helps keep the face of the film free of bubbles, which cause spots on the final negatives. Other than that, I process sheet film

negatives just as I would 35mm negatives. Processing negatives in a daylight developing tank requires no darkroom at all. A kitchen sink works just fine, so long as you can load the tank with film in total darkness, such as in a closet or changing bag.

Once you have processed the negatives you can then select the images from which you would like contact prints or enlargements, which can be handled by a photo processing lab. By processing your negatives yourself, you can get an accurate idea of your results quickly, however—even the same day you took the pictures.

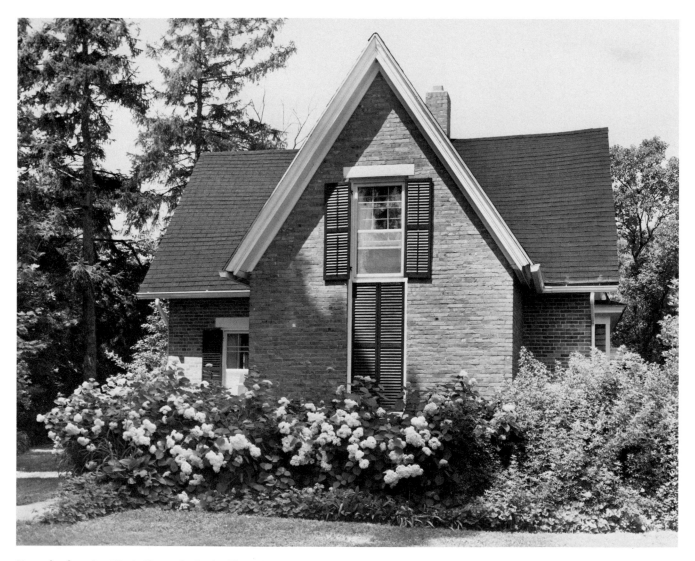

Here, the charming Hoxie House, in Cooksville, Wisconsin, was photographed with a 150mm Rodenstock Sironar lens on a 4 x 5 view camera. I enjoyed making this photograph, because going through the exercise of setting up a view camera forced me to slow down and work deliberately. Architectural photography can be a hobby, as it was on this day, rather than just an assignment or a job.

The 35mm photographer pondering seriously whether to get into the 4 x 5 view camera field or not has some excellent books on the market to help in his decision. Four hardcover books, all listed in the bibliography, on large-format architectural photography came out between 1974 and 1977. In reverse order of publication date, these books were by Julius Schulman, Joseph Molitor, Eric DeMare, and John Veltri. As they are quite expensive, you may wish to check local libraries for copies before deciding which, if any, to order. Shulman's, the most recent, is probably also the most comprehensive in its treatment, even including a section on setting up and operating a professional architectural photography office. In 1973 the Petersen Publishing Company produced its inexpensive, magazine-format guide to architectural photography, which is widely available at photo stores. It is also very informative and concentrates almost exclusively on large-format photography.

Older architectural photography books, from the 1950s and earlier, are listed in the bibliography, but are hard to find. If you wish to read these older books, you can obtain them on interlibrary loan at major libraries.

Available without charge are two fine monographs on architectural photography written by Jack Boucher, chief photographer for the National Architectural and Engineering Record, created in 1979 to combine the functions of the older Historic American Buildings Survey and the Historic American Engineering Record. The NAER is a division of the National Park Service in the U.S. Department of the Interior. "Suggestions for Producing Publishable Photographs" is available from the National Trust for Historic Preservation; "Photographic Specifications for Contract Photographers" can be obtained from NAER. Addresses are in the appendix, as are further bibliographic references.

6 Film

It is part of the architectural photographer's work to choose photosensitive materials suitable to the job at hand and see to it that they are handled correctly.

—*John Veltri, 1974*

THE photographer today will generally start in the 35mm format. If he is interested in architecture, he may develop an interest in the medium formats or large formats, either as a supplement to 35mm or instead of it. Therefore, films for these three formats are of the greatest interest.

Small (35mm) Format

There are a tremendous variety of films from numerous manufacturers available for 35mm cameras. Kodak's films are the most widely used and, therefore, will serve as the basis for discussion. The architectural photographer most commonly will use a black-and-white negative film of moderate-to-slow speed, and a color transparency, or slide, film. At times a color negative film may be desired, and experimentation with black-and-white infrared film is definitely worthwhile.

A film's speed, or light-gathering ability, is denoted by an ASA number, which is an abbreviation for the American Standards Association. The higher the ASA number, the faster a film is, meaning the less light is needed to expose it properly. A film with a speed of ASA 400 is twice as fast as an ASA 200 film. Using the same aperture, if an exposure of 1/15 second is needed to expose ASA 200 film properly, then only 1/30 second would have been necessary for an ASA 400 film.

A handy fact worth remembering about ASA numbers is that, when taking a picture illuminated by full sunlight, the proper exposure is an aperture of f/16 at a shutter speed equal to the reciprocal of the ASA speed. For such a scene, therefore, an ASA 125 film would need a shutter speed of 1/125 second. When your exposure meter dies, this relationship can save you.

Thirty-five-millimeter film comes from the factory in individual cassettes containing either twenty or thirty-six exposures. It is in a vapor-proof container that was prepared in a controlled-humidity environment. Thus, it may be refrigerated for short-term storage or frozen for prolonged periods prior to exposure. Factory-loaded film has two advantages: the first exposure on a roll always starts with Number 1, a number visible on the developed film, and the film can be safely frozen.

A signal benefit of utilizing 35mm film is that it can be acquired in bulk rolls up to 100 feet long and loaded by the user into recyclable cassettes. This results in important cost savings. In order to do this, an inexpensive daylight bulk-film loader must be purchased to hold the big film roll and feed it into cassettes in total darkness. The cost of the bulk-film handling equipment is usually saved within the cost of two 100-foot-long rolls of black-and-white film, or of one bulk roll of color film. A 100-foot roll of film contains the equivalent of about seventeen individual 36-exposure cassettes. Operating a daylight bulk-film loader is easy. I have found that the last frame on an individual roll of film can be rescued by turning the lights out for the brief period starting when the leading edge of the bulk film has been taped onto the cassette's roller and the cassette has been closed until the cassette has been positioned for rolling the film into it, and the light-tight access door has been secured.

Compared to 4 x 5 film, 35mm film is very

inexpensive, its primary advantage. You can afford to bracket shots frequently and take numerous views, almost without restraint. Bulk-loaded film cuts the cost-per-frame of black-and-white film to a minuscule level, even including processing. Thirty-five-millimeter film also is relatively compact, enabling you to carry huge numbers of frames, in comparison to more bulky 4 x 5 film.

A bewildering array of film is available in the 35mm and 4 x 5 formats. The four most useful types are fine-grained, panchromatic black-and-white, infrared black-and-white, color positive, and color negative films.

Panchromatic black-and-white film. A panchromatic film is so called because it is sensitive to all colors—a word constructed from the Greek derivatives "pan," meaning all, and "chrom," referring to colors. This distinguishes such films from infrared film, which is sensitive to the nonvisible radiation beyond red in the color spectrum.

A film is either fast or slow, depending on how much light is needed to expose it normally. A fast film takes relatively less light. A slow black-and-white film would have an ASA number of less than 100; a fast film of more than about 300.

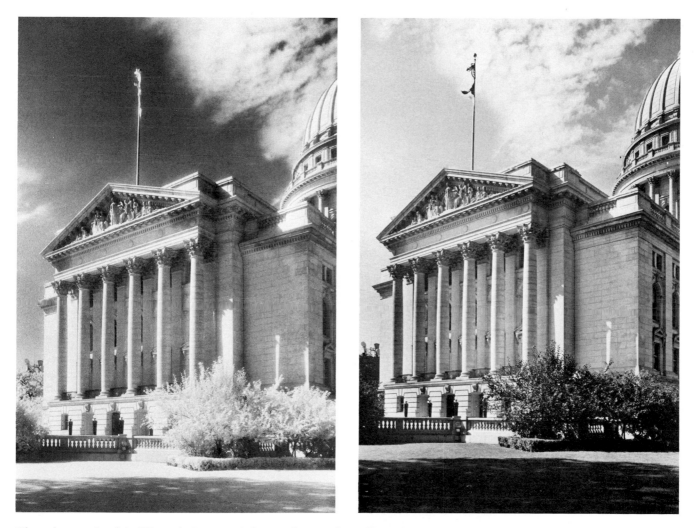

These photographs of the Wisconsin State Capitol were taken on Plus-X film with a green filter and on High-Speed Infrared film with a red filter. Foliage and shadows are lightened, and the sky is darkened substantially, in the infrared view. The infrared effect is lessened in views without a lot of foliage, but the tonal balance of this photograph is changed markedly from being rather bottom-heavy, with panchromatic film, to a more balanced scene with the infrared.

All things being equal, wouldn't the architectural photographer simply use the fastest film on the market? Perhaps, but all things are decidedly not equal. The faster a film is, the less sharp are the resulting images. This is because larger silver particles are embedded in faster films to capture light more quickly, and these particles, or grains, become readily visible in high-speed films. The grainier a film is, the less resolution or sharpness is possible. Sports photographers, who desperately need fast films of ASA 400 or even higher speeds, can accept the resulting graininess. Indeed, they even push their films' speeds higher by intentionally underexposing and then increasing development times. Films, however, can only take so much of this abuse before graininess and contrast increase to unacceptable levels.

Architectural photographers nearly always prefer sharpness to high film speeds, and thus use slower films. Using very slow films, of ASA 32, for example, can produce extremely sharp photographs. Enlargements from such 35mm frames do not equal the crispness of a 4 x 5 image, however.

Kodak's Panatomic-X film, at ASA 32, is the slowest, sharpest 35mm black-and-white film generally available. Ilford's Pan F, at ASA 50, has similar characteristics but is less common. A photographer willing to use a tripod liberally should use Panatomic-X film in his SLR to take maximum advantage of its fine grain. Because of its slow speed, it can be used with a hand-held camera only in bright sunlight or light overcast.

Kodak's Plus-X film, at ASA 125, is almost four

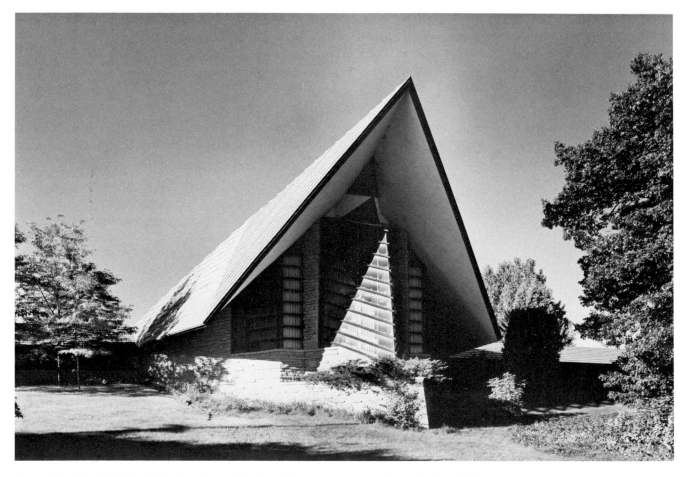

Frank Lloyd Wright's First Unitarian Society Meeting House, taken on panchromatic Plus-X film with a green filter. This is a perfectly acceptable black-and-white photograph of this famous building. (Nikon with 35mm f/2.8 PC-Nikkor and no. 58 filter.)

times faster than Panatomic-X and is an excellent general-purpose film for architectural subjects. To quote Kodak, it offers "the optimum combination of fast speed, extremely fine grain, and excellent picture sharpness even at high degrees of enlargement." In short, it is a good compromise film. Similar films by other manufacturers are Agfapan 100 and Ilford FP4. Where enlargements of sizes larger than about eleven inches by fourteen inches are not anticipated, Plus-X is a good film for architectural photographers.

Kodak's Tri-X film, at ASA 400, is a high-speed film that is moderately grainy. Similar films include Agfapan 400 and Ilford HP5. Because enlargements from Tri-X 35mm negatives are decidedly grainy, this film has limited utility to architectural photographers. It is for low-light, candid photos of buildings in use and for special effects. It is also useful in twilight and night photography.

Medium-format SLRs using 120 and 220 film, of course, are less troubled by grain size in films, because of their larger images. Inasmuch as they tend to have slower lenses than their 35mm counterparts, a faster film, such as Tri-X, is more useful. Other than this, it still pays to use the slowest, finest-grain film possible to enhance enlargements.

Kodak High-Speed Infrared film. Kodak High-Speed Infrared film is the only infrared, black-and-white film still available in the 35mm format, and at that it can be obtained only in 20-exposure rolls. Infrared is an unusual film, and it has quite

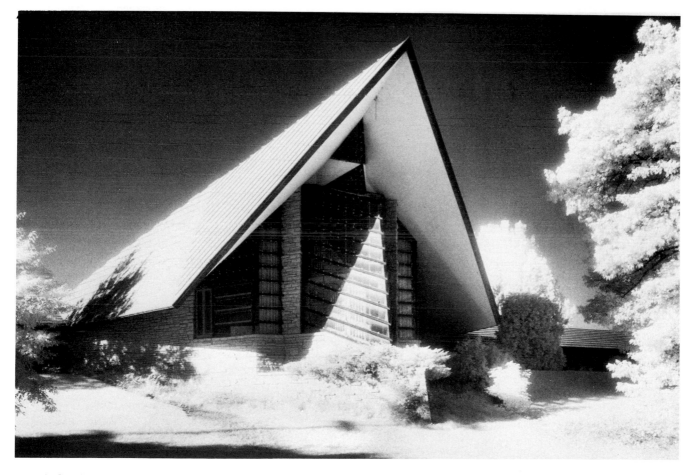

Here is the First Unitarian Society Meeting House, taken on Kodak High-Speed Infrared film with a red filter. Notice the reflection of infrared radiation in the deep eaves, lightening them considerably, and the rendition of grass and foliage. (Nikon with 35mm f/2.8 PC-Nikkor and no. 25 filter.)

different results from normal panchromatic film, such as Plus-X or Panatomic-X. Its peculiar qualities are of special interest to architectural photographers, who should try the film out if they have not yet experimented with it.

Infrared film is sensitive to invisible radiation beyond the red end of the color spectrum. It is also sensitive to visible radiation—reds, blues, and greens. For normal use, most or all of the visible spectrum is filtered out through the use of a red, deep-red, or visibly opaque infrared photographic filter. A photograph taken on infrared film without any filter varies only minimally from one taken on panchromatic film. Use of the correct filter unlocks the film's dramatic and sometimes unpredictable qualities. Typically, skies, lakes, and rivers turn almost black; and foliage, unless in shadow, becomes white. Visible haze can evaporate to such an extent that there is incredible clarity at the horizon. If an infrared picture were taken from the top of Chicago's Sears Tower, on a reasonably clear day, the only thing that would stop you from counting the bricks in a building many miles away would be the the quality of the lens and the resolution of the film.

It is the sharpness and the drama of pictures taken with this film that make it an exceptional architectural photography medium. On the other hand, the film has its drawbacks in handling and focusing. It is so sensitive to infrared radiation that it must be handled in total darkness. That is, the film can cannot be opened to remove the cassette except in total darkness. The camera must be loaded in total darkness, and then kept in darkness or subdued light as much as possible until it is unloaded. The chances are that if you handle this film properly, you will never know what the cassette even looks like. The film is shipped from Kodak to dealers packed in dry ice, and it must be stored in refrigerators or freezers until time to load the camera. Once the camera is loaded, the roll should be exposed as quickly as possible and the film processed rapidly. If you take the film to a commercial processor, remind him that it is infrared film and that he should not open the film can except in total darkness. If the film cannot be processed right away, store it in a vapor-tight bag with some silica gel in it, and refrigerate the bag until you can process the film. In short, handling the film can be a lot of hassle, and if you do not like the results the film gives you, you probably will not put up with it.

Infrared radiation focuses differently from visible radiation. Most SLR lenses have a red mark somewhere on the focusing scale on the lens barrel that is for infrared film use. For most architectural photographs, you must simply set infinity on the rotating focusing ring across from the red mark, and then remember to keep your hands off the focusing ring. For close-in photos, you focus the camera normally, but then set the indicated distance over to the infrared mark before exposure. It is an additional step that is easy to forget.

While infrared film does have a nominal ASA rating, it should be used sparingly. In full sunlight you can normally use f/11 or f/16 at 1/125 second for medium-to-distant scenes, but it is worthwhile to bracket exposures. If in doubt, try a hand-held exposure meter (do not use a through-the-lens meter) set at ASA 50 if you are using a red (A) filter, or ASA 10 if you are using an opaque infrared (87C) filter. Because of the unusual characteristics of scatter in infrared radiation. Kodak recommends that you use as small an aperture as possible to retain maximum sharpness.

You must really experiment with infrared film to understand its peculiarities. For example, grass lawns are highly reflective of infrared radiation when they are green, so you must be careful of having too much sunlit lawn in a view. Lawns can reflect infrared, unlike visible radiation, into shadow areas, almost as though the lawn were a mirror, illuminating under-eaves areas.

Kodak's High-Speed Infrared film is grainier than Plus-X film by quite a bit. There used to be a finer-grained, easier-to-handle Kodak infrared film on the market, but it is no longer available. Therefore, photographers who require extremely fine resolution in infrared pictures will have to use a 4 x 5 camera to reduce the grain in the image. Infrared films are not available in medium-format sizes. Thirty-five-millimeter infrared pictures are adequate, however, when occasional special effects are desired or when a photographer is trying the medium out experimentally.

And I do recommend that architectural photographers experiment a little bit and shoot several rolls of this fascinating film. An exciting, other-worldly feeling is created, as buildings stand out crisply and starkly on a planet seemingly devoid of atmosphere. Unexpected things not apparent to the naked eye happen, as unseen dimensions in familiar scenes are revealed. Try it; you might like it.

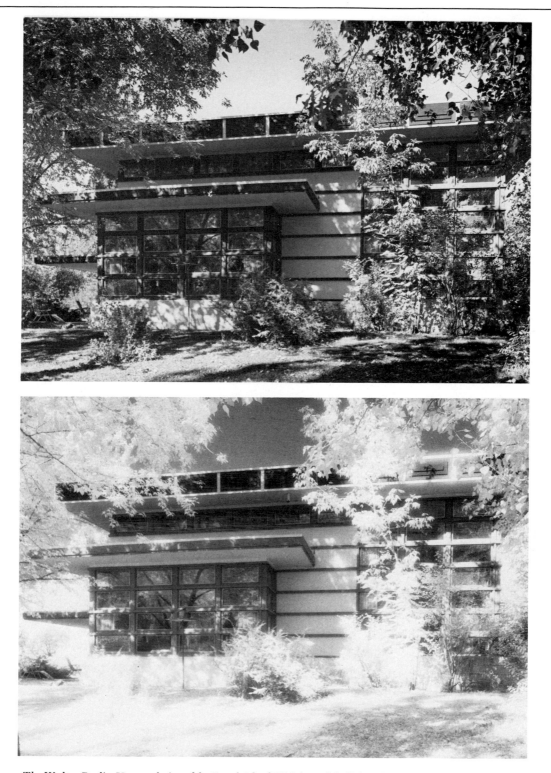

The Walter Rudin House, designed by Frank Lloyd Wright and built in 1958, is shown here both in infrared and panchromatic photographs. The infrared picture seems to make the outline and windows of the building clearer, perhaps because the leaves and woodwork take contrasting tones. Infrared radiation reflected by the lawn illuminates more clearly the area under the eaves.

Color-slide films. As is the case with black-and-white films, color films come in slow and fast types, and sharpness decreases with increasing speed. Other problems occur in using color films, because you must pay attention to the quality and color of light illuminating a scene—concerns you can blissfully ignore when using black-and-white films. Accordingly, color films are normally available for daylight use, for 3,400-degree Kelvin photoflood use (Type A), and for 3,200-degree Kelvin incandescent existing-light use (Type B). The temperature notations in degrees Kelvin (°K) refer to a color-temperature scale by which the color of light is measured. Daylight's color temperature is about 5,500°K to 6,000°K, and lesser numbers indicate redder light. Films and lighting are graded in these terms and must be balanced to each other.

Probably the worldwide standard for high-quality color-slide films are Kodak's various Kodachromes, given designations now that equal their respective ASA film speeds. Kodachrome 25 has an ASA speed of 25 in daylight; Kodachrome 64 is ASA 64 in daylight; and Kodachrome 40 is ASA 40 under Type A photoflood lamps. These films are noted for sharpness and rich colors.

Kodak's Ektachrome films are not as sharp or fine-grained as the Kodachromes, but come in higher speeds: ASA 64, 200, and 400 daylight; and ASA 160 Type B. Moreover, Ektachrome films may be processed by local photo processors or sophisticated amateurs, but Kodachrome films must be processed for best results by Kodak itself.

Because architectural photographers are primarily concerned with sharpness, Kodachromes 25 and 64 are best for their purposes, unless the rapid-processing potential of Ektachrome is needed in a special case. On occasion, too, a high-speed film like Ektachrome 400 is very useful for interior or night photography.

The decision as to which color-slide film to use is more subjective and dependent on local availability and personal taste than is the decision about black-and-white film, because each brand and speed of film has its own personality due to slight variations in color reproduction and in sharpness. Other manufacturers offer their own versions of color-slide films. Agfachrome comes in ASA 64 and 100; Fujichrome has an ASA 100 film; and 3M has films in ASA 100 and 400.

Color films for one type of light source can be color-balanced for another kind of light, through the use of filters. Daylight film can be balanced for 3,400°K photofloods with an 80B (blue) filter, which makes the yellowish incandescent light bluer, to resemble daylight. Similarly, daylight film can be balanced for 3,200°K tungsten light with an 80A filter. If this is not done, pictures taken on daylight film with these kinds of lights will result in decidedly orange images. Other filters, the warm-colored numbers 85 and 85B, correct for Type A and Type B films, respectively, when used in daylight conditions.

The final image on a color-slide film, of course, is positive—the opposite of the negative resulting from the normal processing of black-and-white film. During the processing of such slide films, the image is reversed through a special procedure; thus the film is called by some "reversal" film. This positive image has special attributes to the architectural photographer using 35mm equipment: it can be projected before audiences or classes on slide projectors. The slide itself has become ubiquitous and is unequalled as an instrument for public education, for explaining past projects to potential clients, for instruction in architectural history, and for a plethora of other uses. This projection, unfortunately, is also the slide's denouement, for the color dyes eventually shift and fade. The more it is projected, the sooner the slide is ruined. Even if it is never projected but is stored at room temperature, it will be lost eventually as a usable image. The slide, therefore, is not considered an archivally stable medium (nor, for that matter, is *any* color photo image, whether positive or negative). While it can be preserved for long periods under strict conditions of low temperature and controlled humidity, such preservation measures are generally impractical.

Because of a slide's relatively short life span and the injurious nature of slide projection, some photographers make duplicates of their slides for projection purposes. Duplicates can be made on yet another Kodak color reversal film, Ektachrome Slide Duplicating Film 5071, which is balanced for 3,200°K lighting but can be used with filters in other light. Another option—one I use regularly—is to take numerous exposures of views thought to be important. This is the cheapest method and also produces the best possible results. One slide can then be projected while another can be stored safely for maximum life. Slide-duplicating film can be used in any 35mm SLR camera with a slide-duplicating attachment to produce copies of slides. While results do not equal the original in

quality or color, employing duplicates whenever possible saves original slides.

Color negative film. Color negative film is used when you wish to produce color prints for displays, portfolios, or client-contact books. It is relatively expensive to use, compared both to slide film and black-and-white film. Having prints in some circumstances is helpful, because it avoids the complexities of projection equipment and darkened rooms, and a large color print can be very impressive indeed. Photographers interested in having their color pictures published, however, should stick with reversal films, as printers prefer transparencies, the results are superior, and nearly all magazines reject color prints.

Kodak produces two color-negative films in the 35mm format: Kodacolor II at ASA 100, and Kodacolor 400 at ASA 400, both daylight-balanced films. Also on the market are ASA 100 and 400 films from Fujicolor; 3M Brand Color Print films at ASA 100 and 400; and Agfacolor CNS-2 at ASA 80. All these are daylight films that must be balanced, just like slide films, for other types of light.

There are special-purpose films on the market, both in color and black-and-white, that an architectural photographer might wish to experiment with. These include color infrared, recording, and high-contrast copy. Use of these films for architectural purposes is so limited, however, that they fall outside the scope of this book. Kodak's excellent technical booklets can be consulted about these films.

Over the years, I have found that photographing buildings with both color-slide film and black-and-white film is very useful. The former can be for presentation and occasionally for magazine sales. The latter is needed for displays, permanent records, and official purposes—such as nominating buildings to the National Register of Historic Places. Thus, I always carry at least two 35mm camera bodies on an assignment: one for slides, and one for black-and-white. Occasionally I need a third or even a fourth—for infrared, color negative, or high-speed black-and-white films. In the 35mm medium, this can become quite cumbersome, especially when using a tripod, as you are seemingly forever juggling cameras around and changing lenses, unless you have as many identical lenses as you have camera bodies. This means, of course, that the architectural photographer really should have two of each of his most commonly used lenses, usually his 35mm shift lenses. When I managed to

acquire a second 35mm PC-Nikkor, I found my camera-juggling days were minimized and streamlined.

Medium-format films

Roll film in 120 and 220 sizes for such cameras as the Pentax 6 x 7, Bronica ETR, Hasselbad, and Mamiya RB67 is available in many fewer types than 35mm film. It can be obtained in basic black-and-white, color reversal, and color negative forms, and that is about it.

Film in the 120 size is paper-backed and can produce ten exposures in the 6 x 7 format or twelve frames in 6 x 6. The rare 220 film is only available in Plus-X Pan Professional film, as of this writing; it is not paper-backed and can take twice as many exposures per roll as 120 film.

The following Kodak black-and-white films can be obtained in 120 film: Panatomic-X Professional, Verichrome Pan (ASA 125), Plus-X Pan Professional, Tri-X, and the super-speed Royal-X Pan at ASA 1250. Ektachrome daylight films can be obtained in ASA speeds of 50, 64, 200, and 400; and Type B film is only available in ASA 160. Kodacolor is available in two 120 speeds: ASA 100 and 400. There is no infrared film available in this format.

Medium-format films from manufacturers other than Kodak are scarce. Agfa has black-and-white films in three speeds—ASA 25, 100, and 400—and has one color film, ASA 64. Ilford sells an ASA 50 film, Pan F, in 120 black-and-white, but offers no color film. Fuji and 3M have no offerings at all.

Some medium-format cameras have interchangeable film backs, so you need to have one camera-and-lens combination. By using two or more film backs, you can change films to get both black-and-white and color photos readily. The Pentax 6 x 7 SLR, which uses the lovely 75mm Pentax-Shift lens, does not have interchangeable film backs. To expose more than one film at a time in this system, you need two or more camera bodies.

Large-format films

Nearly all the Kodak films (except Kodachromes and Panatomic-X) available in the 35mm format are also made in 4 x 5 sheet films, and there are more types, as well. Because of the relatively immense film size, large-format cameras can accept grainier films and still produce sharp images. Thus, the ultra-high-speed Kodak Royal-X Pan film, with an ASA speed of 1250—more than three times faster

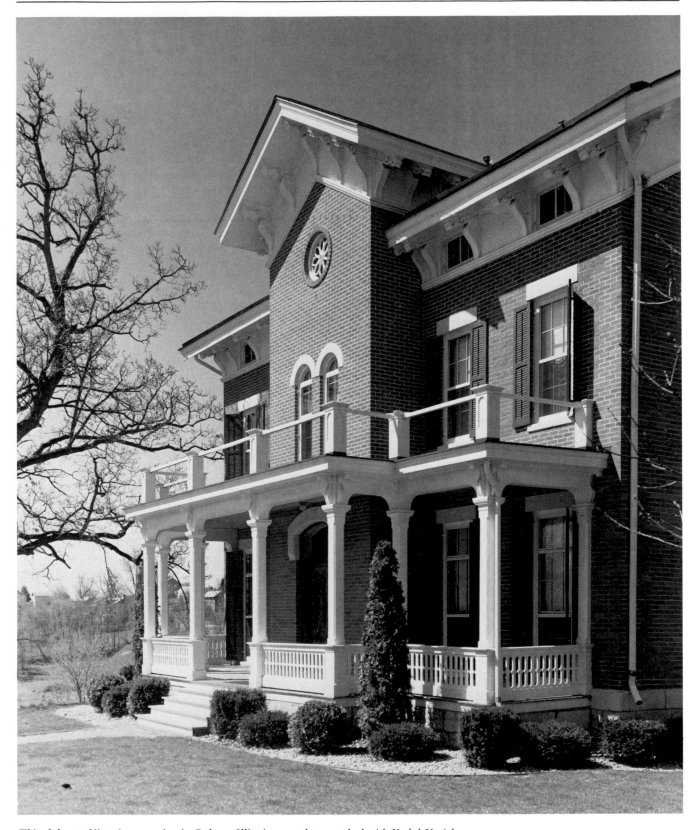

This elaborate Victorian mansion in Galena, Illinois, was photographed with Kodak Verichrome panchromatic-type 120 film. In a Pentax 6 x 7 camera, this film produces an image size of about 2¼ x 2¾ inches, or 6 by 7 centimeters, which produces sharper images than are possible from 35mm negatives.

than Tri-X—helps ameliorate the problem of slow lenses in 4 x 5 photography.

Seeing the results of your first 4 x 5 color transparencies is inspiring. If you are used to 35mm slides or even 2¼-inch transparencies, holding up that first gigantic, crisp, color-saturated 4 x 5 is an unforgettable experience. You can easily count the bricks in a large brick building or the cobblestones in a house. You can become addicted to 4 x 5 color transparencies, which is both good and bad, the latter because of the high cost per frame in comparison to 35mm slides.

Sheet or cut film is handled differently from roll films. It arrives from the factory packed in vapor-sealed bags within boxes, so it can be stored frozen, just as roll film can. Ektachrome comes in 10-sheet boxes, and black-and-white films come in 25- and 100-sheet boxes. A box of film must be opened in total darkness only, such as in a darkroom or a closet with the light leaks stuffed shut. Each sheet is removed from the box and loaded into one side of a two-sheet film holder, and the dark slide is inserted into the holder over the film to keep light out. If you hold a film holder vertically so that the film-entry gate is facing you, hold the film so that the identification notches are on the right side of the top edge and slide it downward under the flanges into the holder. You then insert the dark slide with the little raised bumps facing outward, as the white side of the dark slide's handle will then also be facing outward. After an exposure is made, the dark slide is reversed so that the bumps face inward and the black side of the handle faces outward. That way, you know that the film beneath the dark slide has been exposed and needs to be developed.

Whereas dirt and dust are rarely problems with roll films, they are nagging problems with 4 x 5 film holders and films, as noted in chapter 5. Every effort should be made to load film in a dust-free area, to keep film holders clean, and to keep fingers off negative or transparency surfaces. Always handle sheet film by its edges.

Kodak offers about a dozen black-and-white sheet films and a half-dozen positive and negative color sheet films. Sheet films are also sold by Agfa, Fuji, and Ilford, but these would be relatively hard to find.

Storing films prior to exposure. Protecting film from heat damage is the most common problem an architectural photographer faces in storing it. Frequently architectural photographs are taken in sunny and warm weather. On such days, film must be protected from the heat. Even so, black-and-white panchromatic films can take quite a bit of abuse. Color is more sensitive to heat damage, and infrared film is very sensitive.

Factory-loaded film can be safely stored in a freezer until shortly before it is to be used. For all practical purposes, freezer-storage protects film indefinitely from deterioration, though you should remember to begin thawing a 35mm film roll about 90 to 120 minutes prior to loading it in a camera. A major benefit to using factory-loaded films is that they are packed in water-vapor-tight containers. Thus, the process of freezing and thawing the film will not damage it through condensation. It is important *not* to open vapor-tight packaging until the film is to be loaded, by which time it should have been brought to the same approximate temperature as the ambient air and the camera. Factory-loaded film boxes are stamped with expiration dates before which the film should be used. If the film is stored in a frozen state, however, I have found that the expiration dates can be extended.

Storing the film while carrying it with you during hot weather presents different problems, as most cars are not equipped with freezers or refrigerators. Obviously, film should never be left in closed cars or trunks, lying anywhere in the sun, or in any other place subject to heat. I know one architectural photographer who carries with him during the summer an ordinary cooler in which he carries his film, camera, lenses, and a little ice. One should be careful not to keep equipment *too* cool, however, to avoid condensation on the camera and film when you remove it from the cooler. You may wish to keep Coke at 40 degrees in such a cooler, but not your camera and film, unless it is for prolonged storage during a long drive. Keep film in separate coolers from beverages and at a higher interior temperature. I do carry film in a sealed plastic bag thrown into a beverage cooler, but only if I do not need it any time soon.

User-loaded film cassettes cannot be frozen or chilled with as much abandon as factory-loaded film, because the humidity within the cassette container is likely to be too high. I have had no difficulty refrigerating self-loaded film, though I take the added precaution of placing it first in a sealed plastic bag containing silica gel before placing it in the

refrigerator. If you can load film and then place it into film cans that are moisture-proof, and do so in a low-humidity environment, you can refrigerate film and perhaps even freeze it after it is loaded. In northern climates where houses get dry during the heating season, it makes sense to hand-load much film in the dead of winter and then store it for use during the year.

After exposure, of course, the vapor barrier of the film can has been broken, so film cannot be frozen while it awaits processing. It is best simply to keep it at room temperature, protecting it from excessive heat, and then have it processed as soon as possible.

If rapid processing is not available, seal it in as low a humidity environment as possible, but not below 25 percent relative humidity, and then refrigerate—but do not freeze—it.

After processing, I store black-and-white negatives at room temperature, and I do the same with slides and transparencies. However, there are certain refrigerators on the market that can produce cool, low-humidity environments. These were reviewed in a fascinating article, "Storing color materials: frost-free refrigerators offer a low-cost solution," published in the October 1979 issue of *Industrial Photography.*

7 Sun and Sky

Forms, volumes, and details are revealed in relation to the direction and intensity of light falling upon them. Exteriors . . . are subject to varying intensities and directions of daylight, and there are always certain times of day and certain conditions of light that are most favorable and logical for any given problem. The photographer should . . . proceed accordingly. Since he cannot move the sun, he must wait or adjust his point of view for the best effects.
—*Ansel Adams, 1963*

On a black-and-white photograph, all the tonal values of nature from white through the intermediate gray tones to black can be captured by selecting the proper filter to obtain maximum pictorial effects and technical correctness.
—*Julius Schulman, 1977*

THE sun shone brilliantly on that crisp, autumn day as Jill and I loaded the view camera and 35mm system into our small car and drove west. We had been waiting for weeks for that rare day: a clear, sunny sky in autumn when deciduous trees were at their peak of color. We were on our way to Prairie du Chien, about two hours away, to photograph historic Villa Louis for an upcoming article that called for an autumn scene.

Villa Louis, an imposing nineteenth-century mansion, faces due east, which means you have to get there in the morning to have a sunlit facade. We had left very early that morning, on the wings of a perfect weather forecast; you don't want to waste four hours in driving. Everything was absolutely correct for getting precisely the picture we needed.

As we drove, we had the radio on quietly in the background. A revised weather forecast was broadcast; clouds were moving in from Iowa toward southwestern Wisconsin. By noon, Prairie du Chien would be blanketed in solid overcast! Rats! The leisurely, pleasant drive had suddenly become a race, in complete violation of the national speed limit. As we approached our destination, we could see the sharp, solid line of clouds moving east toward us. I swerved through the streets of Prairie du Chien. As we arrived, the sky had broken clouds. Without time to study the subject carefully or ponder photographic options, I set up the view camera to get a straight-on view up a lovely, brick sidewalk of the main facade of the High Victorian Italianate mansion. Minutes after I tripped the shutter, the sky had become solid overcast. Had the race been won? The chance to study angles and possible vantage points had not been available. Fortunately, the resulting picture was adequate and was eventually published with the intended article. But the careful viewer can detect a slight tilt in the scene that resulted from my haste. Being concerned at the time, I had taken back-up pictures with my 35mm SLR to avert disaster, but these weren't needed.

The moral of this story is that the sun is the most important "tool" of an architectural photographer. An unavoidable corollary is that the weather forecaster (I call them "foreguessers") is one of his most important consultants. Sometimes I am reminded of my days as a student pilot, as I hang on every word of local forecasters, balancing their predictions with my own glances out the westward window.

65

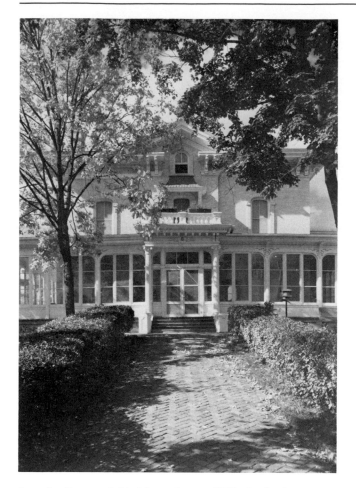

Just after I snapped this 35mm picture of Villa Louis, the overcast settled in. We barely won our race with the weather.

Weather forecasting is so important to architectural photographers that they should be aware of the nationwide string of weather-broadcasting stations that has been built by the National Weather Service. These operate on VHF frequencies 162.55, 162.475, and 162.40 MHz, and can be received by special crystal-controlled weather radios now produced by several manufacturers. A high-quality, pocketable weather receiver is now a mandatory item of equipment in my camera bag. The best and most up-to-date forecasts are available through these stations, which broadcast twenty-four hours a day. They also broadcast hourly radar summaries, which tell you precisely where precipitation is, in the vicinity of the transmitter.

The sun is in different positions at different times during the day, and its elevation above the horizon varies with the time of day and the date. These may be truisms, but a surprising number of people who photograph buildings act as though they are unaware of these seemingly obvious facts. They manage to capture back-lit buildings or buildings cast in deep shadow by summer's noon-time sun.

The position of the sun during the day and the year is of such importance that it warrants a brief discussion of solar phenomena. The earth orbits the sun once a year, and it spins on its axis, which is tipped from the plane of its orbit. Thus, to residents of the northern hemisphere, it seems as though the sun moves north in daily stages until the summer solstice, usually June 21, when it is "highest" in the sky at solar noon and the day is the longest. Then it moves south again until about December 21, the winter solstice, when it is at its lowest point in the sky and the day is the shortest of the year. In between each solstice are the spring and autumn equinoxes, generally March 21 and September 21, when day and night are each twelve hours long. Of course the sun is not moving up and down annually; the earth is simply revolving around it on its tipped axis, giving the illusion of solar motion.

Because of our tipsy earth, the architectural photographer's working day and conditions vary throughout the year. The sun rises well north of east in June, and sets well north of west. In December, it rises and sets well south of east and west, respectively. At noon on June 21 at Key West, Florida, the sun stands at 88½ degrees above the southern horizon—almost straight up—causing problems for photographers trying to avoid shadows. At noon on December 21 at Seattle, Washington, the sun is only 19 degrees above the southern horizon, providing very limiting photographic conditions.

The chart on page 68 shows the angles above the horizon that the noon sun reaches throughout the continental United States at the equinoxes and the solstices. It also shows the direction in which the sun both rises and sets at these times. (In the latter chart, 90 degrees is due east, 180 degrees is due south, 270 degrees is due west, and 360 degrees is due north.) This information is not in the least merely academic to the architectural photographer. For example, if you wish to photograph the facade of a Denver building that faces 20 degrees, you know you cannot do it with direct sunlight in December, because the sun rises at about 120 degrees, or more than 90 degrees off the plane of the facade. Even a building facing northeast (45 degrees) would be hard to

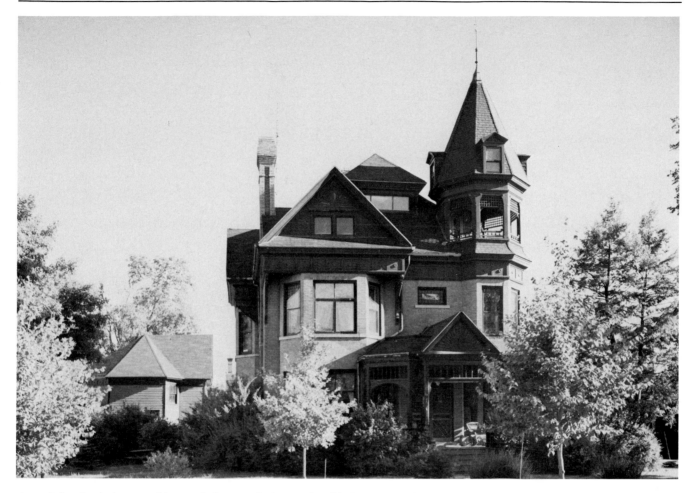

A north facade can be an architectural photographer's nemesis. This Queen Anne house faces due north, requiring a very-late-afternoon exposure—in this case, an afternoon in June—to get a usable image. Even so, the result is not entirely satisfactory. Behind the house, to the left, is an octagonal carriage house.

manage there at that time because of the angle of the rising sun. By the time it would get high enough for photography, it would have intersected the plane of the wall; and it does not even reach a noon elevation of 30 degrees.

These are extreme examples that serve to illustrate my main point. The serious architectural photographer must be at least aware of the location of the sun at different times during the year and the day. He must know where it will be, above the horizon, and with respect to the cardinal points of the compass.

If this were not enough trouble, half the year, in most places, solar noon actually occurs at 1:00 P.M., a by-product of daylight savings time. This oft-forgotten fact has ruined my best-laid plans more than once, and meant that I had to wait around for

another hour for the sun to move to where I had thought it would be when I planned the trip.

When you are preparing to photograph a building, especially if travel is involved to get to it, you simply have to plan ahead. If you do not know which way the main facade faces, you had better find out in advance or you may waste an entire trip by coming to an east-facing facade at, say, 2:00 P.M. If you do not already know which way the building faces, you can at least check maps to see whether they will help make an estimate. United States Geological Survey (USGS) maps show the location of buildings and, therefore, their relationship to nearby roads, which frequently give a clue as to the direction the main facade may face. City maps show the directions the buildings face along streets if you know the address and which way the odd-numbered

Table 2
Sun Angle Above the Horizon and Headings to Rising and Setting Sun
Throughout the United States at Equinoxes and Solstices

Latitude	Cities at this Latitude	Angle of Noon Sun Above Horizon:			Direction Sun Rises:			Direction Sun Sets:		
		6/21	3 & 9/21	12/21	6/21	3 & 9/21	12/21	6/21	3 & 9/21	12/21
47½°	Seattle, WA Bemidji, MN Madawaska, ME	66°	42½°	19°	53°	90°	127°	307°	270°	233°
45°	Salem, OR Minneapolis, MN Old Town, ME	68½	45	21½	55	90	125	305	270	235
42½°	Detroit, MI Boston, MA Dubuque, IA	71	47½	24	57	90	123	303	270	237
40°	Denver, CO Indianapolis, IN Philadelphia, PA	73½	50	26½	58	90	122	302	270	238
37½°	Witchita, KS Richmond, VA San Francisco, CA	76	52½	29	59	90	121	301	270	239
35°	Albuquerque, NM Memphis, TN Fayetteville, NC	78½	55	31½	60	90	120	300	270	240
32½°	San Diego, CA Montgomery, AL Fort Worth, TX	81	57½	34	61	90	119	299	270	241
30°	New Orleans, LA St. Augustine, FL	83½	60	36½	62	90	118	298	270	242
27½°	Sarasota, FL Corpus Christi, TX	86	62½	39	63	90	117	297	270	243
25°	Key West, FL	88½	65	41½	64	90	116	296	270	244

and even-numbered buildings face in that city.

Because of the importance directions play in architectural photography, another essential item to carry is a magnetic compass. When I visit a building, I frequently note the direction it faces for future reference. Moreover, on architectural survey forms we have prepared at the State Historical Society of Wisconsin, we have a space for surveyors to note orientation of main facades to facilitate planning follow-up visits.

An excellent technique some photographers use is to make for future reference a quick, simple sketch map of the building they are photographing. On this can be noted other nearby buildings, trees, views photographed, and any other things in the subject's environment that may be important to recall before planning future visits. It is also valuable to note, on-site, the time of day you estimate it would be best to rephotograph the building, so you do not have to compute that again later without the benefit of standing in front of the building as you do so.

The series of photographs on page 69 demonstrates the effect of the sun's position on the facade of an east-facing building during a single spring day. With the sun behind the photographer, the facade seems flat and lifeless, with minimal shadows. Absence of side light means the facade is not sculpted and defined by light. As the sun moves

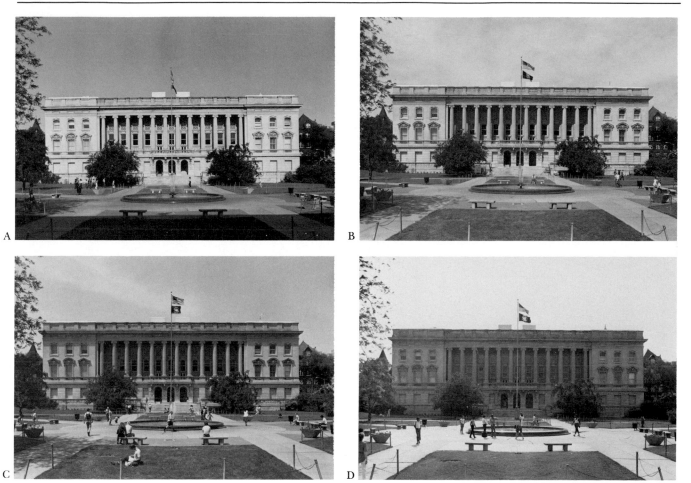

This series of photographs illustrates the way the sun's direction relative to a facade changes throughout the day. In View A, this eastward-facing building is illuminated by an early morning sun; in View B, it is mid-morning; in C, it is almost noon; and in D, the facade is backlit by an afternoon sun. The facade shows the most life in B and C. The building is the State Historical Society of Wisconsin, 1895–1900, Ferry and Clas, architects.

southward, the facade comes to life. Deep shadows are cast by about 11:00 A.M., as the sun rakes across the walls. Finally, the facade is back-lit at about 3:00 P.M., producing an unacceptable image and the possibility of lens flares. It would be better to photograph the building under overcast than when it is back-lit.

A photographer needs to be concerned with more than just the direction of the sun, though that is of primary importance. The qualities of the sunlight and the sky are dramatically affected by atmospheric conditions. For example, in the summer, a humidity haze can settle in for days. It will diffuse the sun and substantially reduce the effects filters will have in darkening sky tones. Good news to the architectural

photographer at this time of year is his weather radio announcement that a cold front is moving in and will clear things out. After the front has passed, you generally have clear skies, bright sunlight, and favorable temperature conditions that will overheat neither the film stored in cars nor the photographers exposing it.

While sunlight is normally needed to produce results preferred for an assignment, absence thereof can sometimes be advantageous for producing photographs with emotional, moody appeal. This is more true with color film, as colors take on a different feel in overcast, even rainy, weather. Interiors can be shot successfully on overcast days with good results, as they avoid sun flooding in

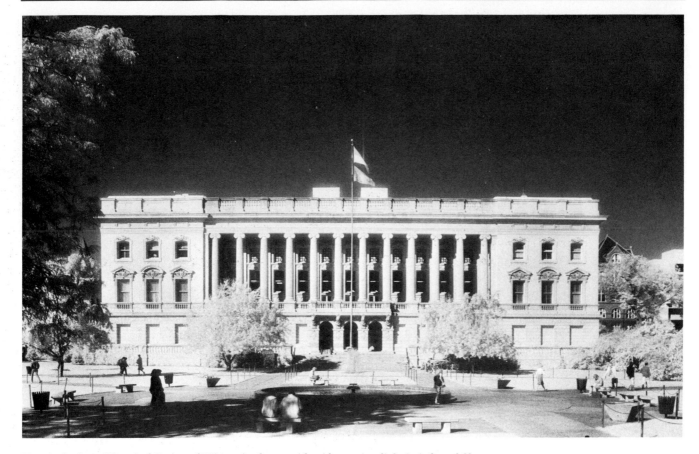

Here is the State Historical Society of Wisconsin shown with mid-morning light in infrared film. The building now stands out against a black sky, characteristic of infrared film on a clear day when a red filter is used.

through windows to produce unwanted glare. Except for unusual circumstances, however, a lengthy trip to photograph a specific building or area is ruined by prolonged overcast or rain. About all that can be done, if you can wait for good weather, is to complete interior photography, try some mood-generating color photographs, plan your shots for the time the sun does arrive, and then—patiently—wait.

Filters for Black-and-White Film

The most common purpose for which colored filters are used with black-and-white films is to darken a blue sky (by using a filter of a color opposite blue on the color wheel). For this purpose, the least darkening of the sky's whitish-gray tone in a final print is achieved with a yellow (K1) filter. Increasing darkness is obtained by moving to a dark yellow (K2) filter, an orange (O) filter, and finally a red (A) filter. A black sky can be obtained by combining infrared film with a red (A) filter or, especially, a visibly opaque infrared (87C) filter. A green (X1) filter achieves about the same darkening of the sky as a yellow filter, while simultaneously slightly lightening the gray tones of green foliage, and is an excellent choice to consider.

The effects of filters are broader than just being used in relation to sky tones. As a green filter lightens foliage, so does any filter lighten the tone of any color that is similar to it, while darkening any color opposite it on the color wheel. Thus, a red filter will wash out red bricks to white or make signs with red letters illegible. These effects— similar colors lightened, opposite colors darkened—can be used by the photographer to obtain whatever results are desired, depending on the colors of an individual scene. Presumably, for example, a blue filter should be used to darken the orange sky when photographing buildings on the

planet Mars, except that then the blue field on a U.S. flag mounted on a spacecraft would vanish in whiteness, obviously a difficult problem.

The amount of darkening one prefers in a sky is subject to personal tastes. I generally use a yellow or green filter; I especially like the green because, with an orange or red filter and panchromatic film, foliage can become oppressively blackish. A summer haze reduces the effects of filters considerably, and on such occasions I have been driven to using a red filter to get any sky tone at all, being careful about red objects that appear in the scene.

Some photographers prefer to use no filter at all with black-and-white films. They accomplish such darkening of the sky and other tonal adjustments as are desired in the darkroom. This is not really acceptable to most of us, however, as it requires darkroom work not all of us have the time to undertake, and it produces uneven, even crude, results.

Filters that have any appreciable effect on tones reduce the amount of light reaching the film and lens. Those using SLR cameras with through-the-lens light meters need not worry about this too much, as the light reaching the meter also is reduced, and exposure readings are automatically adjusted. When using hand-held, separate meters, as with large-format cameras, the photographer must make an adjustment to the reading in accordance with the "filter factor" of the filter in use. A factor of 2, for example, means that the effective ASA speed of the film is halved, or that the exposure should be increased one stop over that indicated on the meter, depending on which method is used. I find it easiest to reset the ASA speed setting on the meter to account for the filter factor. Every time the factor is doubled from that point, the exposure is increased one more stop. Thus a factor of 4 requires a two-stop increase, and a factor of 8 requires a

three-stop increase. A list of the common filters used with black-and-white film, their designations, colors, and filter factors, is given below.

These designations are used interchangeably. The numerical system is promulgated by Kodak and used throughout its publications. Since the alphabetical system is also in general use, many publications and filter manufacturers will indicate filter designations in both systems. Some filter manufacturers, such as Nikon, have their own, distinct filter designation systems, but can provide charts relating theirs to those above.

The filter factors in the table should be used with some caution, especially when photographing buildings that tend to be the same color as the filter in use. A red filter, for example, allows red light to pass through readily, so a red-brick building photographed through a red filter will be washed out and lack detail if a factor of 8 is used to determine exposure. Intentionally underexposing or using a lesser factor will enhance such a building's detail, while simultaneously darkening the sky further for more drama. Thus, it pays to bracket filtered exposures with underexposures, especially when the filter and the building being photographed are similarly colored.

The filter factors are also affected by the color of the light source. The factors shown in the filter listing are for sunlight. Warm-colored filters—yellow, orange, and red—require smaller factors when used indoors with tungsten or incandescent light because this lighting is warmer in color than the sun and passes through the filters more readily. Under such circumstances, the factor of a red (A) filter drops from 8 to 5, and that of a yellow (K2) filter decreases from 2 to 1.5.

Infrared photography requires the use of a red (A), deep red (F), or visibly opaque (87C) filter. This is because infrared film is sensitive to some blue and

Color	Designations	Factor	Exposure Increase
Light yellow	K1 (6)	1.5	⅔
Yellow	K2 (8)	2	1
Deep yellow	K3 (9)	2	1
Green-yellow	X1 (11)	4	2
Dark green-yellow	X2 (13)	5	2⅓
Deep yellow	G (15)	2.5	1⅓
Green	B (58)	6	2⅔
Deep green	N (61)	12	3⅔
Orange	O (56)	4	2
Red	A (25)	8	3
Deep red	F (29)	16	4

A

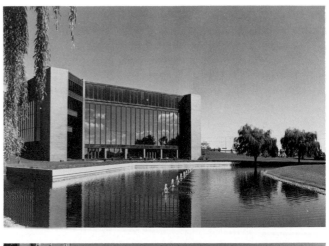

B

C

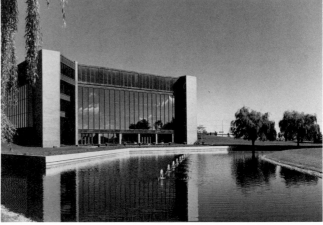

D

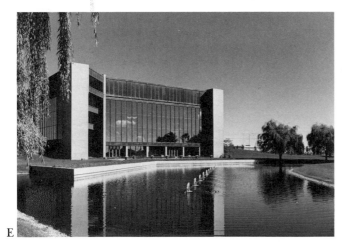

E

This series of pictures illustrates the effects of various colored filters with black-and-white film. The building illustrated has reddish-brown brick corner verticals, and a dark-brown metal cornice. View A shows the building with Plus-X film and no filter. View B was taken with a yellow (K1) filter, and the only real effect is a darkening of the sky. View C was taken with a green (X2) filter, and the grass and foliage is lightened slightly, compared to the view made with the yellow filter. View D was taken with an orange filter, and the sky is darkened more, while the brick tone is lightened; both effects are more striking in view E, taken with a red (A) filter.

green colors, and these must be screened out to obtain photographs illuminated only with red and infrared radiation, or exclusively with the latter. The purpose of a red filter is to admit some visible light rays—the reds—in addition to infrared, to enable the photographer to see an image through the

viewfinder of an SLR. To use the opaque 87C filter, the camera must be mounted on a tripod, focused (remembering the different focusing mark for infrared film), and the view composed, all before installing the filter on the lens. The filter factors in the table are for filters used with panchromatic films and do not apply to infrared film. The approximate factor of a red or deep-red filter used with infrared film is 1.6, much less than its factor with panchromatic film because of the peculiar sensitivity

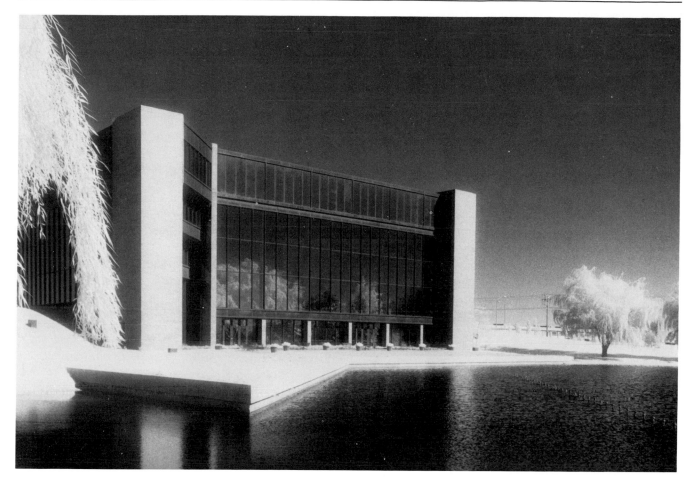

This view of the building pictured in the series on page 72 was taken with infrared film and a red filter: the sky is black, grass and foliage are white, and the bricks are very light.

curve of infrared film.

The series of photographs on page 72 demonstrates the effects on one scene of red, orange, green, yellow, and no filters with Plus-X film, and of a red filter with High Speed Infrared film. The effects of the various colored filters with Plus-X film are relatively subtle, compared to the infrared rendition.

Filters for Color Films

The darkening of blue sky tones when using color films can be achieved in one, or both, of two ways. Shifting a PC lens vertically will darken a sky's blue appreciably, due to light fall-off toward the edge of the lens's area of coverage. As you shift the lens, you move the film toward that edge, and anything there gets darkened somewhat. Normally, when shifting the lens upward, this darkened area is the sky.

The more common and well-known way to darken the sky is with a polarizing filter. Any polarized light can be controlled with a polarizing filter by rotating the filter so that its lines of polarization are in line with, or in opposition to, those of the light source. The sun's light is polarized. Studio lights *can* be polarized by covering them with their own polarizing filters. Such filters are very tricky to use, especially in determining the correct exposure. I routinely take an unpolarized photograph whenever I use the polarizing filter, to be certain I will have at least one correct exposure. I have also found that some polarizing filters will impart a color to the final transparency or print. If you are purchasing a polarizing filter, you should not buy the cheapest model around, but select a quality product by a reputable manufacturer. I have also found that you cannot always trust a meter reading taken through a

polarizing filter. You should double-check the reading in comparison to a reading taken without the filter in place, according to the instruction sheet's exposure factor for the filter, usually 2.5.

In addition to darkening the sky, a polarizing filter can be used to reduce and almost eliminate reflections of objects illuminated with polarized light. Moreover, a polarizing filter can increase the color saturation of people and objects in the scene. As with most things, a little experimentation with such filters is advisable before one begins taking photographs that count through them.

Ultraviolet (UV) and skylight filters are two other filters commonly used with color films. Some photographers leave one of these on their lenses, whenever other filters are not in use, to protect the lenses from abrasion. The clear-looking UV filter penetrates invisible ultraviolet haze that can make photographs seem hazier than the original scene looked to the naked eye. The skylight filter does this and also adds a slightly amber tint to the scene, which is helpful on overcast days and in photos taken in shade. Neither of these filters has a very noticeable effect on colors.

On days when there is heavy overcast or when there might be a bluish cast to a scene, as on a snowy winter day under a blue sky, I have found that a filter warmer in color than the skylight filter is helpful in reducing the blues. It is a light-balancing filter similar to a Kodak 81A filter, and I call it my "cloudy day" filter. There is a series of light-balancing filters like this, which photographers can select according to their needs and tastes.

Color-compensating filters have a different purpose: to balance the film being used to the type of light being used, if that light is not as intended by the manufacturer. The basic filters for balancing daylight film to tungsten light and Type B film to daylight are covered in chapter 6. In addition, there are literally dozens of color-compensating (CC) filters made in graduated densities of six basic colors. With these, you can correct any color film for virtually any lighting source, according to your needs. Though there is a basic filter for balancing daylight film to fluorescent lighting—the FLD filter—the only way to attack the problem of balancing the multitude of fluorescent light types to color films is with CC filters in various combinations. Interested readers should consult technical booklets on this topic for suggestions on how to proceed.

Architectural photographers generally are not trying to create bizarre or special effects in their photographs; but when they do get the urge to do so, there are various filters and attachment lenses to help them experiment. The diffusion filter gives pictures a soft, romantic feeling. A cross-screen, or starburst, filter turns points of light into four-pointed stars and can do interesting things to metal surfaces in direct sunlight, though it also decreases contrast and sharpness. Multiple-image lenses are made in every imaginable shape and combination of shapes, and produce repetitions of single images in various ways. These kinds of filters produce effects that can add spice to a slide show, but the photographer should experiment generously and use them cautiously. Never count on an important photograph being shot through such a filter, and always take back-up photographs that are either unfiltered or conventionally filtered.

I have now loaded you down with so much equipment and information about architectural photography that it is appropriate to pause and recall that the more you have to remember and juggle, the easier it is to foul up. You can never afford to forget the basics.

8　Back to the Basics

Mistakes remembered are not faults forgot.
—Robert Henry Newell (1836–1901)

I HAVE ruined a lot of photographs in my time. Worse, employees under my charge assigned to photograph buildings have ruined still more. To err is human, but what is annoying about my own goofs and those of others is that they are usually dumb, unnecessary mistakes. You know how it is; you get your film back from the lab and discover the spoiled frames in horror. Your reaction? "Ye gods! How could I have done *that*?!"

How, indeed? Most photographs are ruined because the photographer forgot the basics. Upon discovery of the mistake, the photographer is chagrined and most likely reluctant to admit his oversight, even to his closest confidant. Here are some of the stupid ways I have blown it:

1. I didn't get the 35mm roll started right and shot the whole "roll" on immobile film: 36 exposures on one frame.

2. I left the camera meter's ASA setting on 400 while shooting Kodachrome 64, etc.

3. I forgot there wasn't any film in the sheet-film holder.

4. I left the dark slide in place in the 4 x 5 film holder while taking the "exposure."

5. I used out-of-date film improperly stored.

6. I didn't get the 35mm film all rolled back into the cassette before opening the camera back.

7. The buildings in the picture were crooked because I wasn't careful lining them up.

8. Bulging building: I overshifted the PC lens.

9. I punched the shutter button and got a blurred building.

I could go on, but I am not a masochist. These illustrate my point: forgetfulness and lack of

Here is a popular view of the Hale Blacksmith Shop, an octagon in plan, and the Hale House, built circa 1830, in Alloway, New York. Remembering the basics is necessary when you are a tourist, as I was this day, and you do not want to be disappointed when you return home.

attention to basic details can ruin your most sophisticated plan. And they can be very costly if you have to drive many hundreds of miles to reshoot pictures you fouled up. When that happens—and sooner or later it will happen—you will feel very frustrated, stupid, and angry with yourself, for there is no one else to blame. You are not alone, however; everyone has occasional lapses.

Here are some of the basic precautions I try to think about whenever I am on a photography trip:

1. Understand your equipment and the instructions for using it thoroughly. Review instructions for little-used equipment before taking

75

it out and then take the instructions with you. It is surprising to me how many times equipment "breakdowns" are really photographer breakdowns.

2. Unusual lighting conditions—back-lighting, snowy scenes, beach scenes—require care and thought. These tend to overload meters and, therefore, underexpose films.

3. It is impossible to be too careful in lining up buildings with the edges of frames and the lines on viewfinder grid screens and ground-glasses. Tilted buildings remain one of my biggest bugaboos.

4. Experiment to find the shift limits of your PC lens and 4 x 5 lenses, and then do not exceed them.

5. After taking a meter reading, think about it: does it really make sense?

In handling film:

1. Do not use film—especially color film—after its expiration date, unless it has been stored frozen.

2. Load and unload color and panchromatic film in subdued light, never in sunlight. Load and unload infrared film in total darkness.

3. Use the infrared focus setting with infrared film, and when shooting infrared, remember that it is "different." Think about it constantly when using it.

4. Protect all film at all times from excessive heat—anything over about 75 degrees Fahrenheit.

In handling 35mm SLRs:

1. Load film carefully and then put slight tension

The last building designed by Louis Henri Sullivan was the Farmers and Merchants Union Bank, on the right, a National Historic Landmark. Aware of the building's national significance, the bank officers chose the design on the left for a compatible addition. Is the new design a success? You decide. I wished here merely to record a stage in the history of one of America's major landmarks.

on the rewind knob so you can watch it to see if film is advancing through the camera properly.

2. Whenever you load film, check the ASA setting on the camera's meter to be certain it is the same as that of the film.

3. Squeeze the shutter as carefully as a marksman would, and then follow through after exposure, regardless of the shutter speed set.

4. Use a tripod as much as possible.

5. Rewind film carefully, slowly, and fully into the cassette, and you will then never forget whether or not a given roll has been exposed.

6. Check the meter's batteries according to the camera's instruction manual, but know how to make a proper exposure without a functioning meter. If the batteries are aged, carry fresh spares.

7. Practice using new PC lenses on a tripod before trying them hand held, so you can see what they do. Do not overshift the lens by pointing the camera downward as you shift upward (the typical goof).

8. Check the diaphragm coupler on automatic lenses occasionally to be certain it is operating smoothly and freely.

9. Use a shutter speed of 1/125 second or faster whenever possible if you are shooting hand-held.

In using 4 x 5 view cameras:

1. Work deliberately; do not rush anything. Think about each step in the procedure before you execute it.

2. If you use a 4 x 5 camera only occasionally, practice setting it up, shooting pictures, and taking it down before you go out in the field.

3. Review the use of a hand-held meter before using it; take the instructions along.

4. Use a magnifying glass to check focus at full aperture.

5. Know how to load sheet-film holders properly; do not insert film upside-down.

6. Establish a rigorous system, whatever you choose, for handling 4 x 5 film holders, cut film, and dark slides. Write it down and don't forget it.

7. Check the corners of the ground-glass carefully to be certain you have not overshifted the front standard without tilting it to compensate.

8. Remove dark slides before exposure and replace them afterward, but before removing the film holder from the camera. (Obvious, perhaps? *Don't* think about it and see what happens.)

9. Protect the film holders and camera from dust and dirt, and clean film holders before loading film.

This is not a comprehensive list, but it hits the major points I have learned from experience. Oscar Wilde said, "Experience is the name everyone gives to their mistakes," as the list above intimates. The photographer who does not pay close attention to these basic details will personally experience the wisdom of Wilde's remark. The good photographer seems not to make elementary mistakes *only because he never forgets the basics.*

The discussions that follow are especially important areas of concern for architectural photographers.

Shutter speed and release. Any pistol marksman knows that the secret of his success depends on the way he releases his trigger. The photographer can learn from the marksman in understanding how best to release the shutter with minimum camera vibration.

A marksman quickly learns that he must control his breathing and squeeze the trigger smoothly. If he jerks or pulls the trigger, the shot will fall well off the little black circle in the center of his target. In fact, the marksman does not really know at what precise instant his pistol will fire. If he knew, he most likely jerked the trigger. Similarly, the camera shooter should control breathing and must squeeze the shutter release slowly and smoothly, not punch it. Like the marksman, if the photographer has squeezed the shutter, he will not know the precise instant that the shutter will release. Also like the marksman, he should follow through the shutter motion. When the shutter has been released, get in the habit of looking through the viewfinder steadily to check the scene again. The photographer who hurries his shot will have blurred, imprecise photographs. He should be just as careful and deliberate as the pistol marksman and should foster the same follow-through. The beginning photographer could "dry fire" his camera frequently, practicing smooth release and follow-through.

The "book" repeatedly states that photographs made with a hand-held camera can be taken at speeds no slower than 1/30 of a second. For many years, I adhered to that gospel. I have since learned that if one is desperate for a photograph of a dimly lit interior, for example, it is possible to squeeze off a shot at speeds as slow as 1/4 of a second and get usable images. If you find yourself in such circumstances, do not be afraid to try; but take several shots to increase the likelihood of one

turning out. Many such slides are sharp enough for slide shows, but would never be suitable for a display or reproduction.

My normal practice is to set my shutter at 1/125 of a second and forget it as much as possible for outdoor, daylight photography. Unless my depth of field requires a slower exposure time, this speed generally ensures clear, distinct photographs. A faster speed should be used if there are wind-whipped trees or pedestrians in the scene. Even when using such speeds, however, the photographer should control his breathing and squeeze off his shot.

A handsome doorway with sidelights and heavy molding is one of the signatures of the Greek Revival Style of historic architecture. This 1848-vintage doorway is on the Duncan House, Cooksville, Wisconsin. A medium-range detail photograph like this speaks volumes about architecture and focuses viewers' attention on what you want them to see.

Hand motion is exaggerated in using a telephoto lens, so a speed at least as fast as the reciprocal of the len's focal length in millimeters should be used. Thus, when shooting a 200mm lens hand-held, I use at least 1/250 of a second for my shutter speed.

Depth of field. Depth of field is the amount of space that is in focus, receding from the camera toward, and perhaps including, infinity. The smaller the aperture selected, the greater will be the depth of field. Also, the shorter the focal length of the lens, the more depth of field there will be at any given aperture, a significant advantage in small-format photography.

Most architectural photography is done at a focus setting of infinity. Unlike aerial photography—where, if your focus is less than infinity you had better speak with the pilot—architectural photography sometimes employs other settings. When the photographer wishes to incorporate a close foreground with a distant building, a generous depth of field is needed. You can then mount the camera on a tripod and use the smallest aperture on your lens coupled with whatever shutter speed is necessary for correct exposure. In this case, selecting the focus setting is troublesome. If you set the lens at infinity, you deprive yourself of potential foreground depth of field, and the reverse can throw the building out of focus. Thus, you can select an imaginary point in between that keeps the foreground and the building in focus, judging this matter with the help of the previewing stop-down button of your camera. Using a wide-angle lens would also help because of its greater depth of field, assuming its wide-angle perspective would be appropriate.

Of course, depth of field also can be used selectively to focus on a point in space for emphasis, leaving the foreground and/or background intentionally out of focus. Here, the reverse of the above discussion applies; use an open aperture and a long-focal-length lens if possible. If you are attempting to create both situations—deep and shallow depths of field—several exposures are advisable. Even though previewing the scene through the stop-down procedure is helpful, the true results will not be seen clearly until the film has been processed.

When using a 4 x 5 view camera, focus is especially critical because of the long-focal-length lenses

required. A 90mm lens is a wide-angle lens on a view camera, but a telephoto lens on a 35mm camera, with the resultant loss of depth of field to the photographer. A photographer used to the 35mm format must be especially careful when moving up to a 4 x 5 camera, because a routine picture in the small format can become a real brain-teaser in the large format. A pocket magnifying glass is helpful in checking the focus in all parts of a 4 x 5 ground-glass. One of the major reasons large-format photographers have to use lengths of exposure that seem unnaturally long to the 35mm photographer is the need to increase the depth of field for relatively long lenses.

Tripods. For the best architectural photographs, a tripod is an absolute necessity. Learn to treasure the tripod. Whenever a photographer anticipates possible reproduction of a photograph or the substantial enlargement of it, he should use a tripod. Whenever he wishes to be certain his verticals are correctly aligned and parallel, he should use a tripod. This is not always easy advice to follow, for setting up, leveling, and using a tripod are time-consuming, take away spontaneity, and slow you down. It is too easy, when contemplating the hassle involved, to just snap a picture without the tripod and move on. Regrets, if any, will come later.

What is so great about a tripod? It gives your negatives and slides enhanced sharpness because camera motion is eliminated, assuming you have released the shutter properly. This permits much clearer prints to be made for display purposes. And when beady-eyed magazine editors pull out their magnifying glasses—as they do and will—in order to examine your slides, negatives, or transparencies, you will having nothing to fear and may have a leg up on the competition. If you doubt this, take the same picture with a tripod-mounted camera and then with a hand-held camera and compare the difference under a strong magnifying glass, yourself, when you get your negatives back.

Even with your camera mounted on a tripod, you should release the shutter carefully. Use a cable release held carefully so there is slack in it. If you do not have a cable release, you can use your camera's self-timer to release the shutter. Of course, you can use very slow shutter speeds on a tripod, enabling you to increase depths of field to the maximum possible and to take twilight and night scenes.

A tripod is mandatory to get buildings precisely aligned with grid screens and to shift PC lenses or front standards of view cameras without inducing human errors. Tilted, splayed, or converging buildings can only be truly avoided with a tripod-mounted camera, even though one can get very good with a PC lens on an SLR shooting hand-held. It is painfully obvious when perspective correction was attempted, but just missed, and even more so when whole buildings were tilted sideways.

A final advantage of using a tripod is that it forces you to slow down and think about what you are doing. This, alone, improves photography. I notice in myself the tendency to snap and run. I get carried away and try to photograph a building from every conceivable angle. As I take one shot, my mind is already pondering the next one. The acts of extending a tripod's legs, mounting the camera, and leveling the whole outfit enable my overactive mind to ponder the view at hand and the best ways to proceed with capturing it.

Probably no piece of advice I issue in this book will be more ignored by 35mm photographers than the good sense of using a tripod. But assuming you are now persuaded to do just that, what kind should you get? Either you opt for a lightweight tripod that fits in your gadget bag, or you select a heavy, braced tripod that always seems to be in the way. Of course, I recommend the latter route. Accept the ignominy of having to deal with a tripod that will not fit conveniently anywhere, and get on with it. Be thankful you are not a pole vaulter! The lightweight tripod is not a stable camera platform, and this is the first priority. I have both types. There is my lovely little folding tripod that fits tidily into its cute leather pouch, from which it rarely exits. And then there is my ugly, ungainly monster that always travels with me—because it is always reliable.

Exposure meters. Photographic exposure meters are marvelous inventions that enable you to take much of the guesswork out of exposure calculations. But they are not perfectly reliable under all circumstances, as owners of automatic-only SLRs are discovering, and their inherent limitations should be understood.

The normal meter in use is one that reads light reflected from the subject. This is the kind of meter in your SLR camera and is probably the most popular hand-held meter, as well. The other type of basic meter is the incident-light meter. It must be held at the subject, pointing back toward the camera, and is, therefore, less convenient to use. Either meter can work well, but let us consider the

I took this view of the Iowa County Courthouse, built in 1859 in Dodgeville, Wisconsin, with a hand-held shift lens and an orange filter. The view reveals the strength and solidity of the Greek Revival Style. Even though it was a weekend, I could not avoid including at least one parked car.

reflected-light-reading meter more fully.

Such meters are designed to average the quantity of light read to produce a certain level of tone in the film, a medium tone that is neither too dark nor too light. Thus, for example, if you take a picture of a plain, white card, it will turn out gray. If you do the same with a dark card, it will turn out the same tone of gray if you follow the meter's recommendation. The meter wants to make everything it sees medium-gray. Knowing this, you must compensate for it. If you are taking a picture of a white card, or a light scene, you must intentionally overexpose the film to get a correctly exposed view; the reverse, of course, is true for a dark card or scene. Nearly everyone has seen slide shows with dark, illegible title slides or lists of items that should have been very

light. In shooting them, the photographer did not compensate for the white background by overexposing.

Reflecting-light meters also can be overwhelmed by back-lighting or excessively light surroundings, such as snow, sand, or bright overcast. Taking a picture of a building surrounded by snow on an overcast day is a sure formula for bad underexposure if the photographer does not compensate. These problems can be handled by moving close to the building to be photographed and taking a reading with the meter near it, or by using a spot meter, or by bracketing exposures on the side of overexposure.

Kodak manufactures an 18 percent gray card that can be quite effective in handling some difficult meter-reading situations, and especially in photocopying dark or light subjects. All you need do with it is place it before the meter under the light source and take a meter reading off the 18 percent gray card. It *is* the tone of gray the meter wants everything to become.

Applied common sense. I used to work as a planner for city government. When asked by the public what planning was, I generally replied something like, "It's applied common sense." And there is a lot of truth to that. It applies as well to the basics of using cameras. The most difficult part of invoking common sense to solve problems seems to be taking the time and making the determination to do so. Over the years, I have reviewed many ruined photographs with their photographers, and the vast majority of the time the problem that caused the disaster was not taking the time in the first place to think things through and work deliberately.

The same thing applies to so-called equipment breakdowns. Applying common sense to the problem, if coupled with reasonably thorough familiarity with the equipment, will most often result in an on-the-spot "cure." I remember the time when one of my staff rushed in with a "broken" Nikon FTN camera; you could not see through the viewfinder. Somehow the mirror had become "stuck" in the upward position, I was told. The solution was to return the mirror-lock-up button to its downward position, permitting the mirror to return to normal activity. Somehow, the photographer had inadvertently moved this crucial button to the wrong position but was not familiar enough with the camera to know what had gone wrong. Had he been three hundred miles away, an entire trip could have

been lost because of this simple condition—curable by applied common sense.

Whenever planning a photography trip, applying common sense can avert disaster well beforehand. For example, if you plan to photograph a bank in the middle of a busy downtown area, do not plan to go there on a working day if you want to minimize cars and pedestrians in the view. When do you go? How about Sunday? In fact, Sunday is a prime time for architectural photographers for this very reason. When you leave home, check to be certain you have enough film and bring more than you think you will need. Have you tried to buy film somewhere on Sunday morning? Indeed, it does not hurt in the least to prepare, based on your personal experience and needs, a field checklist. You can use it to be certain you have all you will need for a trip.

In the hurly-burly of daily life in our pressure-cooker world, the application of common sense is becoming a rare activity. The architectural photographer really needs to take the time to apply it, and always to remember the basics.

9 Composition

Search for composition first of all. The building will take care of itself . . . all methods of approach and all techniques of the medium mean little unless one can "see" photographically, imagining how an unlimited view in three-dimensional space will appear in a two-dimensional picture.
—G. E. Kidder Smith, AIA, 1963

Composition is a thinking process of making order out of the chaos that nature presents and of organizing many diverse elements into a comprehensible unit.
—Ben Clements & David Rosenfeld, 1974

LEARNING how to handle composition well in architectural photographs arises out of thoughtful experience, a desire to create fine photographs, and an ability to see a scene mentally in two dimensions. Once all the technical matters of photography become second nature, then you can deal with composition, which is really the heart and soul of architectural photography.

In this chapter, I will discuss composition in a relatively superficial way. Those readers interested in studying this matter in greater depth could consult Ben Clements and David Rosenfeld's excellent book, *Photographic Composition.* It is a down-to-earth discussion of composition and includes a step-by-step course on the elements and arrangement of compositions. The book makes extensive use of architectural subjects to illustrate its points.

When I am photographing a building, I generally think in terms of three types of desired products. The easiest of these are record photographs, which are intended to document a building's facades, environment, and important details. These are for gathering information about a building quickly and for later reference. In taking such photos, I usually give relatively little attention to compositional matters. When I have finished taking these views, or sometimes while I am taking them, I might move on to taking quality photographs. I envision these as possibly accompanying a National Register of Historic Places nomination form or being included in a survey document. They could also be used to flesh out displays or looseleaf photo books. In taking

quality photographs, I concern myself with perspective correction, proper filtration, lighting, and composition—things I might ignore in making record shots. I could be embarrassed to have a record photograph published, but the second type of photo could be published in some booklets, magazines, or pamphlets.

The third type of photo—when I get very serious about what I am trying to do—is what I consider a genuinely publishable photograph. To get this kind of photo, I will wait for the right weather and may well use a medium- or large-format camera instead of a 35mm SLR. I haul out a tripod. I will study the building from all directions, perhaps with the aid of an SLR's viewfinder. Generally, I take these photos for free-lance assignments, on speculation for projects I intend to submit to publishers, or of doomed historic buildings. For this third plateau of photography, I try to make the best photographs I possibly can, so that the photograph itself has some aesthetic merit and evokes a reaction from its viewers. Clearly, composition is my major concern when creating these images.

As the director of a state historic preservation program, I have had the opportunity, over the years, to observe dozens of employees as they photograph buildings. Some of them take only record photographs. They do not feel a need to go beyond such photos and do not seem to care about composition. To some of them, the equipment itself presents an obstacle they never overcome. To others, the medium of photography holds little interest, despite their interest in fine architecture. Yet there

The Seventh-Day Baptist Church, in Albion, Wisconsin, is the subject for a simple composition. It is framed by an overhanging branch and buoyed by cumulus clouds, which have been defined through the use of a dark-red filter and panchromatic film.

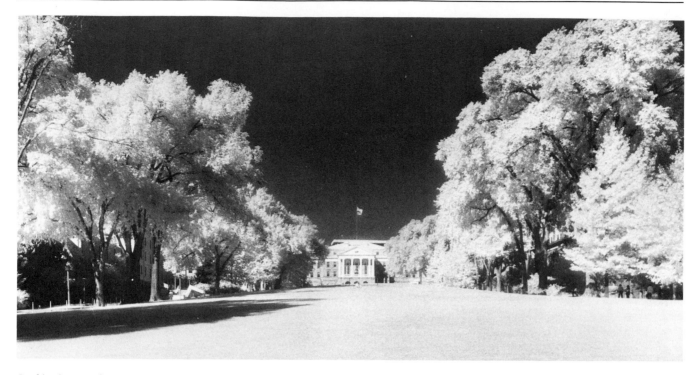

In this view, on the University of Wisconsin campus, all forces lead to the facade of Bascom Hall, originally built in 1855. Great, pillowy, volumes of trees could as well be cumulus clouds. The pedimented portico dominates the scene, in spite of its smallness, because of its lightness and the directionality of the lines of trees. This photograph was made on infrared film and with a red filter.

are others who simply cannot stop at record shots. Whether by constitution or curiosity, they wish to go beyond merely recording the facts of buildings; they want to instill an individual vision in the images they create. They try to translate the natural world before them into a personal, aesthetic, two-dimensional statement.

I have never been able to predict or understand why one person will have an interest in photography as a medium capable of producing excellent images, while another will not. I know one nationally renowned architectural historian who holds a Ph.D. degree in art history—and is a self-confessed "terrible photographer." In spite of his extensive understanding of art and architectural history and architectural practice, his personal aesthetics do not translate into the medium of photography. Mastery of a craft cannot commence unless a person is interested in the medium and wants to achieve proficiency, regardless of his talents and brilliance otherwise.

Numerous fine photographers and architects have written articles and books on the subject of photographic composition. Though each approaches

the topic from a different angle, common threads run through many of their discussions. All recognize certain elements of composition—lines, shapes, textures, volumes, darks and lights—which are present in good photographs. These elements are identified by the photographer and related to each other through the act of composition. Painters are able to take the same elements and relate them through conscious design, even in abstraction. An architectural photographer, however, must work with the actual appearance of the world around him and manipulate elements by the use of contrasts, similarities, centers of interest, rhythms, directionality, and, perhaps, balance. The act of composition is accomplished with the techniques we have already discussed: camera placement, quality and direction of light, film types, filtration, format, and chemical processes. An oversimplified formula, then, is: *Composition = Elements + Techniques.*

Elements of Composition

Line. Straight lines are predominant in the world of architectural photography. A good exercise for a

Here is a simple composition in which the converging lines created by the bricks in the street draw the eye toward the modest house which, by its lightness, dominates the frame. A very low camera angle was used to emphasize the bricks in the lower foreground. The shadow lines created by the clapboards appeal to the sense of touch.

Here is a bold, spare statement—one might call it "American Romanesque." The church stands like an exclamation point on the rolling, midwestern farmland—a sentinel before looming and ominous cumulus clouds. The barren trees seem appropriate in this metaphor for the conflict between man and the forces of nature.

photographer is to go into a city, find straight lines about him, and photograph them as simply as possible. Later, when he is on assignment, he will be more aware of the presence and dynamics of the lines he sees. A line has both quality and direction, as any draftsman knows. Several lines may be parallel or intersecting. Lines may be placed anywhere within the viewfinder. In short, incorporating a line or a series of lines in a composition calls for judgment and understanding about them.

In buildings, lines may be found in clapboarding, in other kinds of siding, in mortar joints, corners, edges of volumes, mullions, roof eaves or ridges, beams, posts, columns, flutes, doorways, and accessories. Shadows may emphasize lines or even create them. Lines are crucial in composing an architectural photograph, for they can give an image directionality and rhythm that is either restful or restive. Lines can lead a viewer into a picture, or throw him out of it. They can point to the center of interest, or cause the viewer's eye to miss what the photographer had thought was the center of interest.

Lines can have symbolism, as architects know all too well. The most obvious example is a medieval cathedral, where a procession of parallel vertical lines forces the viewer or worshipper to cast his attention both upward and down the nave. The vertical line as a religious symbol has become ubiquitous and even trite in church architecture. Frank Lloyd Wright used a pair of intersecting lines pointing skyward in his First Unitarian Meeting House roof, a symbol of which he was not only conscious, but proud.

An architectural photographer, therefore, needs to be aware of the presence of lines in his viewfinder

Here, a children's swing-set creates a diagonal line leading the eye to the contrapuntal lines of the park shelter's roof. All lines direct the eye to the vertical masonry structure of the shelter. This park shelter is set alone in a large grassy area; it was hard to find a foreground element to relate to the building.

so that he can capitalize on them as part of his composition and not have them defeat his intent. He should also know that four lines in particular have an overpowering effect on his results: the edges of his frame.

Shapes. When you start with a frame, you have one shape preordained for you by the camera's manufacturer. It is the format of the film. I prefer always to work with the full frame in composition. Some photographers can compose knowing full well they will crop their views later, but I do not have this ability. Accordingly, like most photographers, I must work within the framework of a format. The oblong format, such as 6 x 7 centimeters, 4 x 5 inches, or 35mm, seems natural to me. Perhaps this is because a person's normal vision is naturally horizontal. The vertical format then works as a counterpoint. Some photographers, however, prefer to work with a square format.

As soon as you introduce a single subject into a viewfinder, you have broken the frame into two parts: the subject is positive space; the area around it is negative space. Only in three dimensions is this really negative space. But in a photograph, it is just as real and as powerful a shape as the subject itself. The relationship between the subject and the negative space is infinitely variable, even if the shape is as simple as an egg or a plate. A good exercise for a photographer is to experiment by photographing simple shapes as they appear around him. By repositioning shapes within the frame, the dynamics of the composition are considerably changed. As the rectangle is the predominant form in cities and towns, such experimentation makes especially good practice for an architectural photographer. In practicing, look for simple shapes and try making them the center of interest within the frame.

When more than one shape is included in a frame, the relationship between them and the edges of the frame becomes complex. One shape can be made dominant by contrast, or they could all be interrelated through rhythm. As with lines, the important thing is to be aware of the influence shapes have in the final composition.

Textures. Every material object has a texture, including buildings. Photographs of buildings can be especially effective when they reveal the texture of a surface, as Clements and Rosenfeld noted: "Even though surface variation may be purely visual and there is no opportunity for physical touching, the

A simple, rectangular shape dominates this view and is enlivened by the texture of the clapboards. Here, the negative space is in the form of a meander, which prevents the scene from being completely static. Incidentally, no lens known to man could straighten out this building.

appearance of a texture is sufficient to transmit a stimulus to the brain and a sensory touch response is experienced." I agree with them. The most memorable photographs I have seen, regardless of the subject, are ones that appeal strongly to tactile responses.

Coarse textures are familiar to us all. Stone, brick, siding, clapboarding (especially weathered), and concrete (especially textured) are examples. But smooth surfaces also have textures that evoke responses. The fabled glass box and the smooth steeliness of the Streamlined Moderne style are good examples of this. Of course, the best way to emphasize a coarse texture is with raking sidelight, as when the sun approaches the plane of a masonry wall. Polarizing filters can raise havoc with or

This photograph is rich in texture because of raking sidelight, which emphasizes the coarse surface of the cut-stone quoins and coursed rubble walls. It is a historic building serving as a visitors' center in Sackets Harbor, New York.

Move in close to buildings to capture details and textures. Here, strongly converging lines of cobblestones lead the eye to stop at the vertical lines of the fluted Doric column, which dominates by its whiteness. Sunlight reveals the column to be cylindrical, and the texture of the stones and flutes is apparent to the viewer. The building is the First Baptist Church, at Phelps, New York, built in 1845.

emphasize some textures. The glint of reflection off a glass surface, for example, can be almost eliminated with a polarizer, but a coarse surface's tonality and texture can be deepened with the same filter.

There is strong relationship between the senses of touch and sight. Powerful textural photographs are extremely evocative. The architectural photographer especially needs to be aware of this phenomenon. A special photography session simply shooting textures in familiar surroundings is a good way to achieve this understanding.

Light and dark. Along with lines, the areas of lightness and darkness in a photograph are the most important influences on over-all composition. Perhaps that is what is so surprising about the use of

infrared film: it can change such relationships dramatically. Through the use of lights and darks, the photographer can control the attention of the viewers. For example, in a generally dark scene, the viewer's attention will be focused on the lightest area; the same can be true in reverse.

Inattention to lightness and darkness will ruin photographs, as will inattention to any other element of composition. I have spoiled countless photographs in my day, often by having an immense area of blackness, usually caused by the shadows of trees, in the foreground. Visualizing relationships between light and dark is to me one of the most difficult parts of photography. I believe I can see a shape, a line, or a texture if I am consciously looking

Sometimes stairways provide interesting patterns in interior photographs, as here at the Old Post Office, Ashland, Wisconsin. The viewer's eye is drawn upward by the spiraling forms and by the white square in the center of the photograph.

for it, but I do not have that confidence about tonal values. I am surprised more often by tonal problems than by anything else.

Volumes. If an architectural photographer is likely to be aware of any compositional element, it is volumes. When viewed from the outside, buildings themselves are volumes that are modeled by sunlight. Other volumes are present as well, however, though perhaps less conspicuous: trees, shrubs, objects, and clouds. In fact, a building is no more important a volume than is a tree or a cloud. All are volumes that relate to each other somehow in the composition.

Volumes are three-dimensional, of course, but are seen in two dimensions in a photograph. An illusion of volumetric three-dimensionality is established through lighting. Flat lighting, as noted in chapter 7, washes out the qualities of volumes; angular lighting

is better for revealing them. Angular lighting is also better for revealing texture, a happy coincidence. Volumes are seen in and relate to each other in space, and it is the degree to which a photographer understands this and illustrates it that is important to successful architectural photography.

A good exercise is to find simple volumetric forms in the everyday world and photograph them clearly, so that they can be understood, even appreciated, by viewers.

Compositional Techniques

Regarding the photography of building exteriors, G. E. Kidder Smith has written, "Given reasonable sunshine, the two main determinants are *where* one stands and *when* one stands there." Clements and Rosenfeld wrote, "Each picture should have only one

I have never photographed octagonal houses very well, perhaps because wherever you stand, in relation to them, they always have their backs turned toward you. They are simple volumetric forms, but they intrude in the frame uncompromisingly. Photographing them in the center of the frame doesn't work, for me; so, here, I tried moving the Edward Elderkin House, of Elkhorn, Wisconsin, built in 1855, off to one side. That helped to reduce the static, stocky look of the octagonal shape and is an improvement over my other views of this structure; still, there is much room for improvement.

principal idea or topic." If you put both of these pronouncements together, you have a pretty good capsule operating theory for compositional techniques.

Camera placements and lens focal length. These two factors are wedded at the heart of composition. A camera can be placed anywhere with respect to a building. It can be in any direction from it, at any distance to it, and at any height with respect to it, within practical limits. Direction, distance, and height form the three dimensions of viewpoint. Distance, however, is modified by lens selection, because lens selection determines the relationship of the subject to the negative space in the frame.

Before I set up a camera anywhere, I try to see the view from all possible angles. If it is an isolated building, as is often the case, I walk around it to discover all the faces of the building and details that might be worth photographing. Upon selecting a direction from which to set up the camera, I need to select a distance. This is a carefully considered decision. It might be affected by compositional elements desired, such as a framing tree, a lower foreground element, or a roof shape or feature. Then I select the lens that places the frame where I would like it to be with respect to the building and setting.

Using a 35mm SLR presents difficulties on occasion, because PC lenses are available only in

Here, the diagonal lines of the building draw the viewer in toward the entrance. The angular sunlight reveals the bold masses of this structure. Shifting the camera even a few inches to the left or right would have completely changed the picture. The building is Helen C. White Hall, University of Wisconsin, built in 1972, Fitzhugh Scott, Architects.

Frank Lloyd Wright's Greek Orthodox Church in Wauwatosa, Wisconsin, actually is a rather small building, though here it appears large because of low camera angle and lens selection, a 20mm very-wide-angle lens. The spiraling lines draw the viewer into the picture, which seems appropriate because the building itself is circular in plan. A major foreground area was unavoidable, because the lens does not shift, and tilting a lens of such extreme focal length can be disastrous. Standing farther back from the building gives it a more realistic perspective, but also removes drama from the final picture.

35mm and 28mm focal lengths. This means that, to get the subject-to-frame relationship you want, you sometimes must be closer to the building than you would like to be. For example, I occasionally lose roof features, such as cupolas, that I would like to have retained in the view. The large-format view

camera avoids that problem, because perspective correction can be made with a lens of any focal length mounted on it.

Another problem with the 35mm SLR is its extreme depth of field when the focus is set at infinity, which is often the case in architectural photography. Though you can use the limited depth of field in the 4 x 5 format to emphasize buildings through selective focusing, that is generally impossible in the smaller formats.

In 1949, author Helmut Gernsheim wrote, "One of the most difficult pictures, and usually the least interesting, to make of any building or interior is the whole view." This emphasizes the need to move into buildings with regularity, and not always to stand off in the distance. Kidder Smith wrote, "Always take one or more pictures from no more than ten feet from the subject." This is excellent advice! If photographers make one error more than any other in shooting buildings, it is selecting a camera-to-subject distance that is too great. When photographing any building, it is always a good idea to take numerous pictures from various directions and distances.

If the camera is correctly placed, there are occasions when moving it just a few inches—even fractions of an inch—will completely change the feeling and concept of the resulting image. This is especially true in terms of direction from the building and height of the camera.

A low-level camera can lower horizon lines and eliminate clutter behind a building. If poles, wires, and superstructures behind it intrude in the composition, a lower position might cure the problem. Of course, lowering the camera also changes the roof lines of a building, perhaps exaggerating them too much. A lowered camera can also emphasize the texture of the foreground or bring a planting bed or fountain into view as a foreground element, giving the photograph added depth. In other words, once the direction and distance are tentatively selected, a photographer would be well advised to experiment with various camera heights.

When a view seems to have too little focus for attention, or seems too cluttered, it is probably time to simplify the concept of the photograph and move in closer.

In 1949, Leslie Shaw wrote, "Never select a viewpoint which gives a dead-on field of view. An oblique angle . . . will produce a far more pictorial effect." Shaw cautioned thus in order to avoid his

perceived "danger of symmetry . . . which, in this type of work, must be generally avoided." Writers of the 1940s and 1950s were inclined to the issuance of rules for composition, which probably only stimulated photographers to prove them wrong. I am fond of straight-on views of some buildings, providing the lighting is oblique. This is especially effective with rather humble and homely structures that have their front facades, but little else. Lighting is important in such scenes for dramatic effects.

Light. Light is the generator of the visual arts, including photography. It alone can define the lines, textures, shapes, volumes, and tonal patterns of which composition is made. Chapter 7 discussed the mechanics of sunlight, which an architectural photographer needs to keep in mind at all times.

Sunlight can enliven a facade or create a composition. It can function like a spotlight at certain times, riveting attention on one point. The direction and quality of the sunlight on a facade is all-important to the composition. A photographer who leaves on an assignment to photograph a building without having considered the direction and quality of the light is literally flying blind. He is like a painter who brought no brushes or paints, but just assumed he would be painting.

Mechanical and chemical techniques. Mechanical and chemical techniques have been discussed in some detail already and have a substantial effect on composition. A selection of film helps determine the nature of composition by affecting the potential of lights and darks and/or hues of colors. Filters have a major effect, especially in dramatically altering the tone of the sky and the contrast between facades and sky. Those who do their own darkroom work know that development times and chemicals affect final tones, and that dodging and burning-in on the enlarger can completely change dark-light relationships and photographic centers of interest. For the finest prints, a photographer really needs to do his own darkroom work to assure that the concept of the photograph is carried through into the print. Many of us, myself included, do not have the time or equipment to do this. It means, simply, that we cannot achieve the finest results of which photography is capable.

Miscellaneous thoughts. Any successful photograph has a compositional idea that gives it unity and coherence. Arriving at an effective design is often

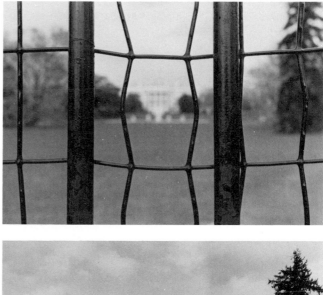

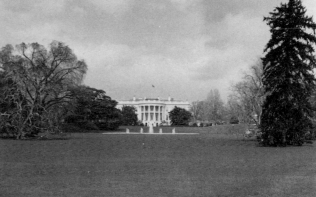

Even moving a camera a few inches can completely change the character of a scene. These two photos are an obvious illustration. One is the typical tourist's view of the White House in Washington, D.C.—camera lens poking through the fence, which has been conveniently spread for lenses. The other is taken a few inches further back, with the focus changed. The camera position is little changed, but the effect is completely different.

intuitive, achieved while framing photographs. In general, I believe it is easiest and most effective to keep the design as simple and evocative as possible. Try asking yourself, as you set up your camera, "What is the basic organization of this picture? What will hold it together?" If you have an answer in your viewfinder or on your ground-glass, you may have a good photograph in the making.

All the elements of design affect the "glue" of the composition. They can provide directionality, so that the photograph draws the viewer into it and focuses his attention on something specific. They can present similarities or contrasts that attract attention

The texture and volumes of the fluted Ionic columns on the State Historical Society of Wisconsin (1895–1900) are the center of interest in this view. They draw attention by their repetitive rhythm and their texture. The diagonal lines converging to the left tend to throw the viewer out of the picture and are only partially stopped by the large bush on the left. The composition is only partially successful.

and evoke reaction. By a combination of lines, shapes, and tones, a spiraling staircase forces the eye through a tunnel to the center of the photograph. The convergence of lines in perspective can rivet attention on the point at which they converge. The eye can led literally off the edge of the photograph, unless something intersects that motion and reins it in. As you look through the viewfinder, you really need to see and to think about the dynamics of the elements of composition. Awareness of them will eventually bring interesting arrangements into being.

In the introduction, I referred to what I called sanitized photographs. Gernsheim acknowledged that he was an "inhuman photographer"; he preferred to keep people out of his scenes and recommended that others do so, as well. Writing

twenty-five years later, John Veltri spent much time discussing the inclusion of human figures in architectural photographs for the recognition of scale. There is no hard-and-fast rule about what should be included in architectural photographs— other than the buildings themselves. It depends on what you are trying to say in your pictures. There are times when it doesn't really matter whether there are human figures in the scene or not. The same cannot be said for overhead wires, bicycles, cars, and other societal litter.

Cervin Robinson wrote a provocative article in the *Journal of Architectural Education*, complaining about the sanitizing tendency of professional architectural photographers. "Typically," he wrote, "the architectural photograph is taken in brilliant sunshine on a rare, deep-blue-skied day. Interiors

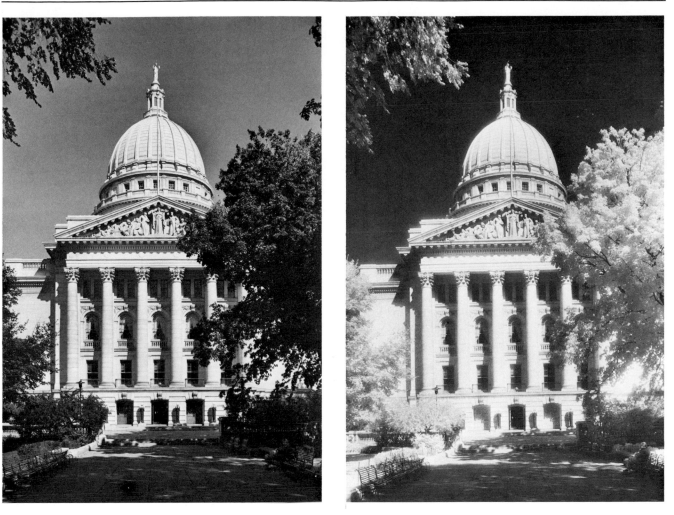

These views of the Wisconsin State Capitol show how film selection can have a dramatic effect on composition by altering the presence and arrangement of darks and lights. View A was shot with Plus-X film and an orange filter. I find it unpleasant, largely because of the looming, dark volume on the right: a tree. View B was taken with infrared film and a red filter. Now the tree becomes light, almost as light as the building, and does not overpower the structure. The shrubs flanking the entrance are also lightened, and the sky becomes black—outlining the white dome. I find View B to be much more satisfactory. The dark shapes are at the top and bottom of the picture, rather than scattered through it.

have been tidied as they may rarely be in reality . . . it may include no people." The "standard product," he complained, falsifies reality. And he may have a point. There are images in Peter Blake's *God's Own Junkyard* of trash, pollution, commercial strips, highways, and thoughtlessly designed buildings that are extremely handsome in spite of what they depict. The quality of a photograph is really independent of the character of the scene being photographed. A beautiful photograph can be

made of an ugly building, or even of out-and-out trash.

It is up to you to determine how you wish to show the buildings you photograph and what you wish to say about them visually. Whether you prefer the "standard product" or *cinema vérité*, the elements of composition and the acts of arranging them are the same.

In 1949, writing about an architectural photograph, Gernsheim said, "Whatever is included

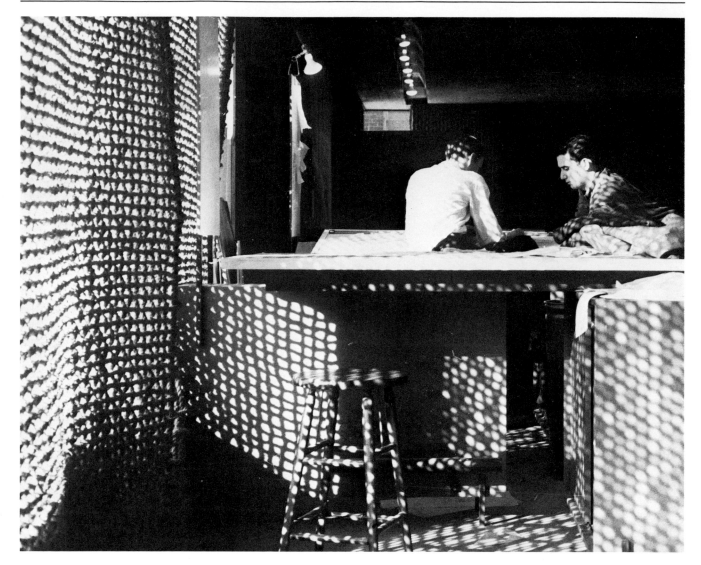

*Sunlight can be used to dramatize and mold photographic images, whether inside or out, as here at
the Art and Architecture Building, Yale University, in 1964.*

in it must have significance." In 1963, Ansel Adams
penned, "Whatever is included in a photograph
must have significance." Whether Adams borrowed
from Gernsheim or not, the point deserves
repetition. My way of stating this is more perverse:
whatever is in the photograph has significance,
whether you like it or not. Accordingly, it behooves
you to control as much as you can.

A photographer can develop selective vision as he
is composing a scene. When the photograph is
developed, he may be surprised to find something in
the scene he was not conscious of when he was
framing the view. When that happens, it means that
the photographer was not aware of all the design
elements in the scene and, therefore, could not be
controlling them. When I was taking flying lessons,
years ago, I once concentrated so hard on flying a
certain pattern that I did not hear the stall warning
blaring in my left ear. The instructor jolted me out
of my selective attention quickly. He taught me
something else, too. Keep your eyes moving and
your mind open, he said, so that you don't miss a
soaring hawk or another aircraft that could threaten
you. In photography, you cannot afford to
concentrate so hard on the basic idea of the
photograph that you become oblivious to other

things going on that could undermine you.

The composition of architectural photographs, at its finest, is the result of thoughtful and intuitive aesthetic endeavor every bit as worthy of being called *art* as is painting. In some ways, it is more difficult, for the painter can start with a blank canvas and work with abstractions; the photographer works with the real world and a confining mechanical process that limits and directs his potential. When the photographer does his job well, everything in the frame does, indeed, have significance, for it relates to the whole composition and supports and reinforces the idea of the picture.

10 Photographing Interiors

Interior architectural subjects are a department of photography which we need hardly inform our readers is one of the most difficult to obtain any great amount of success in . . . this we apprehend is not so much from a fault of manipulation as from the photographer attempting a subject which would be almost certain to meet with failure.
—Photographic News, *February 1859, London*

PHOTOGRAPHING interiors is probably an unfamiliar topic to the average reader, and perhaps it is one that is a bit worrisome if he has seen some of the lush interiors captured by professional architectural photographers. Those interiors were photographed after hours of preliminaries were completed, including the arrangement of furniture and knickknacks just so and the placement of supplementary lighting sources. To those timid readers, I offer this advice: don't worry about that and do the best you can with what you have. Interiors can look very impressive and be very informative without using anything more than a camera, a wide-angle lens, a tripod, and a cable release. Don't be afraid to experiment.

G. E. Kidder Smith, a well-known architect and photographer, has written, "Personally, I have no technical knowledge of lighting architectural interiors. However, I have found that much can be done by natural daylight." Or, one might add, by existing artificial light. Such a candid admission is encouraging and refreshing. The point is that adequate interior photographs can, for most purposes, be taken with existing light, whether natural, artificial, or a blend. Perhaps the only exception to this rule is taking color interiors when there is a mixture of fluorescent light with incandescent or natural light or both. Even then, however, passable interior shots can be made if one accepts some mildly unpleasant colorations and experiments with various filter combinations.

This advice, however, is simply not adequate for the professional architectural photographer, for whom the photography of interiors is a high science

crucial to his commercial success and acclaim. It is perhaps the photography of interiors that is the foremost reason for aspiring architectural photographers to apprentice with a fine professional, for the techniques in obtaining quality, large-format interior color photos are so complex and sophisticated as to be beyond both my understanding and the scope of this book. Julius Schulman's fine book describes case studies that give the reader a hint of what is involved.

Camera position and lighting are the most important ingredients in available-light interior photography. Crucial to the former is the selection of lenses available to the photographer. Frequently, an extreme wide-angle lens is needed to avoid a psychologically cramped photograph. Often, this calls for the widest-angle lens in your possession. A 20mm lens is very useful and almost required for many interiors. The 28mm PC, or shift, lens on a 35mm SLR becomes a significant improvement over the 35mm shift lens. A non-fisheye lens wider even than 20mm would be very helpful on occasion, if you can afford one; this lens would have a rectangular field of view, rather than the circular one common to fisheye lenses. In short, when selecting lenses, look over the options available from your camera's manufacturer and from accessory-lens makers. For interior work, select the widest-angle lens that fits your pocketbook.

A tripod and a cable release are mandatory for interior photos. While you may be able to avoid them for most exteriors, forget that philosophy when you move inside. I have taken some hand-held, available-light interior shots with a 35mm

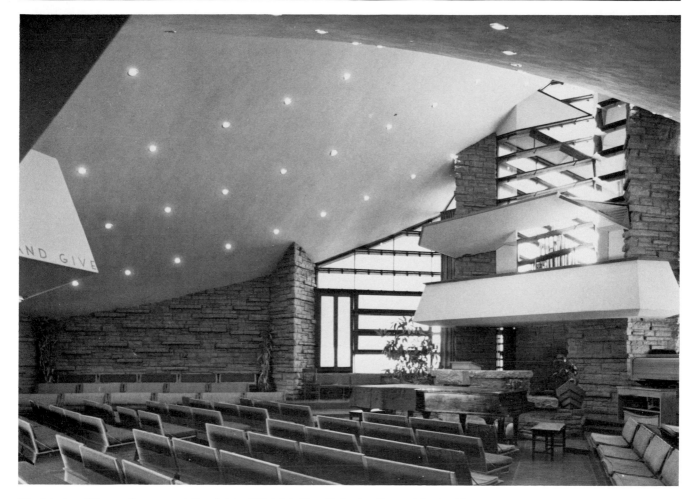

The interior of the meeting room at Frank Lloyd Wright's First Unitarian Society Meeting House was taken with a tripod-mounted Nikon F2 Photomic camera and a 28mm f/4.0 PC-Nikkor lens. No supplemental lighting was used. The only lighting was from the ceiling-mounted floodlights and the windows seen in the photograph.

SLR, but the results show camera movement and lack sufficient depth of field due to the slow shutter speed and open aperture I had to use.

Nevertheless, when your only hope to get an interior shot is with a hand-held 35mm camera, by all means give it a try. The worst that can happen is that you will ruin a few frames of film. In such cases, look around for possible body braces to help steady you. If possible, place your camera on something fixed in place, such as a church pew, the back of a chair, stairs, pianos, or whatever else is there. Breath and shutter-finger control are all-important when using ridiculously slow shutter speeds. Hold your breath, but do not fill your lungs, and then squeeze the shutter slowly. If you have a cable release with you, use it.

An excellent trick at such awkward times is to trip the shutter with your camera's built-in self-timer. You can just set the camera down and then release the shutter without hands touching it—and hands are the transmitters of motion. This can also save the day when you have your tripod but forget your cable release. Finally, it is the only way to go when taking photos straight up into cupolas or domes (place the camera, back down, on the floor).

In positioning a camera on its tripod for an over-all view of a room, you will normally back into a corner, or partially out a doorway, and use a very wide-angle lens. Remember to keep the camera perpendicular, to avoid convergence, even with fixed, nonshifting lenses. The effect of tipping a camera away from the vertical is dramatically

This is not an award-winning-quality picture, but it is a passable image taken without supplemental lighting under extremely adverse conditions of glare and back-lighting. The First Universalist Church, built in 1834 at Childs, New York, serves as the headquarters of the Cobblestone Society and was photographed with a 20mm Vivitar lens on a tripod-mounted Nikon FE.

In photographing an over-all room or space with a fixed lens, pay special attention to the lower foreground, as there will usually be a lot of it. Raising the camera by elevating the tripod or seeking a higher vantage point, on stairs, a ladder, or a balcony, is effective in reducing the foreground when necessary. Of course, if you are using a 28mm PC lens, and this has a wide enough angle of view, then you can simply shift the lens upward as necessary to control the foreground.

Light and shadow are the crucial concerns after the camera is positioned. Here are some suggestions:

1. Sun flowing in through a window can be a disaster. It can be reduced by pulling a shade or curtain or, better yet, try photographing such interiors on overcast days or when the sun is temporarily blocked by a cloud. In some ways, the ideal lighting conditions for interiors are the reverse of those for exteriors. Overcast is preferred, and north-facade windows provide the best light. Uncontrolled, direct sunlight will result either in a burned-out white area on the print and/or dense, black shadow areas.

2. If there are no strong contrasts in the view, expose for shadows. If there are strong contrasts that cannot be reduced, try exposing for light shadow areas, and then bracket your exposures in several frames. Normally, I find it is best to err on the side of overexposure in interiors.

exaggerated with wide-angle lenses. If you must depart from the vertical, do it with gusto. If the over-all view is oblique to walls, you probably will not have to worry about reflections of you and your camera. However, when shooting one-point perspectives, be wary of finding yourself reflected in mirrors, windows, or glossy wall surfaces.

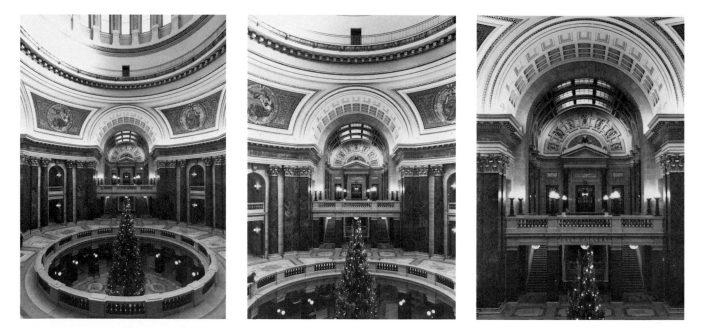

Series of interior photos taken with 20mm, 28mm, and 50mm lenses: the Wisconsin State Capitol at Christmas. These photos demonstrate how restrictive a 50mm lens is in interiors, even when dealing with large spaces, such as this. Even a 28mm lens cannot produce an over-all view.

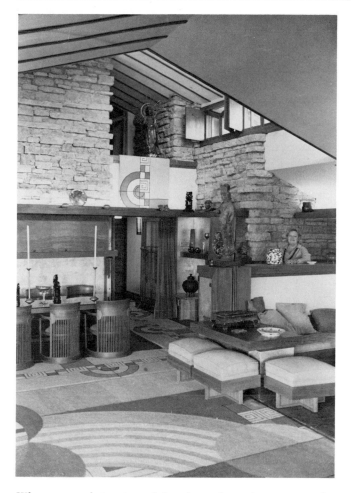

When you are desperate, and there is no alternative, you can take passable interior photos with a hand-held camera. This view of the interior of Frank Lloyd Wright's living room at Taliesin was taken during a tour of the building, when others in my party were out of the scene.

The Wisconsin State Capitol was designed by New York architect George B. Post and built between 1907 and 1917. This view of the West Gallery was taken with a tripod-mounted Nikon F2 Photomic and 28mm f/4.0 PC-Nikkor lens shifted upward.

3. When it is reasonable to do so, move the camera so that illuminated windows are out of the view and use them for indirect illumination of the space.

4. Stained-glass windows are easily burned out by direct sunlight. They should be photographed when in shade or on overcast days, remembering to balance color films for overcast with an appropriate filter.

5. When possible, place the well-lit areas of the view toward the center of the picture, allowing those areas with deepening shadows to drift toward the edges. This will help focus the viewer's attention on the center of the photograph.

Those who are willing and who have the time to experiment with supplemental lighting can try some

more things. The camera can be set at a very small aperture, such as f/16 or f/22, and then set on "time" exposure and the lens opened. An assistant can then use an electronic flash, hand-held, to illuminate darker areas. This works especially well on night exteriors, as an entire, modest building can be illuminated with a sequence of flashes. In some cases, the lens will be covered occasionally while the flash unit recycles and the assistant moves to a new position.

Some photographers become adept at "painting" with light. In this procedure, a photoflood unit is used to wash the walls or shadow areas with continuous motions during a long time exposure at small apertures. An assistant walking through the view with a light in continuous motion is not visible

In this photo, taken for a free-lance magazine assignment, the editor wished to focus on the lush table settings at Villa Louis, Prairie du Chien, Wisconsin. The only lighting was existing room lights; the camera was mounted on a tripod.

When attempting to paint with light or use multiple flashes from independent positions to illuminate interiors, it is best to leave the normal room lights turned off; otherwise they will overexpose themselves on the film during longtime exposures. When the supplemental lighting attempts are concluded, the room lights can be turned on briefly so that they appear lit in the finished view.

As you can see, however, using even simple supplemental lighting is difficult and requires experimentation and experience for good results. This is why I, and probably most other photographers of architecture, rely almost exclusively on available lighting. Handsome results, certainly adequate for such purposes as National Register of Historic Places nomination photos or slide shows of architecture subjects, can be obtained with it. When trying interior shots, it is important to be willing to experiment and to fail regularly. You should be willing to try many exposures in the beginning to get the "feel" of selecting exposures. Be especially careful of strong contrasts and seek to reduce them by whatever means are readily at hand.

In shooting color slide interiors, you need to be aware of lighting coloration, a factor you can ignore in black-and-white photography. Most of us use daylight film normally, and in such instances you should carry a filter for incandescent interior lights and one for fluorescent lights. The chapter on filters deals with this in more detail, though someone interested in filtration for fluorescent lighting should seek a source of information that deals with this complex subject at length. Many scenes, of course, blend daylight, incandescent lights, and fluorescent light all in one view. If that is unavoidable, all you can do is shoot the scene, with and without various filter combinations, and choose the view you like best later.

Architecture is, in part, the art of manipulating interior space. Conveying dynamic spaces through slides or photographs is difficult, and usually involves a series of photos taken from different vantage points to illustrate as well as possible the spatial flows involved. Some have experimented with motion pictures to explain interior spaces. The camera moves through these spaces to give the experience of walking through a building. This is not a realistic option for most of us, however, because it requires an entirely different set of photographic and projection equipment, and because the quality of Super-8 or even 16mm movies simply does not match that of 35mm slides or prints.

during long exposures. Of course, neither the assistant nor the light must ever stop, even for an instant, to avoid making an impression on the film. The beauty of this system is that it allows dark areas to be illuminated with minimal equipment. It also calls for the photographer to experiment with the procedure before using it seriously.

An electronic, camera-mounted flash can be used to photograph some interiors, but the results are usually disappointing. They tend to be flat, one-dimensional pictures with overexposed foregrounds, underexposed rear areas, and usually with a reflection of the flash. A camera-mounted bounce flash is better, depending on the height and color of the ceiling, but that still produces rather uninteresting results.

An interesting and innovative new system for exhibiting spatial movement with 35mm slides was demonstrated at the 1980 annual meeting of the Society of Architectural Historians, and it offers some promise. A photographer using this technique begins by photographing an interior space every few feet as he proceeds through it, moving the camera smoothly from position to position without dramatic changes in the angle of view. If he then projects the resulting slides in sequence with *dissolve* projection equipment, it produces an illusion of moving through space because of the overlap of the slides as one fades into the next, each taken a little beyond the former. This concept cannot be demonstrated in a book, obviously, but is worth trying if you are attempting to illustrate to an audience the dynamics of a complex spatial flow. It is a cross between motion pictures and still photography that offers the benefits of perspective control and image clarity possible only with the later.

If there is one overriding impression I would like the reader to get from this chapter, it is do not be afraid to experiment. All a failed attempt will cost is some film. The severe space and lighting limitations of interior photography are challenges more than they are impediments. It is genuinely fun to see whether you can capture the essence of a space in spite of the obstacles the building throws up before you. And I predict that you will be pleased more often than you will be disappointed by the results you obtain. Often you will not be able to do a single thing to improve your lighting or the arrangement

Natural light from a bank of windows to the right of the judge's bench illuminated this view in the courtroom of the Green County Courthouse, Monroe, Wisconsin. The Nikon 35mm SLR was mounted on a tripod, and the 25mm f/2.8 PC-Nikkor was shifted upward to correct for perspective distortion.

The roof trusses spanning the drafting room at Taliesin had just been restored with a federal historic preservation matching grant when I photographed this interior view with a hand-held SLR.

Here is a passable interior view of Louis Henri Sullivan's Merchants National Bank, Grinnell, Iowa, built in 1914. The Sunday I arrived, the bank was closed, of course, so I held the camera lens against a glass door—my "tripod"—and took a long exposure. The resulting color slide was converted into a black-and-white print for this illustration, via a color 35mm internegative. That the image is fuzzy and crude is not surprising—that it even exists *is!*

of the parts of the scene. So what? Accept that fact, and do what you can with what you have. Experience is a great teacher; glorious flops may be the best lessons of all.

The second major impression I leave you about interiors is that they are, in many ways, the opposite of exteriors. Good light is absence of sunlight.

Exposures are not certain; bracket frequently. Err on the side of overexposure inside, but underexposure outside. The best-lit facade faces north. Use slow shutter speeds . . . and a tripod! Indeed, if you are lousy at photographing exteriors, you may be a natural with interiors.

After Exposure

ONCE A roll or sheet of film has been exposed, it needs to be processed. If a negative film, it should have contact prints made, and perhaps also some enlargements. Thereafter, it ought to be organized in a system so that the photographer can retrieve it, and it should be stored under as favorable conditions as possible.

Processing. Color transparencies, whether 35mm or 4 x 5, are usually processed by professional laboratories, although some color films can be processed by the photographer with the proper skills and equipment. The chances are that most of you will have color film processed commercially. Kodachrome and Ektachrome 35mm slides can be processed directly by Kodak through the use of mailers. These provide a tremendous service and can be a bargain, as well. You can stock up on mailers at a favorable price and become immune to price increases until a new supply is needed. Moreover, Kodak itself does the processing, and getting the film to and from Kodak is no more inconvenient than a trip to your nearest mailbox. However, if you are in a hurry for the results, you should use Ektachrome, which can be processed overnight by commercial processors locally; Kodachrome usually takes at least a week through the mails. Risking film to the mails induces another hazard, though, in all my years of mailing Kodachrome films to Kodak, I have lost but one roll of film, which seemingly vanished from the face of the earth—probably somewhere in Chicago's immense mail network. Since then, I take the following precautions with mailers: I staple the envelope shut to assist in holding the film can in it; I place my name and address on the film can itself with a self-adhering label, so that if the envelope is torn open en route, the can is still identified and is returnable.

Processing large-format cut-film transparencies should be done by a reputable professional photo lab that is used to handling this film type. All Kodak sheet film for positive transparencies is Ektachrome, so that is possible. Small processors may not handle sheet films much, so steer clear. You might check with local professional photographers to see where they take their color film for processing. One of the best processors in my part of the world operates out of the basement of a motel and is known only by the pros.

Black-and-white negatives are a different story. They can be processed at home easily in a daylight processing tank, which may be advisable for 4 x 5 negatives unless you can find a local processor who deals with them routinely (see chapter 5). A very few large photo labs in major cities like New York and Chicago *can* process 4 x 5 negatives without ruining them, but if you try one, send a test negative or two, first. If you are concerned about the long-term storage of your negatives, then self-processing is probably best, so that you can be certain all the residual hypo has been removed from the film. Some commercial processors provide special archival processing for an additional cost. If long-term storage is one of your requirements, it is worth the extra cost. Otherwise, almost any commercial processor is used to handling 35mm negatives and does so cheaply.

If you obtain contact, or proof, sheets of your negatives when they are processed, you will have a handy reference to them. From these, you can select those frames of which you would like enlargements. The popular "jumbo" 3½ x 5 prints of 35mm frames may be fine for family albums, but not for

referencing your collection. A contact sheet of a roll of film is less expensive than a set of jumbo prints, and it provides better reference. The same logic holds true for 35mm color negatives and 2¼-inch negatives.

Black-and-white enlargements can be purchased from photo labs in various grades at various costs. Some offer two grades, machine-printed and custom-printed, while others offer more. For the photos in this book, I used machine prints whenever possible to economize, depending on the nature of the photograph. Obviously, the more hand labor involved, the higher the cost will be.

A great war is now being waged about the use of synthetic resin-coated (RC) paper as opposed to the traditional standby, purified wood-pulp fiber-based paper. Without getting into an analysis of that issue

Sometimes an unpretentious, straight-on view of an unpretentious building is the best one. I have always liked this simple photograph of a brick building on its brick street with its fading General Insurance Agency sign.

to any depth, suffice it to report that current opinion is that RC stock does not last as well as fiber-based paper. Presumably, improved technology could change that, in the future. If archival permanence is in your scheme of things, you want fiber-based paper. If not, you need not worry too much about the battle. Photos in this book were printed on both types of stock, depending on the processor. One processor I patronize regularly is Gamma Photo Labs in Chicago, and Gamma still uses fiber-based paper as much as it can. The president of this company advised me, however, that he may not be able to keep that policy much longer, due to the availability of fiber paper and its cost. The Historic American Buildings Survey (HABS, see chapter 12) insists that all prints and contact sheets it receives be done on fiber-based paper with archival processing, because it is interested in very long-term storage.

The main idea behind archival processing of films and papers is to be absolutely certain that all development and fixing chemicals have been removed from the media involved. If that is not done successfully, the chemicals will cause premature discoloration of the image and the film or paper. Crucial to that is the removal of the last chemical used: the hypo, or fixing bath. Special hypo eliminators can be obtained from any photo store and should be used in tandem with extra-long final washings. Kodak markets a hypo test kit that can be used to see whether all residual hypo chemicals have been removed. Kodak's publication J-11 includes a Hypo Estimator Scale for use with this kit. HABS standards require visible levels no higher than comparison patch No. 1. Detailed information on archival processing of all types of media is found in Kodak's excellent booklet F-30, *Preservation of Photographs*, and need not be repeated here.

Filing. Professional architectural photographers generally set up interwoven files based on job numbers. For a complete description of one such system, see the chapter on setting up an office in Julius Schulman's *The Photography of Architecture and Design*. Most of us, however, would be more likely to use a system based on something other than job numbers, as the latter really only makes sense to a professional photographer, though it might also be useful to a professional architect.

Every photographer should set up a system that makes sense for him. You will need to have a system that accommodates negatives and transparencies in as many formats as you use. You may then establish

a master 3 x 5 card file that indexes the collection according to whatever subjects make sense to you: architects' names, geographical locations, architectural styles, building types, job number, and so on. If you use one medium exclusively, or most of the time, that makes things easier. For example, if you only take 35mm slides, your job is quite simple, because individual slides can be labeled and filed in whatever order you wish. In such a case, you may not even need a 3 x 5 master-card file. If you use 35mm negatives, 35mm slides, 2¼-inch negatives, 2¼-inch transparencies, 4 x 5 negatives, and 4 x 5 transparencies, as I do, your job is more complex, as all these media have to be rationally interrelated. The card file becomes the core of your system.

It is impossible to design a system that is universal, so I will just outline what I do personally and what we do in our office to give you some ideas.

The greatest volume of my media are 35mm negatives and slides. They, then, are the core of my files. Medium-format and large-format media are related to them through the card file. When black-and-white 35mm and 2¼-inch negatives are returned from processing, I assign each roll a number in sequence, regardless of format in these cases. The basic four-digit number starts with two digits for the year and then two digits for the number of the film roll taken that year—a number assigned when the film returns. If I go over ninety-nine rolls that year, I then have some five-digit numbers. Thus, for example, the number "8314" would refer to the fourteenth roll of 35mm and 2¼-inch film shot in 1983. To indicate the frame number on a given roll, I follow these numbers by a hyphen and the frame number from the film itself. Thus "8314-27" is the twenty-seventh frame on the above roll. Those who load their own 35mm film will find that a frame number can be from 1 through 44 and that the first exposure on a given roll will probably not be number 1. I label the contact sheet for each roll with the same roll number as the negatives and file the contacts separately. One could punch contact sheets with a three-hole punch, if desired, and file them in notebooks. In our office, we use a variation of this system for architectural surveys (see chapter 12).

Slides, because they come back from processing as individual units rather than rolls of film, can be filed differently from black-and-white film rolls. My personal and our office slides are generally filed geographically. Architectural historians may prefer to file slides by architects' names and/or styles. Architects may prefer clients' names or job numbers. Choosing a filing system involves decisions each photographer must make individually.

When slides and processed negatives come in, you should take the time necessary to make out 3 x 5 cards on them. I maintain subject cards by building location, by architect, and for other subjects not related to architecture, such as hobbies or family members. I note on each card the roll and frame number for black-and-white negatives, whether or not I have slides for the subject, and, if I do, their dates and quantities. That seems to work for me, but others may need more voluminous systems. I look forward to the day when home computers will be inexpensive and widely available, for then I may be able to retire my card file and create a much more useful system based on the computer.

Four-by-five negatives and transparencies resemble slides more than film rolls, in terms of a filing system, because they can be filed individually. Four-by-six card filing boxes work fine for 4 x 5 sheets of film and are inexpensive, so I use them. I use the same subject headings for 4 x 5 files as I do for 35mm slide files in order to keep things as simple as possible. Kodak recommends that you do not use wooden filing drawers or boxes for photographic materials.

When 4 x 5 materials are processed, note them also on the 3 x 5 central card file. You will then have a single card or group of cards for a given building from which you can instantly ascertain what you have in your collection in all types of media. Julius Schulman recommends thorough cross-filing, so you can always find out what you want to know at any time. Therefore, you may wish to have 3 x 5 cards for a single building made out for its location, its architect, its style, its use, its job number, its client name, or even its materials—all depending on your industriousness and need to know.

Storage envelopes and conditions. Negatives and medium or large transparencies must be filed in envelopes or sleeves. Slides can be stored in drawers, cases, or three-hole, twenty-slide sheets. Wood and wood-based products are not suitable for storing negatives or transparencies. Kodak does not recommend semitransparent glassine envelopes or sleeves for long-term storage, but does recommend envelopes of the "best quality" paper carefully selected with glue seams at the edges, not at the

Fluted Corinthian columns flank the main entrance to the George Eastman House, Rochester, New York. Here is housed a superb collection of historic and modern photographs, as well as an assortment of historic cameras dating back to the birth of photography.

center. Clear sleeves of cellulose acetate are used extensively and are "generally satisfactory," according to Kodak. But they do not permit water vapor to pass through them, and they can catch dirt inside, scratching the films. Thus, control of humidity and dirt is mandatory if they are used.

In temperate climates, especially in air-conditioned buildings, negatives can be stored satisfactorily. Relative humidity should be held between 30 percent and 50 percent. Storage in high-humidity areas without air conditioning is problematical.

Color images are much more impermanent and fragile than black-and-white images. The primary factors affecting storage quality are temperature, relative humidity, and exposure to light. The cooler the temperature (provided relative humidity does not climb excessively), the longer the color images will last. Dyes in color films deteriorate with exposure to light, so they should be viewed as little as possible. Frequently projected 35mm slides should be photographed in duplicate originally or duplicated later. That way, one set of slides can be preserved while the duplicates are projected. Kodak feels that "excellent color fidelity for generations" can be expected with Kodachromes and Ektachromes if they are stored in the dark under conditions of 70 degrees Fahrenheit and 40 percent relative humidity.

Few of us operate museum photographic collections, so few of us are really interested in archival storage. However, we should understand that films do deteriorate and that, with a little care about heat, humidity, and darkness in storage conditions, we can do much to reduce their decay. For those interested in this matter and concerned with long-term storage of photographic media, consult *Collection, Use, and Care of Historical Photographs*, by Robert A. Weinstein and Larry Booth, published in 1977 by the American Association for State and Local History, and Kodak's *Preservation of Photographs*.

Submission to publishers. Photographers submitting materials to publishers for possible publication should send slides in twenty-slide sheets. Depending on the nature of the submission, contact sheets of 35mm negatives or selected enlargements can be submitted. Publishers are generally not interested in color prints, and many prefer medium or large transparencies to 35mm slides for color images, as the former reproduce better and are more easily viewed on a light table.

Bear in mind that a photographer's photographs are covered by copyright law. He owns all rights to them unless he assigns rights to another in writing. Thus, he should print, write, or stamp a copyright notice on all photographs submitted for possible publication. For a complete discussion of the law and photography, consult *Photography, What's the Law?* (See appendix.)

Also worth consulting by those interested in publication is the widely available *Photographer's Market*, brought up to date annually. Most local libraries should have a reference copy of this book, which lists thousands of known publishers who purchase photographs regularly.

Slide shows. Almost anyone seriously photographing buildings will be called upon to present architectural slide shows from time to time. Educational and service organizations, historical societies, American Institute of Architects chapters, and social clubs are typical groups that find such presentations interesting.

If you do many slide shows, you will find it easier to store your slides in drawers or cases, rather than in sheets, as it is tedious to remove and replace slides frequently with the latter. You might even develop one or more "canned" slide shows, in which case it is reasonable to store those slides right in their projection trays.

Regarding slide shows themselves, do not make them painfully long. You will generally find your slides much more interesting, yourself, than will your audience, so take it easy on your viewers. A half-hour is a nice maximum, unless you know your audience is *really* tuned in to the topic and hanging on your every word and image. And mix your slides up in terms of their feeling and distance from subjects. If you show eighty slides of buildings, all taken from the same angle and distance, your audience will be asleep early in the show. Weed out poorly exposed slides. It is better not to illustrate a building than to show a poor slide of it. Don't apologize to the audience for a bad slide—don't show it! Run slides through the projector rapidly. If you are going to talk about a certain building for two minutes, do not leave one slide on the screen all that time. Show perhaps eight to twelve views of it, at

George Washington's famous Mount Vernon, in Virginia, is a major eighteenth-century tourist attraction. This photograph was originally a 35mm slide and was converted to a black-and-white print through a 35mm color internegative. The view emphasizes the spare simplicity of the facade facing the Potomac River.

different angles and distances, illustrating different things. That will also help you organize your talk. If you mention the tooling on the stonework, show a close-up of that tooling.

Some people have a gift for talking. Others do not. If you don't, and if you're serious about public presentations, take a course in public speaking. When a building is first illustrated on the screen, do not start your statement about it with the phrase, "This is . . ." Also, do not use hackneyed jokes. If you wish to inject humor into the talk—*always* a worthwhile goal—let it arise naturally out of yourself and the subject matter under discussion. Laughter will at least wake some people up and make them wonder what they missed!

After some of the talks I give, someone will come up to me afterward and complain that the talk was too short. That is a real compliment. It is an old axiom of show business that you should leave the audience begging for more—if you can. Under no circumstances should you then go back and lengthen your show! If no one ever comes up afterward to tell you the talk you give is too short, then go back and shorten it until someone does. On rare occasions, my audiences will complain as soon as I stop that I should go on some more. *Do not do so!* Stop! If you wind up shortening your talk into oblivion, then you need to reanalyze your slides and your speaking style completely, as apparently no one wants to see and hear your presentations. If you are going to err by being too brief or too lengthy, *always* err on the side of brevity. Your audience will thank you for it consciously or subconsciously. A corollary is that you should never show slides at a party, unless everyone knows you are going to do so well in advance and everyone has a convenient avenue of escape. If you hear cries of "More! More!," thank the audience profusely; then graciously—but absolutely—*refuse* to show more. Never say, as I have personally witnessed, "Oh, I have more slides in the car. I'll just get them and be right back." To one trapped in a darkened room watching slides in which he has only modest interest, slide shows are among the most deadly things in existence. Accept that fact and never forget it. One trick I have used successfully is to hold the slide show in a separate room and announce to those assembled that it is about to begin, making certain they do not feel compelled to come in to watch and that there is plenty to occupy them elsewhere. When you are a dinner speaker,

however, that is impossible; so keep your talk *short* and *lighthearted.*

Displays. If you are proud of some of your photographs, you can frame or mount them for your home and/or your office walls. That can be accomplished most inexpensively by dry-mounting them on boards. More protection can be afforded by then framing them under clear, ordinary glass, not the so-called nonreflective kind. Frame-it-yourself kits are now widely available, inexpensive, and professional looking. I prefer the metal frames, which go well with photographs and are not distractingly ornate.

The advice in Kodak's *Preservation of Photographs* regarding mounting prints for display purposes should be followed. Kodak recommends using dry-mount tissue instead of any type of glue or chemical, as the tissue provides a barrier between the print and the mounting surface behind it. Note that a special, low-temperature, dry-mount tissue is required for prints made on RC stock.

Considering the costs of original art by local artists, the cost of enlarging and framing a good print is reasonable. Be bold occasionally and try a 16 x 20 or larger print. Photo murals are not outrageously expensive, and some photographic laboratories have a specialty in making them. Of course, a 4 x 5 original negative or transparency is preferable for photo murals or 16 x 20 enlargements, but sometimes the graininess of smaller negatives is interesting in itself. One of my 2¼ x 2¾ transparencies was blown up by a chamber of commerce to cover an entire wall. Its graininess is evident, but not really distracting when you stand back from it.

Display boards for public education purposes can be both informative and very attractive if they are designed creatively and utilize good photographs. If the photograph is not top-quality, however, do not use it on a display board. I find there is always a balancing act to be done between the information to be presented and the quality of available photographs. If the information to be illustrated is necessary and the photos are poor, obtain new photographs rather than accept poor images. Good photography should be required because it is so much more effective in reaching and touching people. Depending on your budget, the services of a professional photographer are worth considering in making display boards.

12 Special Considerations

THERE ARE some special tasks and considerations architectural photographers should know about, especially those working with historic buildings. Certain federal agencies have special requirements for the submission of photos of historic structures, and there are special procedures for architectural surveys and for producing rectified, scalable photographic prints. The latter are especially useful to architects working with schemes for existing or historic buildings.

National Architectural and Engineering Record (NAER). The National Architectural and Engineering Record is a division of the National Park Service in the U.S. Department of the Interior. It was created in 1979, to combine the older Historic American Buildings Survey (HABS) and the Historic American Engineering Record (HAER) into one entity. Both offices document historic properties with large-format photographs, measured drawings, and histories. Documentation by NAER is maintained in the Library of Congress and by 110 libraries throughout the United States. As of this writing, NAER documentation included about 68,000 photographs and 40,000 drawings of about 20,000 historic buildings and structures.

The Historic American Buildings Survey itself got its start during the Depression as a federal project to generate employment for out-of-work photographers and architects. They were turned loose to document America's historic buildings through carefully prepared measured drawings and photographs. In the Historic Sites Act of 1935, the program was codified as HABS and given a stable basis, although it was inactive from 1941 to 1957. Teams from HABS have been documenting historic buildings primarily during special summer projects

ever since then. Other HABS projects are generated by federally assisted construction projects that result in the demolition of historic buildings, which are documented prior to their destruction. Moreover, HABS will accept properly prepared negatives and prints of historic buildings from individuals interested in historic architecture or documenting properties on their own prior to demolition.

Standards adopted by HABS for architectural photography are enumerated in an occasionally revised packet, "Photographic Standards for Contract Photographers," available upon request from NAER (address in appendix). The essential points of these standards are:

1. The camera used must be a 4 x 5 or larger view camera having all necessary perspective-correction features and bubble levels. Lenses must have adequate covering power to accommodate front and rear camera movements.

2. Film must be fine-grain, black-and-white, cut or sheet film, 4 x 5 or larger in format.

3. Processing must be to archival standards, including, specifically, use of a hypo clearing bath and thorough washing to remove all traces of residual hypo.

4. Prints must be contact prints on fiber-based paper (no resin-coated paper is permitted), and placed in labeled envelopes with notations as to the structure's name, the location of the building, a description of the view including compass orientation, the month and year of the view, and the photographer's name.

5. Sunlight is preferred for exteriors, especially of the main facade. Interiors should be supplementally illuminated, if necessary, to reveal details in shadow areas.

6. The area to be photographed should be

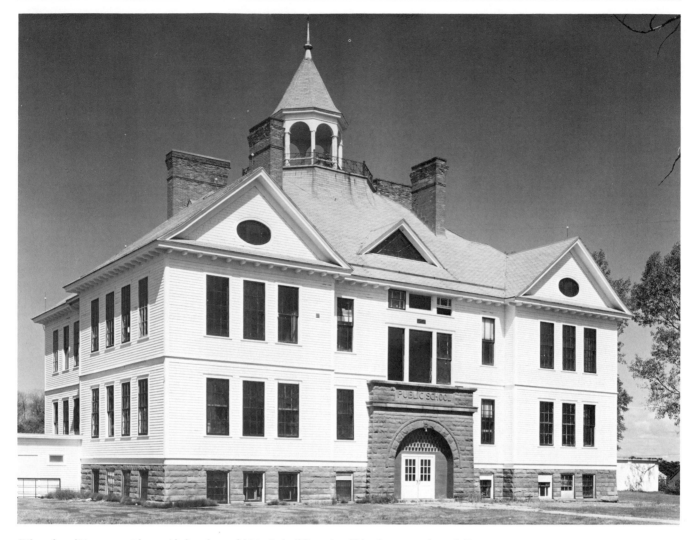

When demolition cannot be avoided, a doomed historic building should be documented carefully with large-format equipment. The resulting photographs should be preserved in an archives or by HABS. The South Shore Public School, Port Wing, Wisconsin, listed on the National Register of Historic Places, was demolished only a week after I took this photograph (two windows above the entrance have already been removed) with a 4 x 5 view camera, a 150mm Rodenstock Sironar f/8 lens, and an orange filter. Efforts to save the building proved fruitless, largely because the community's economic base was not large enough to sustain it.

sanitized; that is, trash, weeds, bicycles, vehicles, and other "undesirable" elements should be removed whenever possible. Aesthetic consideration are considered secondary by HABS staff to clarity in describing the building.

7. No perspective distortion is permitted "unless obviously introduced in a very limited number of instances for special artistic effect," and all areas of the picture should be in "razor-sharp focus."

In short, HABS sets high and traditional standards for its architectural photographs. While these may be difficult for the average photographer to meet, there is satisfaction in having done so.

HABS prefers that buildings included in their projects be photographed by professional architectural photographers. However, others possessing the necessary equipment should not be reluctant to attempt HABS-quality photography should the opportunity arise.

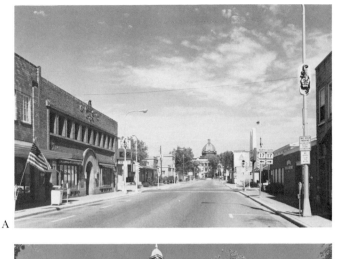

A

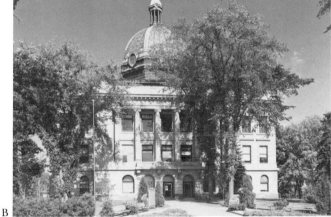

B

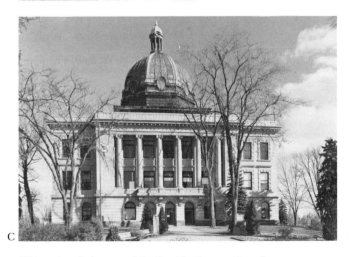

C

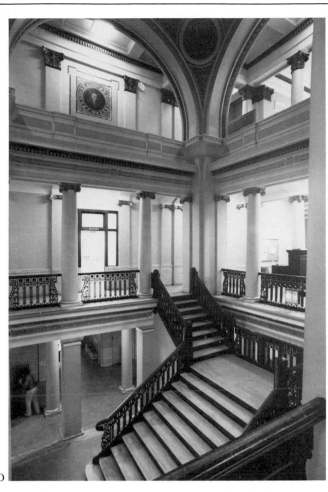

D

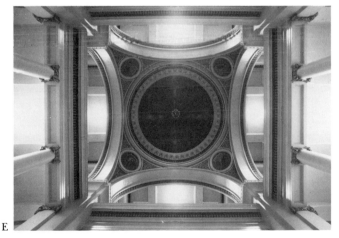

E

This series of pictures of the Oneida County Courthouse, Rhinelander, Wisconsin, was taken for a nomination to the National Register of Historic Places. Photo A shows the courthouse in its setting, terminating the axis of a downtown street. The First National Bank, a Prairie School building designed by Purcell and Elmslie, is on the left. Photo B shows the

main facade in summer; Photo C is in the autumn, permitting a much clearer view of the details of the facade. Photo D is of the interior light well around which the building is organized. Photo E is a view straight up into the skylight under the octagonal dome. Unfortunately, the skylight has been covered over, preventing natural light from passing through it.

National Register of Historic Places. Unlike HABS photography, that undertaken for the National Register need not be carried out with large-format equipment. Indeed, most of the photos in the National Register's archives were taken with 35mm equipment not even having the benefit of perspective-correcting lenses. However, that does not mean that a photographer should be careless with his National Register photos. Professional pride and the modest incentive of possible inclusion of a photo in a National Register publication suggest that the photographer should use care and the best possible equipment in taking National Register photographs. At the least, National Register staff appreciates receiving quality photographs and occasionally laments that it does not receive them often enough.

National Register photography standards, given in the publication "How to Complete National Register Forms," are sketchy but do stipulate that "high quality" prints are necessary. Other standards are that historic sites and buildings should be completely documented by photos, so that persons not familiar with them can understand them, and that medium-weight, black-and-white, glossy, unmounted prints be submitted.

Experience has provided me with some suggestions for illustrating structures to be nominated to the National Register:

1. While 35mm SLR cameras may be used, you should definitely use fine-grain, black-and-white film such as Panatomic-X or Plus-X.

2. If possible, mount the camera on a tripod. If no tripod is employed, at least use a shutter speed of 1/125 of a second or faster to eliminate camera motion.

3. Document the building thoroughly in the field: all exterior sides both in elevation and perspective views; major interior rooms and spaces; interesting interior and exterior details; and the building in its surrounding environment.

4. Take colored slides of most views, as well as black-and-white. The former are useful in presenting a building to an official board or to the public.

5. Avoid using flash in interiors unless it is mandatory in order to get *any* image. Especially avoid flash for black-and-white views.

6. Spend what is necessary to get good-quality, 8 x 10 prints, preferably on fiber-based papers, for better permanence.

7. Use perspective-correcting lenses on 35mm SLRs whenever perspective correction cannot be achieved without them.

8. Plan your trip to the building to be photographed well ahead of time so that you arrive at the site when the sun is in a reasonably good position, especially with respect to the main facade. Keep your trip plans flexible enough so that you can reschedule if the weather is not good.

9. I have found that photography turns out better if you can address your photographic problems without a local sponsor of the nomination following you around. You can concentrate and think better. *Schedule appointments, therefore, to commence after your photography is over.*

Architectural surveys. State historic preservation offices and local preservation commissions, as well as private preservation organizations, conduct surveys to identify historic buildings and structures eligible for entry in the National Register of Historic Places. There is no uniform, national system for organizing and conducting these, so each state has developed its own system. Indeed, I received recently a looseleaf book of copies of blank survey forms from the various states; it is 1½ inches thick.

Photographic procedures are critical to these surveys, because enormous amounts of film can be used, perhaps fifty rolls or more of 36-exposure film per month per surveyor. When dealing with such volumes, details of identification are vital, or else you will wind up with a pile of unidentified rolls of film in your office after processing.

In our surveys at the State Historical Society of Wisconsin, we use the roll of film as the core of our organizational system. Each roll of film has its own assigned number, and the surveyor's first exposure on any given roll is of that number, written on any piece of available scrap paper with a felt-tip marker. Determining what the number is depends on a state's survey system. We assigned a two-letter prefix for each county, such as "JE" for Jefferson County. The first roll of film shot in that county is "01," and each roll afterward is numbered in sequence. Thus, "JE-46" would be the forty-sixth roll of film shot in Jefferson County. Later surveys pick up the numbering where earlier surveys left off.

As the surveyor works, he uses the film-generated numbering system on his survey forms and maps to identify each site as it is documented. On maps, of course, the "JE" prefix can be forgotten, because it is

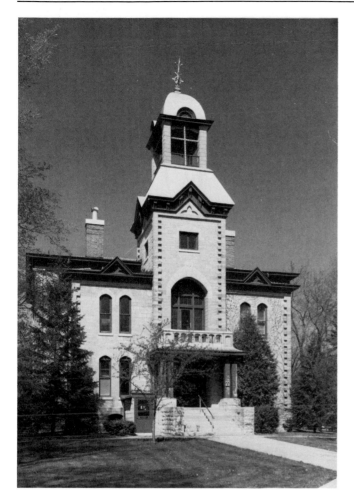

The Vernon County Courthouse, Viroqua, Wisconsin, is illustrated here in a typical photograph of a building taken for a National Register of Historic Places nomination. The building was entered on the National Register in 1980, in time for its one-hundredth anniversary.

self-evident from the map's coverage which county is involved. Thus, the first frame exposed of a given building generates its survey number. "JE-4627," the twenty-seventh frame on roll 46 shot in Jefferson County, might be the first frame exposed of a Greek Revival house, for example. That house would then be noted on the survey map and on the survey form with the number "4627." Back in the office, then, the films, maps, and forms are automatically interrelated by that number.

We file our survey forms, negatives, and contact sheets by county as well, so that all the Jefferson County materials would be found filed together sequentially by film roll number. We file maps separately, as those that we use overlap county boundaries. United States Geological Survey (USGS)

quadrangles, which we use for rural surveys, we file alphabetically by quadrangle name. We use large-scale community maps for urban surveys and file these alphabetically by community name within each county, which does present minor problems when cities overlap county lines, as they occasionally do.

We used to have our surveyors take slides of selected buildings during our visual or reconnaissance surveys, but have suspended that practice. Now our initial surveys are done exclusively with 35mm black-and-white films.

How you process survey films is important and depends on the system of the sponsoring agency. We order both contact sheets of each roll of film and so-called "jumbo" (3½ x 5) prints of each frame. The latter we mount on inventory cards for our statewide inventory of historic places. The former are basic indices to each roll of film. Film roll and frame numbers are noted on each inventory card, of course, so users can readily locate the negatives for any print and the original survey forms. We are lucky in that our film processing laboratory still uses fiber-based papers for its prints, though that could change at any moment. Illinois used an interesting variation on our processing scheme. It obtained enlarged proof sheets of each roll of 35mm film from a major Chicago photographic laboratory and then cut up the proof sheets for mounting on cards.

If it is possible to provide surveyors with perspective-correcting lenses and SLRs to accommodate them, the results are worth it. This is especially true for in-depth, intensive surveys designed to result in nominations to the National Register of Historic Places. It is less important for reconnaissance surveys. When an exceptional property is discovered, it should be photographed as thoroughly as though it were in fact a nomination to the National Register, to avoid the necessity of a later field trip.

An important element in most or all reconnaissance and intensive architectural surveys is documenting potential areas of historic significance: historic districts. While the elements of photography do not change in such cases, the type of information conveyed to later viewers of the photographs is altered. The following considerations are important when you are documenting a historic or architectural district photographically:

1. A major issue in defining districts is what their boundaries are. You need to convey to later viewers of your photographs the visual elements that help

define the boundaries. It is especially important to do that with 35mm slides, as they are a major tool in explaining districts to groups. If you can show the edges of a district photographically, you will be way ahead of the game, and boundary definitions will be made much easier later on.

2. You should attempt to show the over-all character of the district through general scenes illustrating the way the various historic buildings and structures relate to each other and to open spaces. Some photographers have used the technique of taking multiple pictures, in sequence horizontally, from a single vantage point such that each view overlaps the next. You can then piece together a broad panorama; physically, in the case of black-and-white, or sequentially, as with slides.

3. Exceptional monuments in the district—pivotal buildings—should, of course, be individually photographed. Special care should be taken to illustrate the ways major buildings of this type relate to their environments, especially if they terminate axes or dominate areas in some other manner.

4. You should also illustrate individually some representative buildings that form the fabric of the district but are not major monuments, and other buildings that may intrude on the historic character

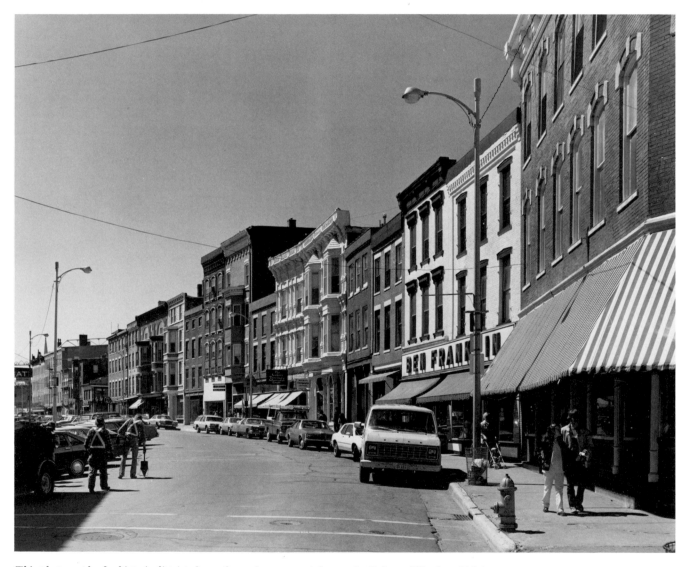

This photograph of a historic district shows the main commercial street in Galena, Illinois, which is lined with marvelous nineteenth-century commercial buildings. The photo was taken with a hand-held Pentax 6 x 7 medium-format camera with a 75mm f/4.5 Pentax-Shift lens and a yellow filter.

of the area.

5. You should prepare a sketch map of the district before you commence photography and note thereon your position for each photograph taken and the direction your camera was facing at the time of exposure. If you think you can remember that information in a complex district, later, when you return to your office, you may be in for a surprise.

If you imagine, from the above suggestions, that you will consume quite a bit of film in photographing a district thoroughly, you are correct. On the other hand, the more thoroughly you photograph it, the more likely it is that district boundaries will be appropriately and efficiently defined later on.

Changing media. An active architectural photographer will need to convert images regularly from one photographic medium to another. Common examples are producing black-and-white prints from color slides and making color slides from black-and-white prints or line drawings.

Slides can be made into black-and-white prints by means of an "internegative," which may be either a color negative or a black-and-white negative, depending on the process used. Using Kodak's Panalure paper, a black-and-white print can be made from a color negative. The most economical way to do this is with a 35mm internegative; the best way to get good results is with a 4 x 5 internegative.

If you use a color internegative to produce Panalure prints, you will find that you retain some sky tone, about the same as would appear had you shot the original scene on black-and-white film with a K1 filter. You will find that Panalure prints made from 35mm internegatives will be quite grainy, but this process is relatively inexpensive, compared to using a 4 x 5 internegative.

Some professional photo labs will take your 35mm slide and make a 4 x 5 black-and-white negative from it; the negative can then be used to make the best possible prints technology will allow, under the circumstances. However, I have yet to find a lab that will use filters in the process of making black-and-white negatives from slides, meaning that sky tones will generally be lost.

Why do it? Essentially, making black-and-white prints from slides is a desperation measure. If you have some aging and fading slides that are nevertheless important, the only way to preserve the images is to convert them to black-and-white media.

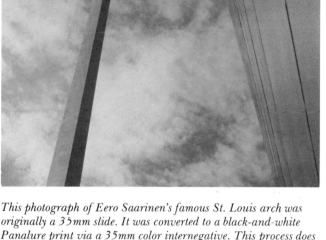

This photograph of Eero Saarinen's famous St. Louis arch was originally a 35mm slide. It was converted to a black-and-white Panalure print via a 35mm color internegative. This process does not produce high-resolution prints, but it can produce usable images.

If you find that you wish to illustrate buildings in an article or book, and you have only slides, you may need to have prints made, preferably black-and-white prints. Unfortunately, this process of conversion is expensive and produces marginal results. Much better would have been to have taken both slides and black-and-white negatives on site, in the first place, with two cameras. In the long run, that is cheaper, and the results are far superior.

Color prints can be made from 35mm slides readily. The procedure is now common. However, color prints are no more archival than the original slides were and are not as suitable for producing black-and-white half-tone illustrations in books and articles.

Positive 35mm slide transparencies can be made

readily from black-and-white prints or drawings by a photographer with a macro lens or close-up accessory screw-in lens elements. Some years ago I found it to be much easier and cheaper to use color slide film for this purpose than positive black-and-white film. This is because the latter is rarely used and is almost never processed commercially. All you need to do is to load Ektachrome or Kodachrome film of the proper color balance for floodlights, or with the proper filtration to obtain the necessary balance, and then use floodlights and a photo-copy stand to photograph the desired prints or drawings.

Exposure selection in making such photocopies is widely misunderstood, and probably causes the most problems for viewers of the resulting slides. Such slides are normally badly underexposed unless the photographer knows what compensations to make. The normal situation is that the photographer is trying to copy a light-colored subject and then makes an exposure according to what his camera meter indicates to be correct. That will assure bad underexposure, because a meter is designed to read average outdoor situations, not light subjects. To avoid that problem, you can simply use a Kodak 18 percent gray card and take meter readings with the card placed in front of the camera's lens, over the subject. Alternatively, you can compensate by opening the lens one or two stops over the indicated exposure, without a gray card. Of course, determining the correct exposure then depends on your past experience in selecting the amount of intended overexposure in relation to the whiteness of the subject. And all that reverses for black or very dark subjects. It's simply best to use an 18 percent gray card.

Captions for 35mm slide shows can be made the same way as copies of prints and drawings. Simply photograph the desired caption after it has been prepared. In these situations, there is a tendency to photograph written or typed copy from too great a distance, making it illegible to the viewer because the text is too small. Err on the side of getting too close to the subject when photographing it and on the side of including too little text in the slide. Once, faced with a four-box cartoon on historic preservation that I wished to use for slides, I decided to take individual slides of each box rather than attempt to place all four boxes in one slide. The result was a series of four slides that could be projected sequentially, as the cartoon was meant to be read, and that method of handling it has enlivened numerous slide shows.

Rectified photography and scalable photographic prints. The purpose of rectified photography and scalable photographic prints is to produce prints, generally in black-and-white, that can be measured to enable the preparation of scaled elevation drawings. With a scalable print, a draftsman need not measure an entire facade in the field in order to have the information he needs for a drawing. He only needs to take a few sample measurements in order, later, to calculate a reproduction factor for a given photograph.

I am suggesting here a simplified system based on the techniques discussed in detail by J. Henry Chambers in his booklet, *Rectified Photography and Photo Drawings for Historic Preservation.* Chambers's system is intended to produce scalable *negatives* by

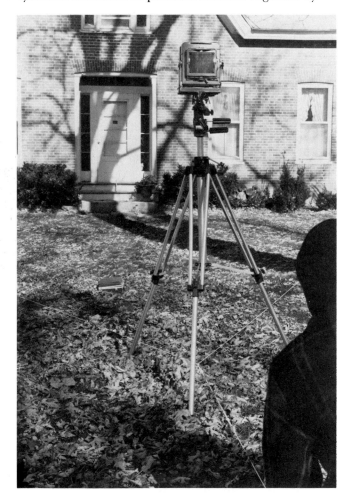

Here is a 4 x 5 view camera being set up for rectified photography for scalable prints. The tripod is located over the apex of an isosceles triangle described by a Y-shaped cord held taut to locate the perpendicular center line of the facade projected outward from the building.

establishing in the field a ratio between lens-to-building distance and the lens-to-film distance. The simplified system I have used does not do that; but, with the aid of a common memory electronic calculator, it allows a draftsman to scale from a photograph regardless of the size of that photograph. Those interested in following Chambers's more complex and, perhaps, more accurate system should consult his publication directly.

Depending on the time available and the sophistication desired, an architectural photographer can take rectified photographs for scalable prints with nothing more than a camera (preferably a 4 x 5 view camera), a sighting hand level, a long tape measure, a sturdy tripod, one target, and some cord for measurement. Clearly, a full transit would make things easier and more accurate, but such an instrument is relatively expensive.

The basic concept of rectified photography is to set the camera so that the plane of the film is perfectly parallel in both the horizontal and vertical axes to the plane of the facade being photographed. Photographs taken when a camera is locked in that position will be rectified and can be measured to produce accurate elevation drawings. By applying a little high-school trigonometry and geometry, we can set a camera in that way.

For small or medium-sized buildings, that procedure involves placing the camera directly over a perpendicular line projected horizontally outward from the center line of the building and then leveling the camera so that it points directly back at a lens-level point on the center line of the facade. If the camera lens is set at zero shift, the film will then be parallel to a vertical facade (the procedure for battered walls is a revision of this).

Upon arriving at a site, then, the first thing to do is locate the vertical center line of the building's facade. Do that by measuring with a 100-foot-long tape measure. Then a perpendicular line must be projected outward from that center line, and over that line the camera will be mounted on its tripod. The perpendicular line can be projected with a transit, if one is available. If not, then two equally long lengths of cord can be used to construct a large isosceles triangle such that the base of the triangle is the facade of the building and the center of the base is at the facade's center line. The triangle's apex is then used to locate the perpendicular, projected line. The camera on its tripod can be located at the apex

or at any point in line with the apex and the center line of the building. To aid in locating the camera, if it is beyond the apex, a sighting aid can be erected directly over the apex. I use an old tripod and a plumb bob for this purpose.

The camera, once placed, is then aimed toward the building so that the vertical center line of the ground-glass or viewfinder screen is located over the building's center line. The horizontal axes of the film and the facade are then parallel. You must then level the camera so that the vertical axes of film and facade are also parallel.

Use your sighting hand level at the same height as the camera's lens to sight on the facade center line to find a point exactly at the same height. Have an assistant tape a target on the facade at that point. If the ground-glass or viewfinder screen is then centered on that point, the resulting negative will be rectified both in the horizontal and vertical axes. If the facade is vertical, as most are, you can double-check your camera's alignment with a bubble level, which will reveal whether there is a gross error.

The diagrams in figures 4 and 5 illustrate a layout such as this and should make it clear.

While taking the photographs, the photographer should also make some sample measurements of the building: an over-all dimension and some other measurements to double-check results in the office. Moreover, if the facade has more than one significant plane closer to and/or farther from the

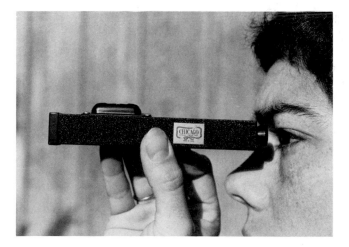

A sighting hand-level can be used to locate a point on a building at the same level as a camera's lens. This aids in leveling a camera in hand-held photography and in targeting a tripod-mounted camera in rectified photography. This is a very useful general accessory for architectural photography.

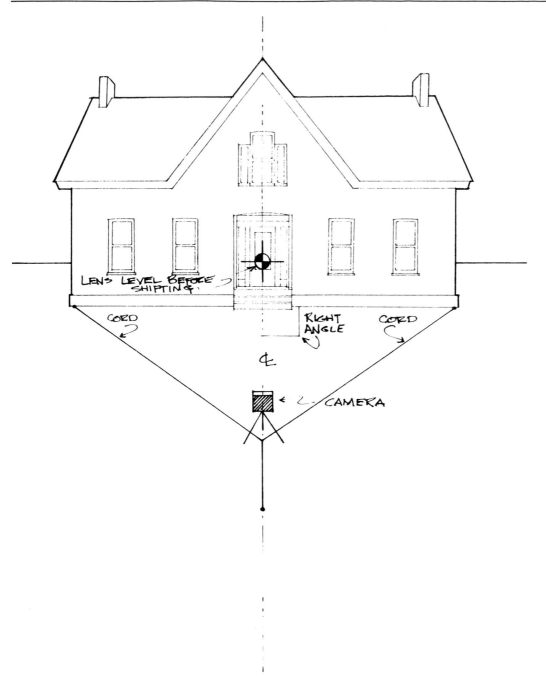

Fig. 4. Here is a set-up for taking a photograph from which can be made scalable photographic prints. The camera is placed along a line projected perpendicularly outward from the center line of the facade and is then aimed back down that line to a point on the building's center line that is at the same level as the lens. The perpendicular can be projected with the aid of two cords of equal length, which create an isosceles triangle on the ground having an apex pointing at the camera. If necessary, a vertical sighting guide can be placed over the apex to locate a point for the camera further out than the apex. The over-all width of this small Cooksville house was 42 feet, 2 inches, which can be used to establish a conversion factor for determining any other dimension on the facade. While this drawing illustrates a camera set on the center of the building, that is not necessary. Several sequential pictures could be required to cover a large building. It is quite easy to set this up in the field if the building is relatively simple, the ground in front of it is accessible and flat, and a cord has been prepared in advance and is staked out with tent pegs.

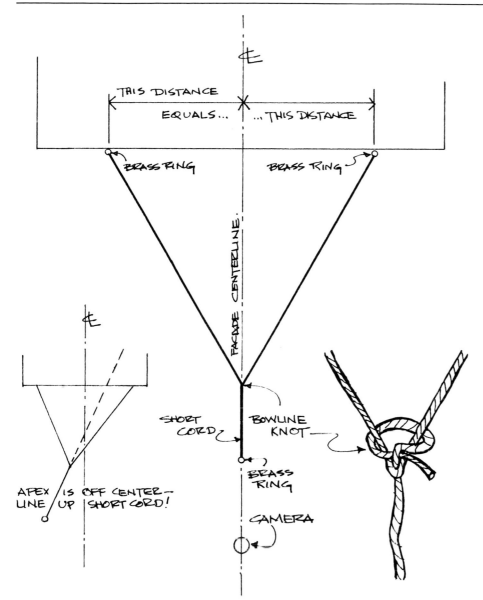

Fig. 5. A single mason's-type cotton cord about 80 to 100 feet long with brass rings tied to each end makes a good measurement cord for locating the perpendicular axis from the face of a building. Have an assistant hold both rings together, then walk out and pull the loop of cord tight to find its mid-point. Make certain the slack in each half of the cord is the same by holding it up to check their sags. They should be the same. Then tie a short length of cord (about 4 to 6 feet) with a bowline knot to the first cord, so that the two cords together form a "Y" with a short leg. Now have the assistant peg one ring a certain distance from the building's center line, and then walk past the center line an equal distance to the other side, and peg the second ring there: be sure to measure these distances carefully. You may then stretch the cords out like an isosceles triangle. Each side of the cord will stretch somewhat. To be sure the amount of stretch is equal on both sides, thus forming a triangle with equal legs, the short cord forming the leg of the "Y" must point directly back at the center of the building. If it points to one side of the center or the other, one half of the cord is stretched tighter than the other and the sides of the triangle would be unequal. Peg this cord down when it is pointing properly. The perpendicular line from the center of the building now passes through the apex of the triangle and through the short cord. Set up a sighting guide at this apex. I use an old compact tripod and hang a plumb bob down from the center of it. The line of the plumb bob, if it is over the apex, can then be used as a sighting guide to locate any point along the perpendicular center line.

camera than the principal facade plane, measurements in those planes also should be made. Advancing and receding planes will have different reproduction factors.

Prints made from these negatives can be scaled in one of two ways. First, if you do your own darkroom work, you can make enlargements with an architect's scale in hand. Adjust the enlarger so that the building's facade projected on the enlarging easel is equal to a convenient scale and then make the print. You will then be able directly to scale the print, at least in one plane. Second, if you do not do your own darkroom work, just have the prints made in

the normal way commercially. Consider obtaining a larger-than-normal print for ease in taking measurements. When you get the prints back, you can establish a conversion factor for each plane in each print by measuring the building in the photograph and dividing that distance into the actual field-determined dimensions of the building itself. The resulting conversion factor can be entered into the memory of a calculator for frequent recall, and any desired dimension on the facade can be obtained by multiplying its length in the photograph by the factor.

Here are a couple of hints I have learned from

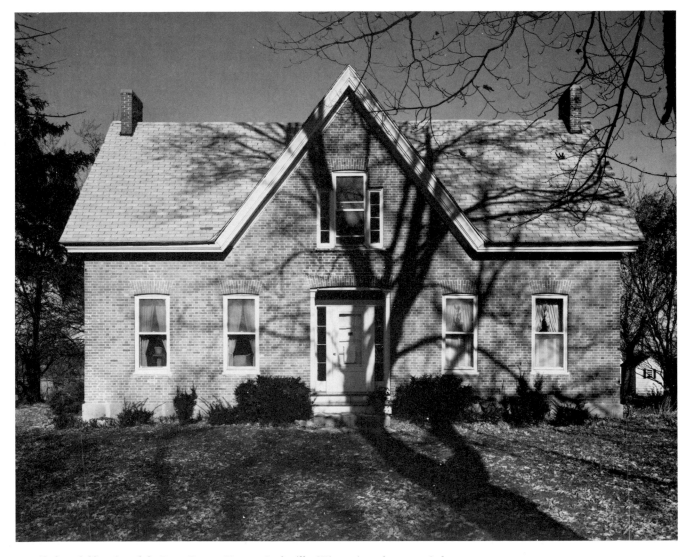

Rectified, scalable print of the Isaac Porter House, Cooksville, Wisconsin, taken on a Calumet CC-402 camera with a 90mm Ilex Acugon lens. The shadow cast on the house by the adjacent tree could have rendered some measurements difficult, but did not. Cloudy or overcast days are preferable for taking rectified photographs.

using this system. The simpler the building and the more open the ground in front of it, the more useful this system is. A 4 x 5 camera is much better for this purpose than is a 35mm SLR, because the 4 x 5's image size is 1,350 percent greater, permitting much more accurate images and, accordingly, more accurate measurements. A 2¼-inch SLR, of course, falls in between. A 35mm SLR could be used with Panatomic-X film, but only for small buildings and only with a PC, or shift, lens in service. Pictures on cloudy days are better than those on sunny days, because shadows tend to obscure detailed lines you might wish to measure. Cords tend to be stretchy, so you must devise a system to make certain the amount of tension in each cord used to locate the apex of the triangle is the same. I use a Y-shaped cord and make certain the leg of the Y points back at the center line of the facade; then tension will be the same, if the original lengths of the two upper legs of the Y were equal before stretching. Someone could try a wire rope to eliminate the stretch, but I have not tried that yet.

As with all new techniques, I recommend that a photographer interested in using this system to obtain rectified, scalable prints practice with it before having to depend on it.

Dissolve imagery in slide presentations. Architectural photographers have not made much use of dissolve controls or units in assembling and conceiving their 35mm slide presentations. That is unfortunate, as a little experimentation with such equipment will demonstrate. A dissolve unit, in its simplest form, operates two slide projectors simultaneously, so that each slide in the presentation's sequence is projected by the alternate projector. The two projectors go back and forth, as a tennis ball does, but they are aimed at precisely the same point on a projection screen. Thus, each slide in sequence fades out while the subsequent slide is fading in, and there is no break between slides. The equipment is easy to master, but two projectors are required with matched lenses and projection bulbs.

Dissolve equipment eliminates the break between slides, which is unavoidable with a single projector, and provides continuity between images. One "dissolves" into the next. The result is a bit like stop-action motion pictures. In fact, dissolve equipment can convert ordinary 35mm slides into a kind of motion-picture system with time-lapse photography. A little experimentation with dissolve equipment and appropriately selected slides reveals some of its potential.

Dissolve projection gives the audience a sense of motion through either time or space. The audience can be given a sense of what it is like to move through an interior space or outdoor environment if slides taken in sequence as the photographer moves from station to station are projected in the same sequence with dissolves. In this case, the slides have to be taken with the dissolve projection in mind. The camera is moved much as a motion-picture camera would be, the photographer making certain that the scene moves smoothly from frame to frame. For example, a photographer can demonstrate what it is like to approach the entrance of a building by focusing on the entry door and taking photographs over and over every seven to ten paces as he approaches the building.

The same system can illustrate the passage of time, whether over hours or days, or over years, or even centuries. We have all seen scientific time-lapse motion pictures of growing plants that seem to make the plants leap out of the ground. With 35mm slides and dissolve equipment, we can accomplish similar results with architectural details. For example, historic photos of existing buildings can be photocopied into slide form. Then you can go out into the field and rephotograph the building from approximately the same position and with the same focal length lens. You will then have a pair of slides that will effectively illustrate how the building has changed. Architects can use this system to demonstrate the progress of a construction project, and the building will seem to leap out of the ground, magically throwing itself together. You have to be certain to photograph the building repeatedly standing in the same position with the same lens. Landscape architects can demonstrate how a building's environment changes by rephotographing the building from the same position at the same time every year. Preservationists can illustrate the methodical, relentless horrors of demolition by photographing repeatedly at regular intervals from the same position a building being demolished. The effect of sunlight on a facade can be shown by photographing a building every hour on a clear day. The possibilities are as limitless as your imagination.

The key is to remember that dissolve imagery can communicate changes that occur either in space or in time. A little experimentation with dissolve units will be the most effective way to understand the potentials. This equipment has been little used or understood by architectural photographers in the past—a situation I hope will soon change. The

psychological linkage among images projected with dissolve equipment is powerful and undeniable and is waiting to be used.

Photogrammetry. Terrestrial photogrammetry has been applied to buildings in the past few years. It employs stereo pairs taken through lenses mounted a precise distance from each other. These photographs are mounted in an expensive, sophisticated, plotting machine, and an operator produces two-dimensional, scaled, line drawings from them. It is a very accurate system unaffected by complex shapes or the placement of planes in space. It was originally developed to produce maps from aerial photographs, but works with any object or building. If you can photograph it, you can measure it accurately with photogrammetry. For more information on this process, read Perry Borcher's booklet, *Photogrammetric Recording of Cultural Resources.* This technique does not use cameras in any way resembling those the average architectural photographer is used to working with and thus falls well outside the scope of this book.

Appendix A
Camera Importers and Manufacturers

Importers of Small and Medium-Format PC (Shift) Lenses

Canon 35mm f/2.8 Tilt-and-Shift
(for Canon 35mm SLRs)

Canon U.S.A., Inc.
One Canon Plaza
Lake Success, New York 11042

Carl Zeiss 35mm f/2.8 PC-Distagon
(for Yashica and Contax 35mm SLRs)

Yashica, Inc.
411 Sette Drive
Paramus, New Jersey 07652

Minolta 35mm f/2.8 Shift Rokkor-X
(for Minolta 35mm SLRs)

Minolta Corporation
101 Williams Drive
Ramsey, New Jersey 07446

Nikon 35mm f/2.8 PC-Nikkor
Nikon 28mm f/3.5 PC-Nikkor
(for Nikon 35mm SLRs)

Nikon, Inc.
623 Stewart Avenue
Garden City, New York 11530

Olympus 35mm f/2.8 Zuiko-Shift
(for Olympus 35mm SLRs)

Olympus Camera Corporation
145 Crossways Park West
Woodbury, New York 11797

Pentax 28mm f/3.5 Pentax-Shift
(for Pentax 35mm SLRs)
Pentax 75mm f/4.5 Pentax-Shift
(for Pentax 6 x 7 SLR camera)

Pentax Corporation
9 Inverness Drive, East
Englewood, Colorado 80110

Schneider 35mm f/4.0 PA-Curtagon
(for most 35mm SLRs)

Schneider Corporation of America
185 Willis Avenue
Mineola, New York 11501

Leitz Schneider 35mm f/4.0 PA-Curtagon
(for Leica and Leicaflex SLRs)

E. Leitz, Inc.
Rockleigh, New Jersey 07647

Bronica 55mm f/4.5 Tilt-and-Shift
(for Bronica 6 x 4.5 SLR cameras)

Hindaphoto, Inc.
446 Sunrise Highway
Rockville Center, New York 11570

Manufacturers/Importers of Large-Format View Cameras

Arca-Swiss cameras

Bogen Photo Corporation
100 S. Van Brunt Street
Englewood, New Jersey 07631

125

Calumet cameras and lenses	Calumet Photographic 1590 Touhy Avenue Elk Grove Village, Illinois 60007
Cambo cameras	Arkay Corporation 228 South First Street Milwaukee, Wisconsin 53204
Linhof cameras	H. P. Marketing Corporation 216 Little Falls Road Cedar Grove, New Jersey 07009
Omega cameras *Toyo cameras* *Rodenstock lenses*	Berkey Marketing Cos., Inc. 25-20 Brooklyn-Queens Expressway West Woodside, New York 11377
Sinar cameras	Unitron Instruments, Inc. Ehrenreich Photo Optical Industries 101 Crossways Park West Woodbury, New York 11797
Wista cameras	Wista Co., USA 715 Ascot Drive Eugene, Oregon 97401
Schneider lenses	Schneider Corporation of America 185 Willis Avenue Mineola, New York 11501
Nikkor lenses	Nikon, Inc. 623 Stewart Avenue Garden City, New York 11530
Fujinon lenses	D. O. Industries, Inc. 317 East Chestnut Street East Rochester, New York 14445

Appendix B
Addresses of Organizations Helpful to Photographers

National Architectural and Engineering Record
National Park Service
U.S. Department of the Interior
440 G Street, N.W.
Washington, D.C. 20243

Jack E. Boucher is the supervisor of photography and pictorial records for the NAER, the nation's archive of historic buildings and structures.

National Register of Historic Places
National Park Service
U.S. Department of the Interior
440 G Street, N.W.
Washington, D.C. 20243

The NRHP is the nation's list of historic structures, buildings, and other resources worthy of preservation and relies heavily on photography to record resources and communicate about them.

American Association for State and Local History
708 Berry Road
Nashville, Tennessee 37204

The AASLH maintains an aggressive publications program relating to historic structures and buildings and is a source for excellent technical information on the curatorial aspects of photography and the preservation of photographic media.

Winona School of Professional Photography
Box 419
Winona Lake, Indiana 46590

This is a nonprofit educational institution operated by the Professional Photographers of America (PPA) designed to meet the educational needs of the professional photographer. It regularly holds courses on architectural photography.

Communication Programs
University of Wisconsin-Extension
610 Langdon Street
Madison, Wisconsin 53706

The University of Wisconsin offers a course entitled "Introduction to Architectural Photography," taught by Jeff Dean. The course consists of five sessions spaced a week apart and is limited presently to twenty students per course. The university may offer this course in the future in Milwaukee as well as in Madison and may set up special, intensive, weekend-long courses.

Architecture Extension
290 College of Design
Iowa State University
Ames, Iowa 50011

Each autumn since 1976, Iowa State University has offered a course instructed by Julius Schulman and entitled, "Visual Communication in Architecture: a Workshop in Architectural Photography." It is limited to about thirty-five students and deals primarily with architectural photography in the 35mm format. It is a 2½-day workshop that involves a day's photography followed by critiques of students' work.

Brooks Institute of Photography
2190 Alston Road
Santa Barbara, California 93108

College of Graphic Arts and Photography
Rochester Institute of Technology
1 Lomb Memorial Drive
Rochester, New York 14623

These are two degree-granting educational institutions with specialties in professional photography. Rochester also has a graduate curriculum. Other colleges with photography degrees can be found through *Lovejoy's College Guide*, in any good-sized library. Technical schools with photography curricula are listed in *The College Blue Book: Occupational Education*.

Professional Photographers of America
1090 Executive Way
Des Plaines, Illinois 60018

Founded in 1880, the PPA has 16,500 members who are professional photographers and a staff of forty. It publishes the monthly magazine *The Professional Photographer* and the annual *Directory of Professional Photography*. The PPA also sponsors the Winona school listed above. The PPA has a system for establishing the credentials of professional photographers, including architectural photography as a specialty.

Architectural Photographers Association
c/o Gordon Schenck
Box 4203
Charlotte, North Carolina 28204

The APA was founded in 1947, merged with the PPA in 1968, and was re-established as an independent organization in 1971. According to Mr. Schenck, it is now "in limbo" and had but

twenty members at last count. Membership was restricted to professional architectural photographers who had been published in architectural or design publications. Mr. Schenck indicated that keeping such a small group going was difficult because the nation's professional architectural photographers are spread all over. In the past, the APA did publish a newsletter; the association's future is uncertain. There is no known national organization for architectural photographers of all stripes, whether amateur or professional.

National Free-Lance Photographers Association
4 East State Street
Doylestown, Pennsylvania 18901

The NFLPA was founded in 1962 and has some 24,000 members and five regional offices. Amateurs and professionals may join. It publishes *Freelance Photo News* irregularly, as well as a variety of directories, pamphlets, and guides.

Photographic Society of America
2005 Walnut Street
Philadelphia, Pennsylvania 19103

The PSA was founded in 1933, has a staff of fifteen, and has 18,700 members who are amateur and professional photographers, as well as camera clubs. It holds an annual national convention and regional meetings, and publishes a monthly journal and annual membership directory.

Shutterbug Ads
Post Office Box F
Titusville, Florida 32780

A monthly, national, classified listing of more than 100 pages containing all types of photographic equipment wanted and for sale. It is sold to subscribers two ways, for receipt by first-class or third-class mail. Included among listings are SLR bodies and lenses, 2¼ SLR bodies and lenses, press and view camera equipment and lenses, darkroom equipment, and much more. A good source for used equipment, but prices vary from true bargains to highway robbery. Asking prices for one lens I once wanted varied from $80 to $280.

Weatheralert
639 South Dearborn
Chicago, Illinois 60605

Radio Shack
Tandy Corporation
Fort Worth, Texas 76102

These are two manufacturers of crystal-controlled VHF radio receivers designed exclusively to receive the three special National Weather Service channels over which are broadcast continuously comprehensive weather forecasts and hourly radar summaries.

Light Impressions, Inc.
131 Gould Street
Rochester, New York 14610

Specializes in products and services for the archival storage, framing, and display of photographic materials. Sells, among other things, desiccants, acid-free boards and papers, vapor-tight envelopes, archival photo processing materials, framing and mounting supplies, negative-storage materials, and books.

University Products, Inc.
Post Office Box 101
Holyoke, Massachusetts 01041

Sells archival, acid-free storage and mounting materials, negative and slide-storage systems and sleeves, exhibition aids, and other museum and media preservation supplies.

Bibliography

A noteworthy contribution to the photography of architecture was made in 1855 by the Reverend F. A. S. Marshall with his pamphlet *Photography: The importance of its application in preserving pictorial records of the National Monuments of History and Art*, which is, as far as I know, the first publication to draw attention to the importance of this specialised subject . . .
—Helmut Gernsheim, 1949

Books on architectural photography

Barry, T. Hedley. *How to Photograph Buildings*. London: Fountain Press, 1927.

Cleveland, Robert C. *Architectural Photography of Houses*. New York: F. W. Dodge Corp., 1953. 170 pages.

DeMare, Eric. *Architectural Photography*. New York: Hippocrane Books, 1975.

Gernsheim, Helmut. *Focus on Architecture and Sculpture: An Original Approach to the Photography of Architecture and Sculpture*. London: Fountain Press, 1949. 142 pages, 64 plates.

Lahue, Kalton C., and Joseph A. Bailey. *Petersen's Guide to Architectural Photography*. Los Angeles: Petersen Publishing Co., 1973. 80 pages.

Molitor, Joseph W. *Architectural Photography*. New York: John Wiley and Sons, 1976. 164 pages.

Schulman, Julius. *The Photography of Architecture and Design*. New York: Whitney Library of Design, 1977. 238 pages.

Shaw, Leslie. *Architectural Photography*. London: G. Newnes, 1949. 191 pages.

Veltri, John. *Architectural Photography*. Garden City, New York: Amphoto, 1974. 192 pages.

Chapters on architectural photography in photography books

Adams, Ansel. "Architectural Photography." In *The Encyclopedia of Photography*, vol. 2, pages 235–244. New York: Greystone Press, 1963.

"Architectural Photography." In *Encyclopedia of Practical Photography*, pages 97–111. Garden City, New York: Amphoto, 1977.

Gilpin, Laura. "Historic Architecture and Monument Photography." In *The Encyclopedia of Photography*, vol. 9, pages 1711–1715. New York: Greystone Press, 1971.

Jones, Pirkle. "House and Home Photography." In *The Encyclopedia of Photography*, vol. 10, pages 1771–1777. New York: Greystone Press, 1971.

Rosen, Marvin J. "Architecture." In *Introduction to Photography: A Self-Directing Approach*, pages 274–278. Boston: Houghton Mifflin Co., 1976.

Smith, G. E. Kidder, AIA. "Architectural Photography with the Small Camera." In *The Encyclopedia of Photography*, vol. 2, pages 245–249. New York: Greystone Press, 1963. (Written before shift lenses were available.)

"View Camera." In *Encyclopedia of Practical Photography*, pages 2530–2536. Garden City, New York: Amphoto, 1977.

Articles on architectural photography

Cox, J. Crowther. "The Photography of Architectural Detail." *Photographic Journal*, April 1936. London.

Dean, Jeff. "Photographing Historic Buildings: Special Considerations." *National Register of Historic Places in Wisconsin Newsletter*, April 1979. Madison: State Historical Society of Wisconsin.

Hockey, William B. "Scaled-Rectified Photography on Site." *APT Journal*, no. 3 (1975). Ottawa: Association for Preservation Technology.

Page, Marian. "Frances Benjamin Johnston's Architectural Photographs." *American Art and Antiques*, July/August 1979. New York.

Reiff, Daniel D. "An Amateur's Guide to Architectural Photography." *Historic Preservation*, January/March 1975. Washington, D.C.: National Trust for Historic Preservation.

Robinson, Cervin. "Architectural Photography: Complaints About the Standard Product." *Journal of Architectural Education*, November 1975. Washington, D.C.: Association of Collegiate Schools of Architecture.

Smalling, Walter. "How to Improve Quality of Photos for National Register Nominations," *How-To #3*, Fall 1979. Washington, D.C.: Heritage Conservation and Recreation Service.

Stumm, Walter. "Architectural Photography: Some Tricks of the Trade." *Pentax Life*, Spring 1980.

Related publications

Borchers, Perry E. *Photogrammetric Recording of Cultural Resources*. Washington, D.C.: National Park Service, 1977.

Boucher, Jack E. *Photographic Specifications for Contract Photographers*. Washington, D.C.: Heritage Conservation and Recreation Service, March 1979.

Boucher, Jack E. *Suggestions for Producing Publishable Photographs*. Washington, D.C.: National Trust for Historic Preservation, n.d.

Cavallo, Robert M., and Stuart Kahan. *Photography, What's the Law? How the Photographer and the User of Photographs Can Protect Themselves*. New York: Crown Publishers, 1979.

Chambers, J. Henry, AIA. *Rectified Photography and Photo Drawings for Historic Preservation*. Washington, D.C.: National Park Service, December 1973.

Clements, Ben, and David Rosenfeld. *Photographic Composition*. New York: Van Nostrand Reinhold Co., 1974.

Eastman Kodak Company. *Kodak Films: Color and Black-and-White*. Rochester, N.Y.: 1978. Publication AF-1.

Eastman Kodak Company. *Kodak Infrared Film*. Rochester, N.Y.: 1976. Publication N-17.

Eastman Kodak Company. *Photography with Large-Format Cameras*. Rochester, N.Y.: 1977. Publication O-18.

Eastman Kodak Company. *Preservation of Photographs*. Rochester, N.Y.: 1979. Publication F-30.

Hecker, John C., and Sylvanus W. Doughty. *Planning for Exterior Work on the First Parish Church, Portland, Maine: Using Photographs as Project Documentation*. Washington, D.C.: Heritage Conservation and Recreation Service, 1979.

McKee, Harley J. *Recording Historic Buildings*. Washington, D.C.: National Park Service, 1970.

Weinstein, Robert A., and Larry Booth. *Collection, Use, and Care of Historical Photographs*. Nashville, Tenn.: American Association for State and Local History, 1977.

Wilhelm, Henry. *Procedures for Processing and Storing Black-and-White Photographs for Maximum Possible Permanence*. Grinnell, Iowa: East Street Gallery, 1970.

Index